NEW-YORK HISTORICAL SOCIETY

NEW YORK CITY IN THE GILDED AGE

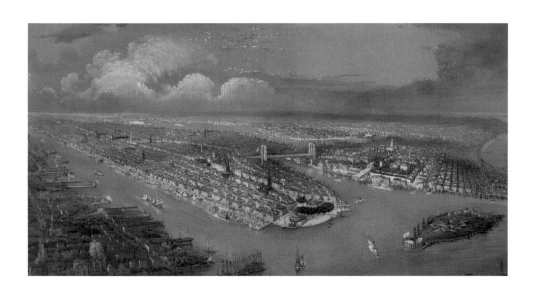

ESTHER CRAIN

BLACK DOG
& LEVENTHAL
PUBLISHERS

To my mother and father.

LIBRARY OF CONGRESS CATALOGING-IN-PUBLICATION DATA ON FILE
AT THE OFFICES OF BLACK DOG & LEVENTHAL PUBLISHERS, INC.

MANUFACTURED IN CHINA

PUBLISHED BY BLACK DOG & LEVENTHAL PUBLISHERS, INC.
151 WEST 19TH STREET NEW YORK, NEW YORK 10011

DISTRIBUTED BY WORKMAN PUBLISHING COMPANY
225 VARICK STREET NEW YORK, NEW YORK 10014

H G F E D C B A

CONTENTS

INTRODUCTION

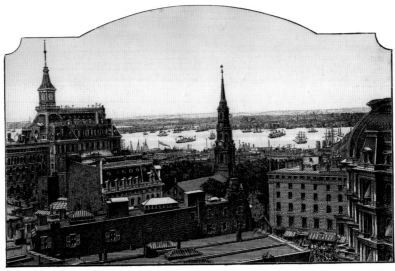

Downtown and the Hudson River

While New York never stops evolving, few eras were more transformative than the Gilded Age, roughly between the late 1860s and 1900. In 1866, New York's population of just over 800,000 was concentrated below 23rd Street. Residents traversed cobblestone roads by horse car. They illuminated their brownstone or tenement homes with candles or gas lamps, and the tallest structure of the nascent skyline was Trinity Church's 281-foot spire on lower Broadway. To reach the new Central Park from downtown required a lengthy, bumpy carriage ride; crossing the East River to the city of Brooklyn meant boarding the ferry.

By 1900, the Empire City had become the Imperial City. New arrivals poured in from across the world and helped push the population to three million. Wealth generated by Wall Street and industrial labor fueled a housing boom of opulent mansions, gable-roof apartment flats, and rows of shabby dumbbell tenements. Electric streetlights bathed nighttime sidewalks in a brilliant glow. Steel-frame office towers rose twenty stories and skimmed the heavens. New Yorkers fanned out north to the Bronx, east to Brooklyn, and other parts of the newly consolidated city. Threading this metropolis were elevated train tracks and a graceful bridge webbed with steel cables. On the

cusp of the twentieth century, New York was bursting with beauty, power, and possibilities.

New York City in the Gilded Age attempts to capture what it was like to live in Gotham then, to be a daily witness to the city's rapid evolution. The rise in popularity of photography and illustrated newspapers in those years has given us this astonishing collection of images through which we can see and comprehend the era. Some document the bigness of New York: the construction of the Statue of Liberty, the opening of the Brooklyn Bridge, the incredible mansions of Millionaires' Row. Others reveal small, fleeting moments of a long-gone time: Alice Vanderbilt posing proudly in her "Electric Light" ball gown, New Yorkers enjoying carriage rides and maypoles in Central Park, and a line of men waiting for free coffee at the Bowery Mission. *New York City in the Gilded Age* astounds with how much everything changed in only three short decades in the city Walt Whitman described this way: "There is no place like it, no place with an atom of its glory, pride, and exultancy. It lays its hand upon a man's bowels; he grows drunk with ecstasy; he grows young and full of glory, he feels that he can never die."

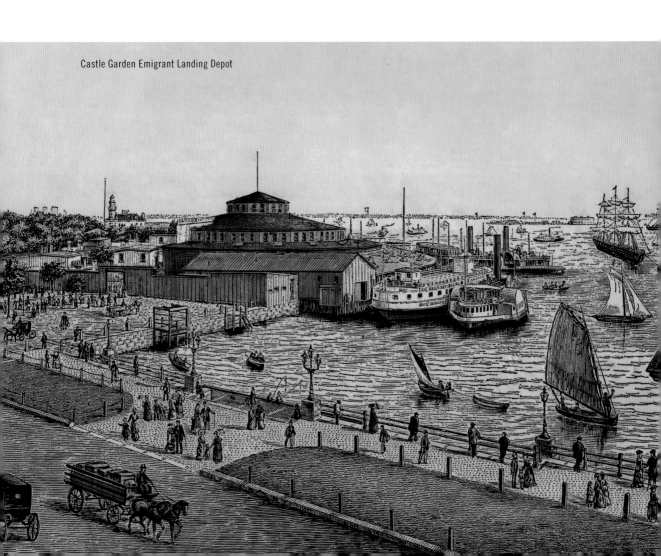

Castle Garden Emigrant Landing Depot

THE STEREOSCOPE CRAZE

One way to experience this era as many in the Gilded Age did is through stereoscopic images. Wildly popular at the time, stereoscopic cards featured two seemingly identical images printed side by side. When viewed through a device called a stereoscope, the images became three-dimensional. "The first effect of looking at a good photograph through the stereoscope is a surprise such as no painting ever produced," wrote Oliver Wendell Holmes in *The Atlantic* in 1859, the year he invented a handheld stereoscope that became popular with the general public. "The mind feels its way into the very depths of the picture." Millions of stereographs were produced, and stereoscopes were common in many homes. In an age before movies and TV, they brought news and entertainment to parlors and living rooms.

The fifty stereographs included here span the length of the Gilded Age. They capture a post–Civil War city getting its bearings again, the growth and expansion of the urban landscape, as well as architecture, historical events, and stark street scenes. View each one through the stereoscope, and the metropolis really comes alive. The 3-D photos flicker and move as if in real time, transporting you into the image. For a brief moment, Gilded Age New York is reawakened, in all its glory and whimsy.

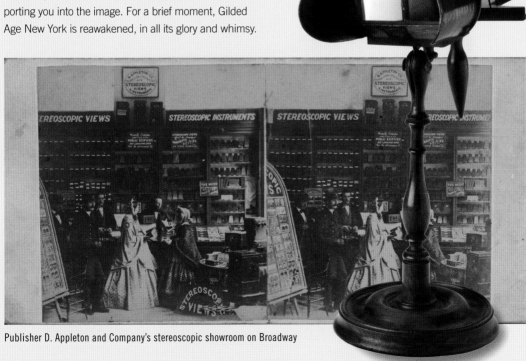

Publisher D. Appleton and Company's stereoscopic showroom on Broadway

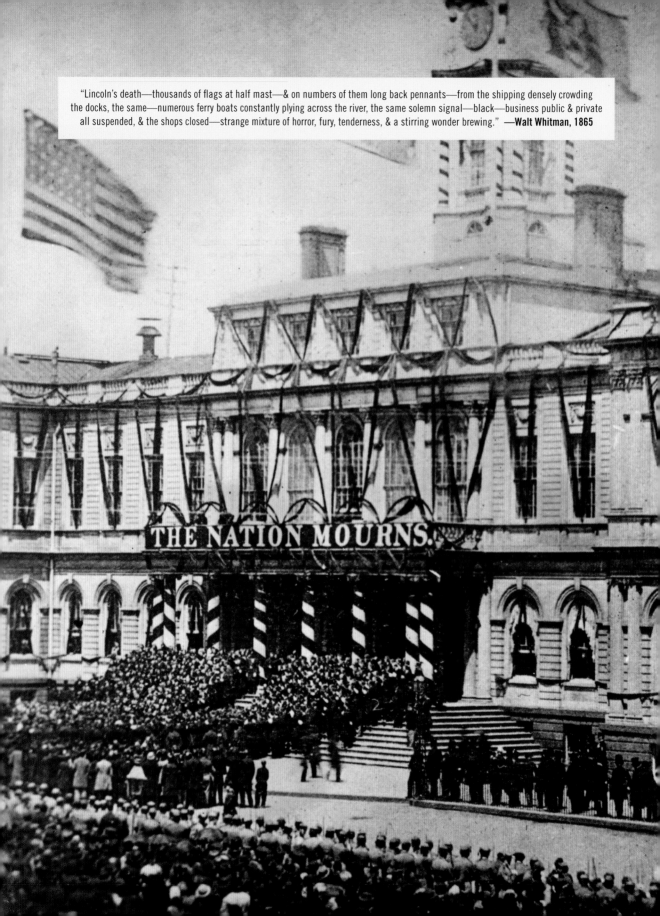

"Lincoln's death—thousands of flags at half mast—& on numbers of them long back pennants—from the shipping densely crowding the docks, the same—numerous ferry boats constantly plying across the river, the same solemn signal—black—business public & private all suspended, & the shops closed—strange mixture of horror, fury, tenderness, & a stirring wonder brewing." —Walt Whitman, 1865

THE NATION MOURNS.

POST-CIVIL WAR NEW YORK

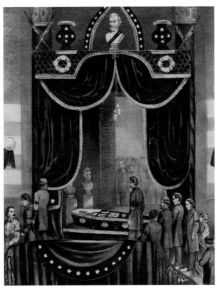

An estimated 120,000 mourners waited in line for hours to peer inside the open casket and say good-bye to President Lincoln in the City Hall rotunda.

MOURNING IN THE METROPOLIS

The wood and silver casket containing the body of Abraham Lincoln arrived by ferry at the Desbrosses Street wharf on April 24, 1865. Under bright, balmy morning skies, crowds of solemn onlookers watched as soldiers carefully placed the casket onto an American flag-draped hearse. Accompanied by a cortege of politicians, military officers, and representatives of civic groups, the hearse began wending its way east, pulled by six gray horses cloaked in black cloth. "The procession moved along Desbrosses Street to Hudson Street, along Hudson to Canal, through Canal to Broadway, and thence to City Hall Park," wrote the *New York Times* on April 11, 1915. "Everywhere dense masses of people lined the way, all of whom reverently bared their heads as the procession passed."

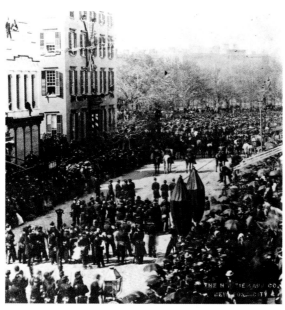

As the procession moved up Broadway, it passed the mansion of Cornelius van Schaack Roosevelt, who had invited his grandsons Theodore and Elliott to view the cortege. They're believed to be the two small figures in the window. Four-year-old Edith Carow, future wife of Theodore and his childhood playmate, was also at the mansion. "I was a little girl then and my governess took me to Grandfather Roosevelt's house on Broadway so I could watch the funeral procession. But as I looked down from the window and saw all the black drapings I became frightened and started to cry. Theodore and Elliott were both there. They didn't like my crying. They took me and locked me in a back room. I never did see Lincoln's funeral." —**Edith Roosevelt to historian Stefan Lorant**

Inside City Hall, the open casket was set on a black platform at the top of a circular staircase over the rotunda. For the next twenty-four hours, the body of the slain president lay in state, as it had done in Philadelphia, Harrisburg, Baltimore, and Washington D.C. At each stop made by his funeral train, throngs of mourners honored the martyred leader.

For most of his presidency, New Yorkers had been sharply divided among class and ethnic lines in their affection and loyalty toward Lincoln. Yet since April 15, when word of the president's death reached the city, their grief had become immense, deep, and palpable. The lawyer George Templeton Strong wrote in his diary on April 16: "An Easter Sunday unlike any I have seen . . .

Nearly every building in Broadway and in all the side streets, as far as one could see, festooned lavishly with black and white muslin. Columns swathed in the same material. Rosettes pinned to window curtains. Flags at half-mast and tied up with crape . . . Never was a public mourning more spontaneous and general."

Eight days after Strong's diary entry, City Hall was awash in sorrow. "Thousands passed reverently before the remains throughout the day and night, and thousands more were turned away, unable to gain admittance," the *Times* stated. "As night came on," wrote one who saw the spectacle, "the scene grew more impressive. The heavy draping of the rotunda caused the light from the chandeliers to assume

a sickly glare as it was reflected from the silver ornaments of the coffin and catafalque on the faces of the passing crowd."

One by one, an estimated 120,000 mourners paid their respects. "So short is the landing between the stairways that eight out of ten of the visitors, in their eagerness to catch an immediate glimpse, and their anxiety to maintain the look as long as practicable, forgot the step at the head of the downward flight and stumbled into the arms of the hard-worked policemen," wrote the *Times* on April 25.

By one o'clock the next day, the president's coffin was taken from City Hall and moved to a canopied funeral car. A second procession of approximately fifty thousand citizens—more politicians, soldiers, and representatives of civic, ethnic, and religious organizations (including a group of African American marchers, who at the last minute were allowed to participate) followed the car up Broadway to Union Square.

The enormous procession passed key locations that connected Lincoln to the city. Just above City Hall, it approached the rough edges of the notorious Five Points slum, which Lincoln had visited as a presidential candidate and where he had become visibly distraught by the destitute children he encountered. At Bleecker Street, it passed Mathew Brady's former portrait studio, where Lincoln had sat for the photo that introduced him to the nation. As the procession reached Waverly Place, it came within blocks of Cooper Union, where Lincoln had spoken in 1860 as a little-known Republican hopeful for president.

At Union Square, the northern end of New York's commercial heart, the procession stopped. Politicians honored Lincoln with speeches; clergymen offered prayers. Tickets were sold for front-row viewing from the sidewalks, while crowds watched and listened from roofs and windows.

Late in the afternoon, the procession resumed, moving west to Fifth Avenue and ultimately to the train depot at Tenth Avenue and 30th Street. From there, the casket would go to Albany en route to burial in Illinois. After the train departed, the city was left to deal with its sorrow and await the return to normalcy.

Maria Lydig Daly, the wife of a city judge who kept a diary from 1861 to 1865, wrote on April 25: "Today President Lincoln's funeral procession passes through the city. The body lies in state in City Hall and some three hundred thousand people, they say, have visited it. I shall not go out to see the show, as the Judge is not at home. I will let the servants go instead; I am sick of pageants . . . Tomorrow the theaters reopen and then, I suppose, all will be over."

A silk mourning ribbon was worn by many to honor the Civil War president.

THE PLOT TO BURN DOWN
NEW YORK CITY

It was supposed to happen on November 8, 1864—Election Day. A handful of Confederate conspirators had hatched a scheme to firebomb New York City's major hotels. Their goal: to disrupt elections and scare the nation into believing that the North's biggest city was vulnerable to Southern saboteurs.

Luckily, city officials were tipped off ahead of time. They positioned thousands of Union soldiers around the city on the lookout for Rebel terrorism. When the conspirators arrived in New York and saw so many soldiers, they pushed the plot to later in the month.

They struck on November 25, the day after the fractured country's second official Thanksgiving. Between 8 P.M. and midnight, the conspirators set room fires in 13 posh Manhattan hotels. Among them were the Fifth Avenue Hotel, at Madison Square; the St. Nicholas, on Broadway at 11th Street; and the St. James, on Broadway at 25th Street. Barges along the North River also went up in flames. A blaze was reported at Barnum's Museum on Lower Broadway.

None of the fires caused any serious damage or injuries, in part because city officials had maintained vigilance in case saboteurs really did try to pull off a "diabolical plot to burn the City of New York," as the *New York Times* called it in a November 27, 1864, article. "Had all these hotels, hay barges, theatres, & co., been set on fire at the same moment, and each fire well kindled, the Fire Department would not have been strong enough to extinguish them all, and during the confusion the fire would probably have gained so great a headway that before assistance could have been obtained, the best portion of the city would have been laid in ashes," wrote the *Times*. "But fortunately, thanks to the Police, Fire Department, and the bungling manner in which the plan was executed by the conspirators, it proved a complete and miserable failure."

Realizing that their plan was a bust, the conspirators fled to Canada. Captain Robert C. Kennedy of the Confederate Army was later captured trying to re-enter the United States, and he was tried at Fort Lafayette, 200 yards offshore from Brooklyn in New York Harbor. Found guilty, he was hanged at the fort's gallows on March 25, 1865.

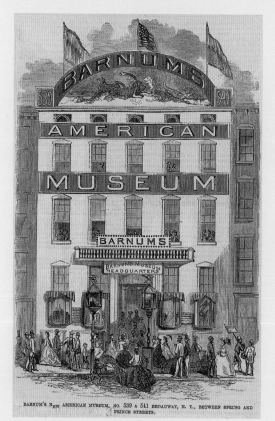

BARNUM'S NEW AMERICAN MUSEUM, NO. 539 & 541 BROADWAY, N. Y., BETWEEN SPRING AND PRINCE STREETS.

The day after a group of Southern saboteurs set fires to hotels, theaters, and P.T. Barnum's fabled museum at Broadway and Ann Streets, Barnum sent a letter to the *New York Times* in which he assured the public of his museum's readiness for any fire, calling it "as safe a place of amusement as can be found in the world." The building burned down accidentally less than a year later, on July 13, 1865.

THE REBELLION IN THE SOUTH

Lincoln's funeral procession ended the Civil War in New York City the same way it began: in a rare moment of unity. As the 1860s began, New York was a tense, fractured metropolis. Economic expansion in the 1840s and 1850s, fueled by huge waves of cheap labor in the form of German and Irish immigrants, made the Empire City the nation's capital of commerce and industry. About 800,000 people called Manhattan home. Omnibuses ferried residents to and from new brick and brownstone neighborhoods past Union and Madison Squares to the commercial districts that fanned out from Lower Broadway.

Then the Panic of 1857 ushered in the worst economic downturn in a generation. Factories and businesses closed; thousands were out of work. Recovery was in sight by 1860, yet city officials feared that Southern secession would cripple New York's economy.

Cotton was America's leading export. Though it grew in the soil of Southern states, city insurers, brokers, and cargo companies financed and shipped millions of dollars' worth to European textile-mill cities such as Manchester, England. The South and New York City each made a fortune off the international cotton trade. If that collusive relationship fell apart, New Orleans publisher James Dunmore De Bow predicted, "The ships would rot at her docks; grass would grow in Wall Street and Broadway, and the glory of New York, like that of Babylon and Rome, would be numbered with the things of the past."

On the eve of the 1860 presidential election, abolitionists and conservative Protestants supported the antislavery Republicans. The merchant class and working class, joined by poor immigrants and the city's political establishment, sided with the proslavery Democrats. On Election Day, city residents

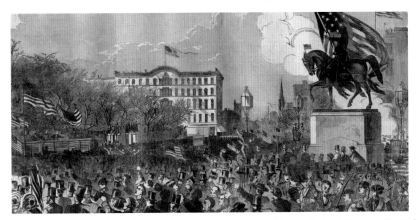

The flag of Fort Sumter is carried by the equestrian statue of George Washington, just outside Union Square Park at Fourth Avenue and 14th Street. Up to 250,000 New Yorkers attended this 3:00 P.M. "monster meeting" in a show of support for the Union. The crowd included native New Yorkers and Irish, German, and Eastern European immigrants; while men occupied the square itself, women and children cheered and waved flags from windows, balconies, and rooftops. (Missing from the historic event are black New Yorkers, who were not welcome at public demonstrations).

delivered almost twice as many ballots to Lincoln's opponents as to Lincoln. But the state gave its electoral votes to Lincoln.

As Southern states began seceding from the Union in late 1860, Mayor Fernando Wood—elected on a pro-Southern platform in 1859—made a last-ditch effort to maintain trade with the South by proposing that the city secede and form its own country. "Amid the gloom which the present and prospective condition of things must cast over the country, New York, as a *Free City*, may shed the only light and hope of a future reconstruction of our once blessed Confederacy," he told the Common Council (the city's governing body) on January 7, 1861. Wood's cronies on the council loved the idea.

Four months later, however, all sympathy for the South evaporated. On April 12, the Confederate bombing of Fort Sumter launched the Civil War. City residents united behind Lincoln's fight to preserve the Union. "President Lincoln's proclamation calling for seventy-five thousand men in order to suppress the Rebellion at the South, and to cause the laws to be duly executed, waked up the people to a realizing sense of their duty, as well as of the danger impending over them," wrote the *New York Tribune* on April 16, 1861. "Knots and groups of men have been seen during the day standing in front of prominent buildings on Broadway and other public thoroughfares, discussing the call for men, and among them all but one sentiment appeared to prevail, and that was to 'fight in support of the American flag, and in defense of the American Union.'"

Thousands of New Yorkers signed up for the military, including six thousand Irish immigrants, who vied to be part of the famous Sixty-Ninth New York Regiment ("gentle when stroked, fierce when provoked" was their motto). Tens of thousands of German immigrants also volunteered for military duty, as did two thousand African Americans. In total, nearly 150,000 New York City residents would fight for the Union over the next four years.

Citywide support for the Union cause hit its peak on April 20. An estimated quarter of a million residents gathered in what came to be known as the Great Sumter Rally in Union Square. "The excitement that prevailed is altogether unparalleled," wrote the *New York Herald* on April 21, 1861, noting the streamers that fluttered from windows, rooftops, and steeples. A giant American flag from Fort Sumter had been draped over a statue of George Washington. "Of the five stands erected for the accommodation of the public, and more especially of the orators of the occasion, each one was filled to overflowing, and the living cordon that surrounded them was packed as closely as human beings could exist amassed together."

George Templeton Strong observed the rally. In his diary that day, he wrote: "The Union mass-meeting was an event. Few assemblages have equaled in it numbers and unanimity. Tonight's extra says there were 250,000 present. That must be an exaggeration. But the multitude was enormous. All the area bounded by Fourteenth and Seventeenth Streets, Broadway and Fourth Avenue, was filled . . . The crowd, or some of them, and the ladies and gentlemen who occupied the windows and lined the housetops all round Union Square, sang 'The Star-Spangled Banner,' and the people generally hurrahed a voluntary after each verse."

WAR ANGER LEADS
TO UGLY RIOTS

The state of Ohio hired Tiffany & Co., established in New York City in
1837 as a "stationery and fancy goods" store, to create twenty
thousand medals for its Civil War veterans. Tiffany also
supplied swords and surgical tools for the Union Army.

The first war of the industrial age didn't just unite the city, it also jolted New York's economy. The Army needed food, clothing, engines, tents, warships, artillery, and other goods. Four thousand city factories employing ninety thousand workers cranked up production and reaped big profits. Some of the iconic brands and businesses that are still headquartered in the city today made big bucks during the Civil War years. Brooks Brothers manufactured thousands of uniforms, and standardized sizing. Tiffany & Co. made medals, swords, and surgical tools. Across the river in the separate city of Brooklyn,

the pharmaceutical companies that eventually became the giants Squibb and Pfizer manufactured medicine and surgical supplies.

But as the Confederates racked up victories and the number of Union casualties continued to grow, support and unity began to fray. In 1862, Copperheads—Democrats strongly opposed to war policy—became more vocal. Army enlistment numbers slipped. In 1863, the Emancipation Proclamation exacerbated resentment of African Americans. And then came the Conscription Act. Passed by Congress in March of 1863, it ushered in the nation's first wartime draft and sent working-class and poor

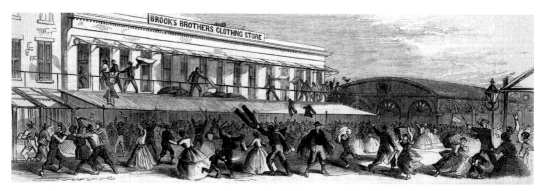

"A large number of marauders paid a visit to the extensive clothing-store of Messrs. Brooks Brothers, at the corner of Catharine and Cherry Streets. Here they helped themselves to such articles as they wanted, after which they might be seen dispersing in all directions, laden with their ill-gotten booty."—*Harper's Weekly*, **August 1, 1863**

residents into a rage. One way to escape it was to pay $300—nearly a year's salary. Well-to-do New Yorkers could afford it. The typical immigrant? Not likely.

This simmering fury came to a head during the Draft Riots of 1863. On the morning of July 11, a Saturday, draft drawings began at the Provost Marshal's office on Third Avenue and 46th Street. The sweltering city remained quiet for two days. The following Monday, that peace was abruptly and violently shattered. By

10:00 A.M., groups of mostly Irish immigrant men assembled at the draft office and burned it to the ground. Emboldened by this destruction, they began rampaging: they set fire to nearby buildings, cut telegraph lines, and tore up railroad tracks. The city police force, weakened because so many young men were away at war, was unable to control the growing mob.

Just past noon, a telegraph officer in New York sent this message to Secretary of War Edwin M. Stanton in Washington: "What is represented as a serious riot is now taking place on Third Avenue, at the provost-marshal's office. The office is said to have been burned, and the adjoining block to be on fire. Our wires in that direction have all been torn down. A report just in says the regulars from Governor's Island have been ordered to the vicinity." Two hours later, the same telegraph officer relayed this message: "The riot has assumed serious proportions, and

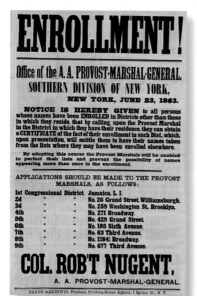

A poster calls for the enrollment of all male city residents to fill quota of new troops from each Congressional District in the city. A result of the 1863 Conscription Act passed by Congress in the spring of that year, the call angered working-class, mostly Irish, New Yorkers, who demonstrated their rage by launching the deadly Draft Riots in July.

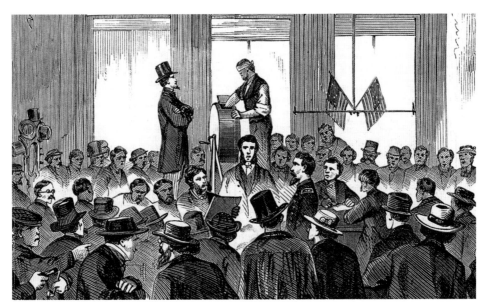

The government resumed the draft in New York on August 19th and was completed in 10 days, without any further incident.

is entirely beyond the control of the police. Superintendent [of Police] Kennedy is badly injured. So far the rioters have everything their own way. They are estimated at from 30,000 to 40,000. I am inclined to think from 2,000 to 3,000 are actually engaged. Appearances indicate an organized attempt to take advantage of the absence of military force."

The rioters continued their rampage all afternoon. They attacked the residence of pro-Lincoln mayor George Opdyke. Shops were looted; a rifle factory was pillaged. "The riot also took the form of a crusade against negroes, and wherever a colored man was observed, he was chased, stoned, and beaten," wrote the *New York World* on July 14. The Colored Orphan Asylum on Fifth Avenue and 43rd Street was set on fire (the children and staff miraculously escaped).

Draft wheel and draft cards used in New York City in 1863.

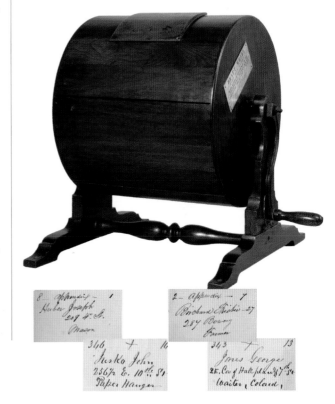

The body of William Jones hangs at Clarkson Street. "A crowd of rioters in Clarkson Street, in pursuit of a negro, who in self-defense had fired on some rowdies, met an inoffensive colored man returning from a bakery with a loaf of bread under his arm. They instantly set upon and beat him and, after nearly killing him, hung him to a lamppost. His body was left suspended for several hours. A fire was made underneath him, and he was literally roasted as he hung, the mob reveling in their demoniac act."
—*The Draft Riots in New York, July, 1863, The Metropolitan Police: Their Services During Riot Week*

A black man walking to his home on Clarkson Street was chased and lynched. Black men were beaten, mutilated, and murdered simply for being in the wrong place at the wrong time. At 9:30 P.M., a third message was sent to Secretary Stanton: "The situation is not improved since dark. The programme is diversified by small mobs chasing isolated negroes as hounds would chase a fox. I mention this to indicate to you that the spirit of mob is loose, and all parts of the city pervaded. . . In brief, the city of New York is tonight at the mercy of a mob, whether organized or improvised, I am unable to say. As far as I can learn, the firemen and military companies sympathize too closely with the draft resistance movement to be relied upon [for] the extinguishment of fires or the restoration of order. It is to be hoped that tomorrow will open upon a brighter prospect than is promised tonight." It wasn't until July 16 that five regiments of New York troops were sent back to the city to restore order. Officially, 119 were killed, but other reports estimated the number to be closer to a thousand.

The A.T. Stewart store's block-long "Iron Palace" opened at Broadway and Tenth Street in 1862. Catering to the city's burgeoning rich and elite, it featured a cast-iron front and nineteen departments spread over six stories, and employed up to two thousand people— including these garment workers toiling in the store's sewing room.

After four years of bloodshed, the South surrendered on April 9, 1865. But the war didn't really come to a close for the city until Lincoln's murder and subsequent funeral procession. United briefly in grief, and with city factories and the banking sector buzzing with money and activity, New York in 1865 was poised for progress. By the decade's end, the omnibuses choking the streets would start to be replaced by elevated trains, the first of which went up on Greenwich Avenue in 1868. And after a lull during the war, workers and laborers returned to Central Park, creating the lakes, paths, bridges, and fountains that turned what was once a rocky, partly swampy rectangle of land into a lovely public park accessible to all. New York was also growing famous for its opulent department stores and a shopping district north and west of Union Square dubbed "Ladies Mile."

Perhaps the only city industry that may have wished the War Between the States didn't end was the newspaper business. Centered at Printing House Square, across Park Row from City Hall Park, the plants of the city's popular morning and evening papers had churned out war news for an anxious public, pioneering the publications of "extras" and Sunday editions. With the war over, the pressure to maintain and even boost circulation intensified. The city of the next three decades would supply more than enough innovation, excitement, and scandal to keep the printing presses working overtime.

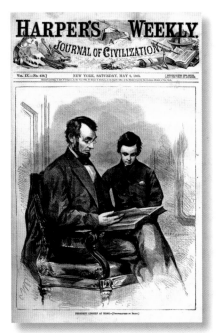

Harper's Weekly, published by Harper & Brothers from their offices on Pearl Street, was the most widely read journal in the United States during the Civil War.

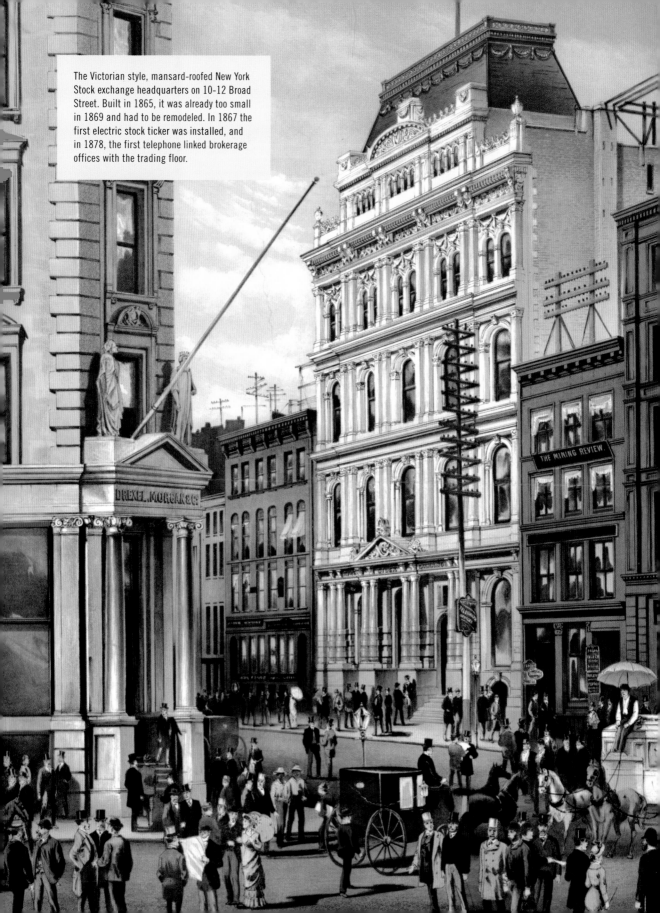

The Victorian style, mansard-roofed New York Stock exchange headquarters on 10-12 Broad Street. Built in 1865, it was already too small in 1869 and had to be remodeled. In 1867 the first electric stock ticker was installed, and in 1878, the first telephone linked brokerage offices with the trading floor.

COMMERCE CITY

At the end of Wall Street, seen here in 1885, is Trinity Church, built in 1846. Its 281-foot spire was the tallest in New York, dominating the cityscape of lower Manhattan until the World Building was constructed in 1890.

SHAMELESS MONEYMAKING

In February 1867, Mark Twain arrived in New York City as a correspondent for a San Francisco newspaper. Still a little-known itinerant journalist (who six years later would coin the term "The Gilded Age" to describe the excesses of the post-Civil War era), Twain had last visited New York in 1853. Only fourteen years had passed. Yet the thirty-two-year-old found himself in an unfamiliar city, a vast, fast-paced metropolis awash in money fever.

"The town is all changed since I was here . . ." he wrote. "They have increased the population of New York and its suburbs a quarter of a million souls. They have built up her waste places with acres and acres of costly buildings. They have made five thousand men wealthy, and for a good round million of her citizens they have made it a matter of the closest kind of scratching to get along in the several spheres of life to which they belong."

A GOLD SCHEME
ALMOST TAKES DOWN WALL STREET

They may not be as well known as fellow Robber Barons Vanderbilt, Carnegie, and Morgan, but Jay Gould and James Fisk were greedy financiers in their own right. Together they hatched a scheme to make millions off the gold market. On one fateful day—September 24, 1869,

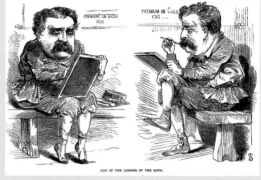

James Fisk in a 1869 cartoon showing the price of gold dropping $30 within an hour.

Jay Gould

dubbed Black Friday—their plan backfired and caused brokerage houses to fail, stock prices to tank, and the U.S. economy to go into freefall for months.

Gould and Fisk's idea was to buy as much gold as they could to artificially inflate its price, hoard it,

and then sell it at a huge profit. The problem was, in an effort to reduce the national debt, President Grant's administration had planned to put U.S. gold on the gold market. Gould and Fisk couldn't let that happen; the more gold in circulation, the lower its value would be.

So in late summer, they bribed Daniel Butterfield, a general during the Civil War and now Grant's assistant secretary of the Treasury, to tip them off when U.S. gold was about to go on the market—they would sell first and reap big profits. Grant discovered the scheme, however, and ordered the sale of government gold on September 24. Instantly, the price of gold nosedived. Gould and Fisk got out in time, but other investors went broke.

Persuasive lawyers plus corrupt judges helped Gould and Fisk escape lengthy prison terms. Gould quickly rebounded and made a fortune off Western Union and the elevated railroads. Fisk had a rougher end: he was shot dead in 1872 by another financier in the luxurious Grand Central Hotel at Broadway and Bleecker Street after a row over money and Fisk's showgirl mistress.

On September 24, 1869, the price of gold reached $160. Fisk claimed he could push it to $200. When the news of the government sale of gold became known, the price fell within minutes to $133. Stock prices subsequently fell twenty percent.

In June, he commented, "I have at last, after several months' experience, made up my mind that [New York] is a splendid desert—a domed and steepled solitude, where the stranger is lonely in the midst of a million of his race . . . Every man seems to feel that he has got the duties of two lifetimes to accomplish in one, and so he rushes, rushes, rushes, and never has time to be companionable—never has any time at his disposal to fool away on matters which do not involve dollars and duty and business."

New York had always been a place where money changed hands. What had started as a colonial trading post two centuries earlier had evolved into the nation's business capital, due in part to the opening of the Erie Canal in 1825, and to the subsequent waves of immigrants who provided cheap, ready labor. The demand for goods during the Civil War further unleashed the city's manufacturing prowess, fattening bank accounts all over Manhattan.

But this wealth-worshipping Gilded Age city was different. Accelerated by a $2 billion infusion from the federal government during the war and the 1864 Banking Act that made New York the repository of the banking reserves of the country, the business of finance began its reign. New national banks provided capital for America's developing railroad infrastructure, telegraph networks, and mining projects. In 1869, the New York Stock Exchange was trading approximately $3 billion in securities annually. New exchanges opened for commodities such as petroleum, cotton, corn, and gold. Smaller, less scrupulous traders sold shares outdoors at the "curbstone" stock exchange near Wall Street.

Curbstone brokers dealt with stocks too small to be listed on the New York Stock Exchange. They would meet outside, rain or shine, at the end of the day to auction stock. They moved inside in 1919 and in 1953 became the American Stock Exchange.

On the surface, this intense investment activity hinted at a robust economy. But there was little to no federal oversight regulating big banks and Wall Street, let alone the small-time brokers peddling speculative stocks. It would take several years before great numbers of unsuspecting investors realized that the bull market was rigged against them.

"The mania for stock gambling which now sways such masses of people, may be said to date from the war and the petroleum discoveries," wrote James D. McCabe in 1872 in *Lights and Shadows of New York Life.* "Since then it has rolled over the country in a vast flood. The telegraph is kept busy all day and all night in sending orders for speculations from people in other States and Cities to New York brokers. Everybody who can raise the funds wishes to try his or her hand at a venture in stocks. Merchants, clergymen, women, professional men, clerks, come here to tempt fortune. Many win; more lose."

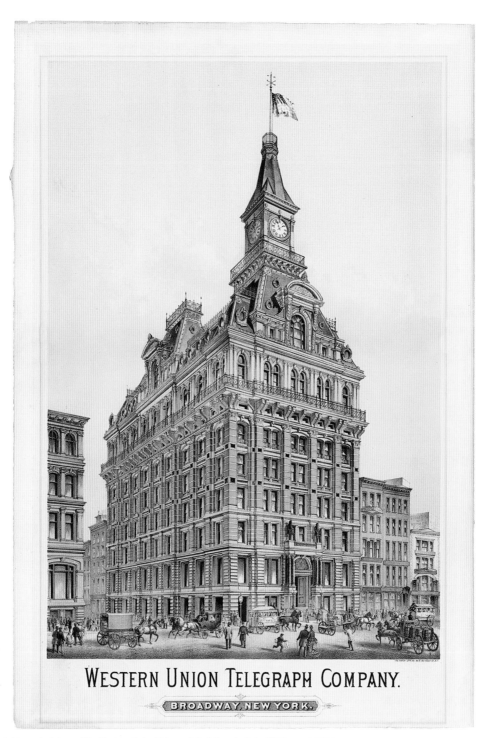

WESTERN UNION TELEGRAPH COMPANY.

BROADWAY, NEW YORK.

Topped by a clock tower, The Western Union Telegraph Building, built in 1875, stood 230 feet high and had 100 telegraph operators working twenty-four hours a day. Along with the Equitable Building, it vies for the title of the first skyscraper in New York City.

A CITY ON THE RISE

New money changed the look and shape of Gotham. "Brown stone" houses were all the rage: in the 1860s and 1870s, rows of handsome mud-brown homes packed the blocks between Madison Square at 23rd Street and Central Park's 59th Street border. The Theater District, along with luxury hotels and restaurants such as Delmonico's, moved with the flow of wealth from Union Square up to the 20s, 30s, and, at the end of the century, the 40s. What used to be strictly residential enclaves were swallowed up by the commercial sector.

"Everything here gives way to business," wrote McCabe. "The changes in the city are, perhaps, more strictly due to this than to the increase the population. It is a common saying that 'business is rapidly coming up town.' Private neighborhoods disappear every year, and long lines of substantial and elegant warehouses take the places of comfortable mansions of other days . . . A few years ago the section of the city lying between Fourth and Twenty-Third streets was almost exclusively a private quarter. Now it is being rapidly invaded by business houses."

Those business houses began transforming New York into a vertical city. Buildings were once capped at five or six stories; by the mid-1870s, eight-, ten-, and eleven-story structures lined the streets. The first Equitable Building, at 120 Broadway, debuted in 1870. Climbing 130 feet and the first office building to feature a passenger elevator, it's arguably the first skyscraper. Five years later, the Tribune Building went up at Printing House Square, towering over City Hall Park at 260 feet, and the Western Union Telegraph Building appeared at 195 Broadway. The dawn of the skyscraper era reflected a city bursting with energy and excitement. Walt Whitman praised these new towers as "cloud-touching edifices." But not everyone was awed. George Templeton Strong found them to be "hideous, top-heavy nightmares."

Nothing altered New York more profoundly than the elevated railway, or "el." The first line opened in 1868, and by the mid-1870s, elevated cars powered by belching steam engines ran along Second, Third, Sixth, and Ninth avenues as far north as Central Park. Iron pillars carried their massive steel tracks three stories above the street, giving New Yorkers a new expansive view of the city.

In the 1880s, the el had reached small uptown enclaves such as Harsenville and Carmensville on the West Side and Harlem from river to river. Parts of the Bronx had been annexed from Westchester in 1874; soon the presence of the el would make the farm villages there a continuation of the urban cityscape. Wherever the el blazed its trail, development followed. Brownstones and new "French flats" popped up near el stations that were once open fields. Tenements were built under and beside the sooty, rattling tracks.

New York's streets weren't quite paved with gold. The uneven cobblestones laid down on busy avenues were typically caked with mud and horse manure (if not the rotting carcasses of dead horses). Pigs occasionally roamed courts and alleys, feeding on the trash that was routinely thrown out of windows. Tangled black cobwebs of telegraph wires crisscrossed downtown intersections.

But some infrastructure improvements gave New York a sheen of loveliness. The first electric lights illuminated Broadway between Union and Madison Squares in 1880. Fifth Avenue's new mansions earned it the nickname "Millionaires Row." A hilly ridge along the Hudson was acquired by the city and set to become Riverside Park. And Central Park brought classes and factions together. "Central Park," wrote McCabe, "the chief pleasure ground of New York, has reached a degree of perfection in the beauty and variety of its attractions, that has made it an object of pride with the citizens of the metropolis."

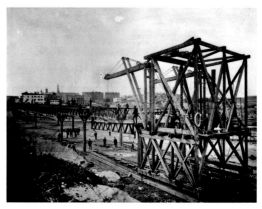

The Ninth Avenue Line opened in 1868, New York's first elevated train. It began at South Ferry and extended up Ninth Avenue to the Harlem River. Here the extension is under way at 66th and Columbus Avenue, in 1878 a largely underdeveloped part of the city.

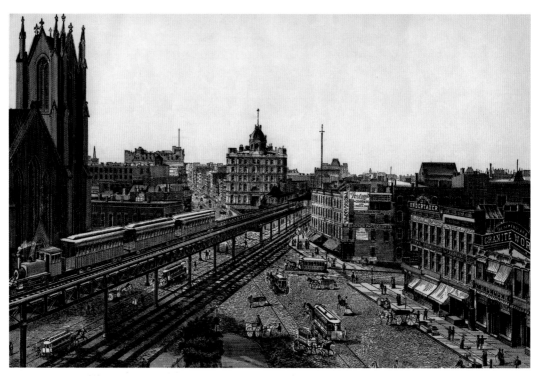

On April 29, 1878, the first steam-powered elevated train made a trial run up Sixth Avenue from Rector Street to 58th Street in seventeen minutes. When the train began running in June, there was an immediate backlash from Sixth Avenue residents about the noise. One resident wrote in a letter on June 18 to the *New York Times* that the noise "is simply unbearable . . . For the nervous, the invalid, or the sick, it is little short of murder. All the day long, hour after hour, without pause, let or hindrance, this rushing, whirring, deafening noise. The ear hardly has time to recover the shock of one train before another of the same kind comes on, and conversation becomes impossible, sleep a ghastly dream in which the roar of Niagara, the wild shriek of the tornado, and the war-whoops of a thousand Indians mingle in one fearful diapason, out of which dream one wakens with a start; to be repeated as soon as he sleeps again."

FIRE ENGINES AND AMBULANCES
HIT THE STREETS

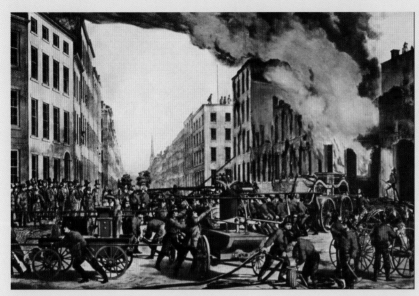

The first company of the Metropolitan Fire Department to go into service was Engine Co. 1, located in lower Manhattan at 4 Centre Street. By the end of 1865, the department consisted of 13 chief officers and 552 company officers and firemen. In 1870, under the new charter, New York City gained control and it was renamed the Fire Department of the City of New York (later FDNY).

New York's first firefighters were little more than a volunteer bucket brigade armed with a couple of hand-drawn pumpers, hooks, and ladders. But a bustling, crowded city needed a professional, full-time department. And after so many terrible fires had wiped out entire districts, as in the case of the Great Fire of 1845, insurance companies, tired of heavy payouts, demanded it.

So in 1865, the paid Metropolitan Fire Department was established. The new military-style department consisted of approximately 600 men. They worked a continuous tour of duty with one day off per month; their salary in 1870 was $1,000 annually. Losses from fires gradually decreased, thanks to steam-powered engines, fire call boxes, and manned lookout towers positioned across Manhattan.

Just as the forerunner of today's FDNY was getting its start, the city's first ambulances were hitting the streets as well. Created by a Civil War surgeon, the service began in 1869 with two horse-drawn vehicles navigating New York's teeming streets. Health care was primitive; medical supplies carried in the vehicles included bandages, blankets, splints—and brandy to stave off infection. "In case of any accident occasioning serious injury to any person, word is telegraphed from the nearest police station to Bellevue Hospital, and the ambulance is immediately started for the scene of the accident," wrote the *New York Times* in 1869. That first year, the service answered about 1,400 calls.

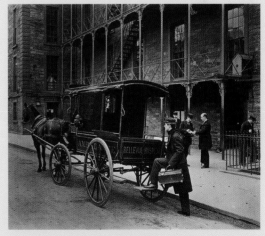

The horse-drawn Bellevue ambulance was the brainchild of Edward B. Dalton, a staff surgeon at the hospital who was the Inspector for the Army of the Potomac during the Civil War and who had devised successful methods for transporting wounded soldiers to field hospitals quickly and efficiently.

CORRUPTION AT BANKS AND BALLOT BOXES

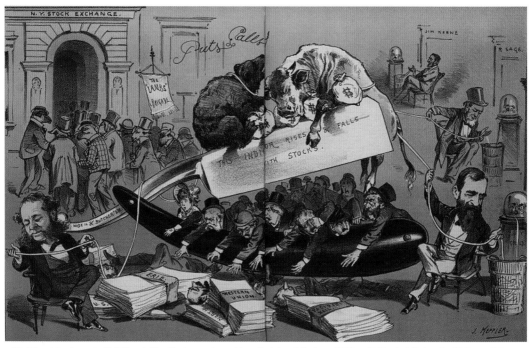

"Cutthroat business in Wall Street. How the inexperienced lose their heads" shows William H. Vanderbilt, Jay Gould, Russell Sage, and James R. Keene checking tickertape connected to a large, straight-edged razor labeled "Wade in & Butcher'em" and "This Indicator Rises & Falls with Stocks." Draped over the handle are many investors reaching for bundles of "Pacific Mail, Western Union, and Erie" stocks; the blade is poised to drop.

In the late 1860s, a new type of businessman emerged. Worshipped as "captains of industry" by some, they were outright criminals to others—as this early reference, from an 1870 issue of the *Atlantic Monthly*, makes clear: "The old robber barons of the Middle Ages who plundered sword in hand and lance in rest were more honest than this new aristocracy of swindling millionaires."

Three of the most notorious were Jay Gould, Jim Fisk, and Daniel Drew. These "rogue financiers" were determined to make a fortune by controlling prices without any concern for the economic stability of the country. Other "Robber Barons" monopolized entire industries. In 1867, Cornelius Vanderbilt, a native New Yorker and the richest man in America, persuaded the New York State government to let him combine the three railroads he owned into one company, the New York Central and Hudson River Railroads. Though Andrew Carnegie became a philanthropist later, he was first known as a union buster who bribed politicians to help build his steel empire. J. P.

Andrew Carnegie and John D. Rockefeller

Morgan combined many competing railways into one super rail line. John D. Rockefeller's Standard Oil, which moved its headquarters to New York City in 1884, made competition-crushing deals with the railroads to control more than ninety percent of oil refining in the U.S. by the 1880s.

Newspapers eagerly called out these men's rapacious business practices. In a November 19, 1882 article, "The Great Oil Monopoly: How the Standard Company Robs the Public," the *New York Times* gave a blunt assessment: "While the Standard is, in the real meaning of the word, the greatest monopoly in America, as powerful in its own field as the Government itself, and holding the entire refined and crude oil market of the world in the hollow of its president's hand, its methods and dealings are the most securely covered up and hidden from the public eye of any corporation that anywhere approaches it in size or ramifications."

COUNTERFEIT FEVER

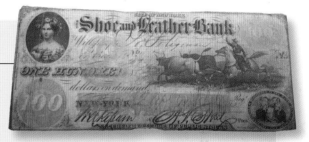

I n the mid-19th century, lots of paper money was in circulation. States issued their own notes, and in 1861, the federal government gave approval to the U.S. Treasury to print its own paper currency, or "greenbacks" as they were called because of their color. In 1863, Congress established a national banking system and the U.S. Treasury oversaw thousands of national banks, which were allowed to print their own notes, issued in denominations ranging from $1 to $1,000. All of these different bills were a counterfeiter's dream, as no one could possibly be familiar enough with each design and appearance to know which were real and which were frauds. In 1877, the Treasury Department's Bureau of Engraving and Printing became the sole producer of U.S. currency.

The Shoe & Leather bank was a legitimate financial institution—"one of the wealthiest and most reliable," according to a 1861 *New York Times* article. But its bank notes were catnip for counterfeiters, who made elaborate forgeries and then circulated them in other parts of the country, where they wouldn't be discounted as fraudulent. The mid-19th century has been described as the "golden age of counterfeiting."

William M. "Boss" Tweed was elected to the U.S. House of Representatives in 1852 and was elected as a New York state senator in 1867. But his real power came from his position as head honcho of Tammany Hall, where he controlled political patronage in New York City. One of his public works projects was the building of the Old New York City Courthouse on Chambers Street, nicknamed the Tweed Courthouse. Tweed himself was tried and convicted of fraud and larceny there in 1873.

Greed wasn't just the province of industry titans. The city's Democratic political establishment lined its coffers through fraud, kickbacks, and payoffs. The infamous William M. "Boss" Tweed was the king of it all. Born on the Lower East Side, the son of a furniture maker, Tweed rose through the ranks to become the head, or "grand sachem," of the Society of Saint Tammany in 1863, a political club on Nassau Street (later Union Square) known as Tammany Hall.

Tammany power came from the first massive waves of Irish and German immigrants to New York, in the 1840s. Licking their chops at all these potential new voters, Tammany members courted them hard: they helped them find jobs and fill out the paperwork so they could become naturalized citizens, and even provided food, shelter, and coal—all in exchange for votes. They stuffed ballot boxes and bribed judges, and their nefarious efforts paid off in 1854, with the election of Tammany-backed Mayor Fernando Wood.

Tweed took over Tammany Hall the year that Irish-immigrant rage fueled the deadly Draft Riots. A mountain of a man, he was a masterful politician who solidified different

Tammany factions and millions of Irish voters into one powerful Democratic machine. After bribing state officials to revise the city's charter, he had control over the entire city government. Tweed quickly got to work setting up public works projects, doling out jobs and funds to corrupt business partners, and scoring huge kickbacks for himself and his ring of cronies.

Well-off Protestant residents generally looked the other way, because Tweed had diffused the anger of Irish immigrants—and also, the value of their real estate continued skyrocketing. But the press hammered

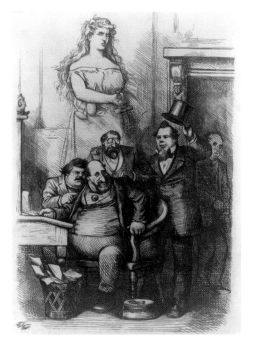

Upon Tweed's arrest and escape, an anonymous Tammany Hall politician was quoted in the *New York Times*: "Tweed had a generous heart. He was the most liberal-handed politician and the most sagacious statesman the Democracy of this State has ever known. He used his great influence to forward the interests of the working classes, and if he appropriated a few millions from the public treasury without warrant of law, he gave freely to the poor, and always respected the rights of the working man."

Tweed. In November 1, 1871, the *New York Sun* printed this blistering indictment: "Mr. Tweed is identified with the greatest robberies recorded in the history of mankind. From the treasury of this city sums of money have been robbed upon fraudulent bills and by the aid of forged endorsements, varying in amount, according to the estimates of the experts who have examined the accounts, from six million to 20 million dollars . . . Nevertheless, there is no doubt who it is that is most guilty."

To his critics, Tweed bellowed, "What are you going to do about it?" He got his answer in 1873, when he was indicted for forgery and larceny, and sentenced to twelve years in prison. "The powerful influences which so long shielded the Tammany thieves from the penalties of the law have at last been overcome, and it is now possible to mete out to all of them the punishment they so richly deserve," wrote the *New York Times* in November 27, 1873. "There is no cause to doubt these officials, and the public have reason to hope that in the end justice will overtake all of those shameless and daring robbers who gained power by unparalleled frauds upon the ballot-box, and used it to enrich themselves out of the public Treasury."

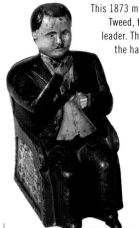

This 1873 mechanical bank shows Boss Tweed, the notorious Tammany Hall leader. The weight of the coin causes the hand to lower and deposit the coin into his pocket.

After serving a year at the Ludlow Street Jail, which he ironically had helped build, Tweed managed to escape in 1875 and flee to Cuba and Spain—where, incredibly, he was spotted (and identified via a Thomas Nast cartoon) and brought back to the U.S. He died of pneumonia behind bars at Ludlow Street in 1878. His legacy is mixed. Some regard him as the ultimate thieving politician; others say that despite the pockets he lined, he protected his poor and working-class constituents in a way traditional government had not. His shamelessness inspired this rhyme, "Boss Tweed Escapes!" published in the *New York Tribune* in 1879:

There was Tweed
Under his rule, the ballot box was freed!
Six times as big a vote he could record
As there were people living in the ward!

THOMAS NAST AND NEWSPAPER POWER

As an illustrator for the top periodicals of post-Civil War New York, Thomas Nast perhaps had more influence than most of the newspaper writers penning articles and editorials from Park Row. Nast began his career at *Frank Leslie's Illustrated Newspaper*, but his best-known work—the first images of modern-day Santa Claus, the Republican elephant, and savage portrayals of Boss Tweed—all debuted in *Harper's Weekly*, where he was a staff cartoonist.

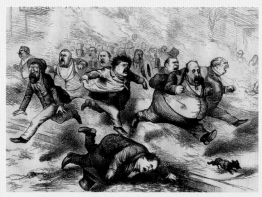

Boss Tweed and members of his ring: Peter B. Sweeny, Richard B. Connolly (stumbling over the curb), A. Oakey Hall, Tom Fields, James H. Ingersoll, and James Fisk joining a crowd in pursuit of a thief, each thinking (and looking like) they are the object of the hue and cry.

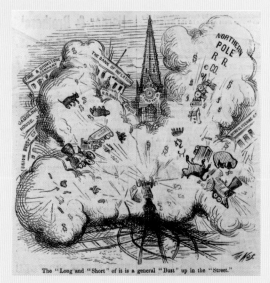

The "Long" and "Short" of it is a general "Bust" up in the "Street."

Industry collides and explodes in Thomas Nast's take on the Panic of 1873, triggered by the bankruptcy of government bond agent Jay Cooke & Company, backer of the Northern Pacific Railroad.

Nast's image of Tweed as a power-hungry, sleazy politician, most notably with a bag of money for a face, annoyed the head of Tammany Hall. "Stop them damn pictures," Tweed reportedly said. "I don't care what the papers write about me. My constituents can't read. But, damn it, they can see the pictures." That only compelled Nast to create more damning cartoons of Tweed and his Tammany Hall ring. Nast's campaign, along with a series of articles by the *New York Times*, led to an 1871 investigation into Tweed's activities that ultimately put him behind bars for the rest of his life.

ECONOMIC COLLAPSE
IN THE TWO NEW YORKS

The failure of the Union Trust Company on September 20, 1873 was the result of two scandals.
The company was the financial agent for the Lake Shore and Michigan Southern Railroad, and it had paid out
$1,750,000 in bond interest for the railroad. Its suspension was due to its inability to recover this sum—
and also, the company secretary, C.T. Carleton, had disappeared with more than $350,000.

In hindsight, it's easy to see the inevitable. Bloated markets engineered by greedy industrialists, combined with a national financial scandal in Washington under President Ulysses S. Grant, slowed the flow of railroad financing. Tweed's corrupt regime had left the city in deep debt, too.

The final blow came with the failure of the banking house Jay Cooke & Co. Cooke's firm had been the chief financier of the Union Army and was now a major inves-tor in railroads. When markets stalled and bond prices sank, Cooke couldn't meet loan payments. His firm declared bankruptcy on September 18, 1873, immediately setting off bank runs, a ten-day closure of the New York Stock Exchange, and a worldwide depression that officially ended in 1879 but took more than two decades to truly cease.

"Terrible panic of Wall Street," wrote William Steinway, a wealthy New Yorker and a partner in his family's Steinway & Sons

RIOT IN TOMPKINS SQUARE PARK

In January 1874, working-class New Yorkers were angry. The recession that had started four months earlier had eliminated jobs; 110,000 men were out of work. City officials turned a deaf ear on calls to create a public works program. No labor laws or social safety nets existed to help struggling residents—and wealthier New Yorkers were ideologically opposed to the city offering any kind of relief.

So the Committee of Safety, an umbrella group of unionists, socialists, and labor reformers, called for a demonstration in Tompkins Square Park followed by a march on City Hall. At the time, Tompkins Square was a swamp-turned-park that had doubled as a military parade ground during the Civil War. Often the site of rallies, it was the center of an increasingly crowded district of tenements populated by Irish and German shipbuilders and other laborers.

On the bitterly cold morning of January 13, work-ingmen's groups assembled at the park. They didn't know that overnight, the city had secretly rescinded their permit to hold a demonstration, and it sent mounted police to disperse the 7,000 marchers. At 11:00 A.M., violence broke out. A young Samuel Gompers, the future labor leader, observed the incident.

"By the time the first marchers entered the Square, New Yorkers were witnessing the largest labor demonstration ever held in the city," wrote Gompers in *Seventy Years of Life and Labor*. "When the demonstrators had filled the square, they were attacked by the police. 'Police clubs,' went one account, 'rose and fell. Women and children went screaming in all directions. Many of them were trampled underfoot in the stampede for the gates. In the street bystanders were ridden down and mercilessly clubbed by mounted officers.'"

More than forty arrests were made. City newspapers generally dismissed the marchers as "foreigners," "communists," and fomented by "idleness." The nascent movement for workers' relief lost momentum. With private charities overwhelmed, the poorer classes were left to fend for themselves.

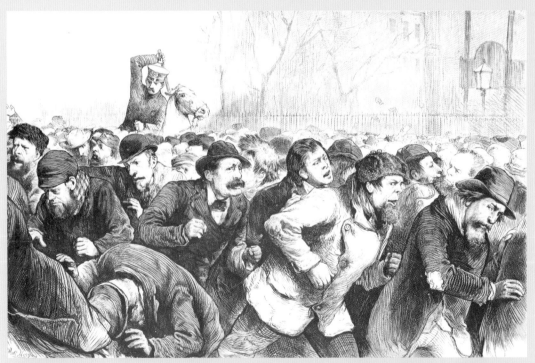

Samuel Gompers wrote that "mounted police charged the crowd on Eighth Street, riding them down and attacking men, women, and children without discrimination. It was an orgy of brutality. I was caught in the crowd on the street and barely saved my head from being cracked by jumping down a cellarway."

piano-manufacturing business. It was September 19. "Many prominent firms fall, and runs on banks . . . " On September 30, he commented, "Financial crisis seems to have reached all parts of the country, it looks very badly." On October 2: "Financial situation growing worse for mercantile circles." Steinway seemed to be realizing what the rest of the city was also coming to terms with: this wouldn't be a problem for New Yorkers only, but a far-reaching financial catastrophe.

The *New York Herald* reported from the luxurious Fifth Avenue Hotel. "By nine o'clock the corridors were densely crowded with the bull and bear fraternity, and the most startling rumors had gained general credence, to the effect that three trust companies would shut their doors today. A leading broker remarked, 'If that is true, hundreds will be ruined, and the occupation of Wall Street will be gone.'"

The crash was the first recession of the Industrial Age. Thousands lost everything. Eighty-nine of the 364 railroads throughout the country went bankrupt. Eighteen thousand businesses failed, and the national unemployment rate in 1876 hit fourteen percent. New Yorkers who had amassed enough wealth retreated to Fifth Avenue mansions, private clubs, and summer homes.

With nowhere to go, the poor and working-class bared the brunt of the crisis. An estimated 25% of the city's one million residents were out of work. Thousands were evicted. Men with no jobs became angry, restless, desperate. New Yorkers were realizing that the financial gulf between workers and those who employed them appeared wider than ever.

On February 9, 1874, months after the Panic set in, the *New York Herald* commented, "The story of the destitution prevailing among the poor of New York which we publish today will startle our well-to-do readers in their comfortable homes. It is not pleasant to reflect that there are two New Yorks, the one plunged in the most abject misery, wanting all the necessaries of life, shivering from cold, borne down by disease, crowded into the unwholesome tenement houses of the poor quarters, which are now, in truth, dwellings of sorrow and affliction.

"Yet while the prosperous citizens go merrily over the beautiful snow to the music of tinkling bells, the poor, huddled together in fireless rooms, chatter and shiver in the piercing night winds, slowly starving to death . . . In the midst of plenty they starve, and the pangs of hunger are rendered more difficult to bear by the sight of the good things they must not taste."

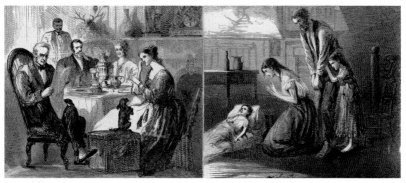

A *Harper's Weekly* illustration entitled "The Landlord and the Tenant—A Tenement-House Story."

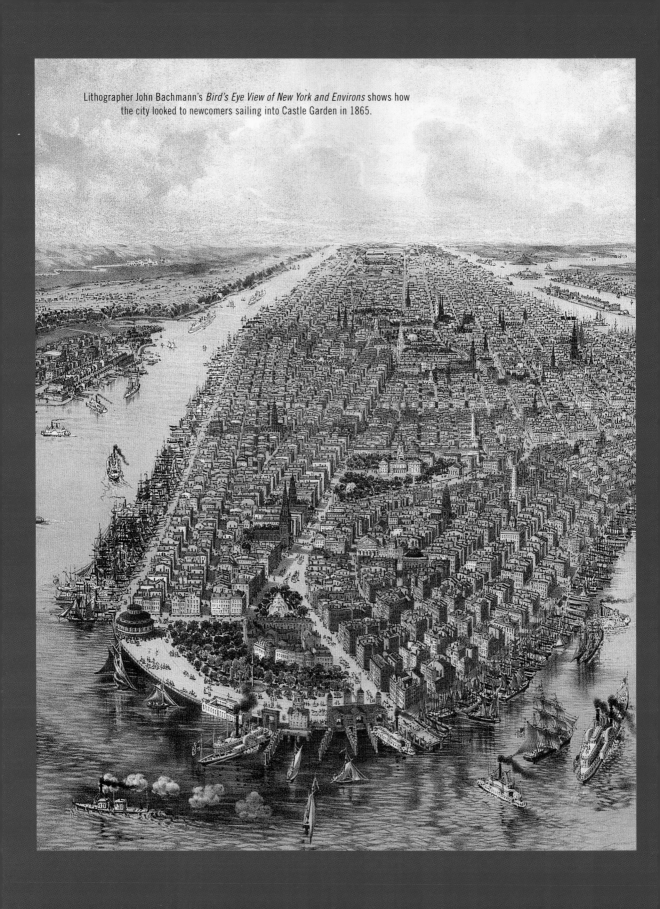

Lithographer John Bachmann's *Bird's Eye View of New York and Environs* shows how the city looked to newcomers sailing into Castle Garden in 1865.

IMMIGRATION

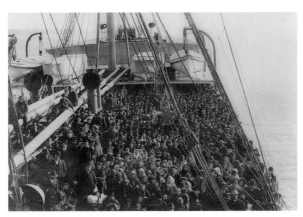

Immigrants from steerage crowd the deck of an Atlantic liner in 1906.

A WIDE OPEN DOOR

If you were an immigrant arriving in New York City from across the Atlantic during the first half of the 19th century, you would receive no official welcome. No barge approached your ship to safely bring you and other passengers to shore. No one ushered you into a building and asked for your name. No clerk helped you locate family, lodging, or work.

Instead, after up to three months in steerage, subsisting on food you packed for your trip, you would unceremoniously disembark directly onto the wharves at the East River or the Battery. You'd walk a bit to chaotic, briny South Street, its slips filled with sailing vessels, or up Lower Broadway, choked with traffic. Amid the crowds and omnibuses and street vendors hawking

sweet corn, you would be left to find your way.

Hungry for workers, the young city had few immigration regulations. The Naturalization Act of 1790 limited citizenship to "free white persons" of "good moral character." A city ordinance from 1790 mandated that sick passengers be dropped off at the Marine Hospital on Staten Island while the ship waited there in quarantine—a detour that time-pressed captains notoriously ignored. And a federal law passed in 1819 required that ship manifests list passenger names, so Congress could keep tabs on how many people were admitted.

With the door wide open, millions came—changing the face of Gotham and reshaping its population. In the 1820s, nearly four out of five residents were native born; by 1850,

it was one out of two, and throughout the Gilded Age, that number shrank to one in four. Between 1815 and 1915, three quarters of the thirty-three million immigrants who arrived in the U.S., entered through New York. They departed from London and Dublin, Le Havre and Hamburg, Glasgow and Liverpool. After a dip during the Civil War, immigration rebounded: from the 1860s through the early 1900s, many were spurred on by the Homestead Act of 1862, which offered free land to immigrants willing to settle in the West.

However, many were left milling around Lower Manhattan with no place to go, preyed upon by con men. To handle all the newcomers, immigrant societies run by ethnic groups stepped in. They offered the assistance and protection that the city would not. Soon overwhelmed by demands, these societies pressured the state to form a Board of Commissioners of Emigration in 1847—the first government-run organization to help find jobs, housing, and medical aid for thousands of men, women, and children.

The Commissioners of Emigration regulated laws concerning ships, boarding houses, railroad agents, and other businesses administering to the new arrivals. They set up an Emigrant Refuge and Hospital on Ward's Island in 1847, which is where some sick passengers went. (Others still went to the Marine Hospital until it was burned down by disease-fearing locals in 1858.) And they established an emergency medical fund for the thousands who arrived ill and destitute.

"The problem to be solved was to protect the new-comer, to prevent him from being robbed, to facilitate his passage through the city to the interior, to aid him with good advice, and, in cases of most urgent necessity, to furnish him with a small amount of money," wrote Friedrich Kapp, one of the commissioners, in 1870. "In short, not to treat him as a pauper, with the ultimate view of making him an inmate at the Almshouse, but as an independent citizen, whose future career would become interwoven with the best interests of the country."

They couldn't guarantee that newcomers would be treated fairly, and they weren't able to make a dent in the anti-immigrant sentiment that permeated the metropolis—a metropolis owing much of its Gilded Age wealth to cheap, foreign-born labor. But the new regulations helped put immigrants on solid footing before they fanned out along Broadway to start their new lives.

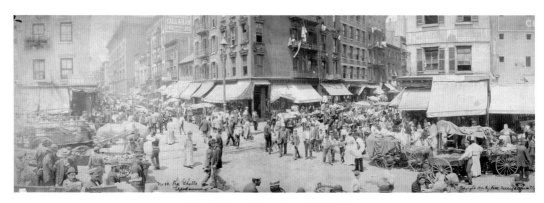

The Ghetto of the Lower East Side in 1902.

WHERE THE NEWCOMERS SETTLED

As immigrants began arriving en masse in New York City in the 1840s, each ethnic group settled its own enclave. The biggest was Kleindeutschland, aka "Little Germany." Bounded roughly by the Bowery, 14th Street, Houston Street, and the East River, it was a thriving, vibrant stronghold of tens of thousands of German immigrants through the end of the Gilded Age.

South of Kleindeutschland but worlds away was Five Points, the notorious slum packed with poor Irish Catholics that extended from about City Hall to Canal Street. The name came from the five-pointed intersection where decrepit wooden houses, rundown Federal-style homes, and two-story saloons and bars converged. Five Points' crooked alleys and dead-end "roosts" allowed criminals and gangs to lay low and tarnish the reputation of the hard-working Irish immigrants (and African Americans) who called it home.

The second wave of immigrants in the 1880s moved into Kleindeustchland and Five Points and remade these neighborhoods as their own. Eastern European Jews turned Second Avenue from Houston to 14th Street into the "Yiddish Broadway," building theaters and concert halls. South of Houston, the Lower East Side was also re-colonized by Jewish immigrants and called, with some derision, "The Ghetto" on city maps and in newspaper articles.

The Chinese carved out a small piece of Five Points at Mott and Doyers streets and created Chinatown. Another slice of Five Points, the Mulberry Bend area, became Little Italy; the once-upper-class brownstones of Greenwich Village south of Washington Square also became home to Italians. A smaller number of Greeks, Turks, and Syrian Christians rebranded Washington Street on the Lower West Side "Little Syria."

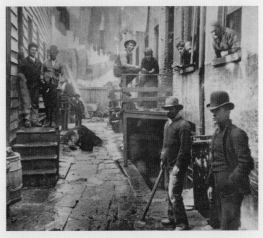

Author and reformer Jacob Riis's 1888 photo of Bandit's Roost, located on Mulberry Bend in the Five Points slum. Five Points' snaking alleys and dead-end courtyards helped make it a breeding ground for disorder and criminal activity.

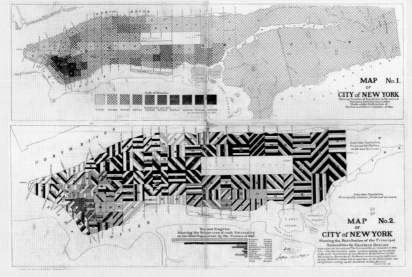

MAP No.1.
OF
CITY of NEW YORK

MAP No.2.
OF
CITY of NEW YORK

The Tenement-House Committee Maps were drawn by F. E. Pierce in 1894. The first map shows population densities in Manhattan. The second map shows the distribution of ethnic groups in distinct neighborhoods. Both demonstrate Jacob Riis's conviction that "a map of the city, colored to designate nationalities, would show more stripes than the skin of a zebra, and more colors than any rainbow."

DESTINATION: CASTLE GARDEN

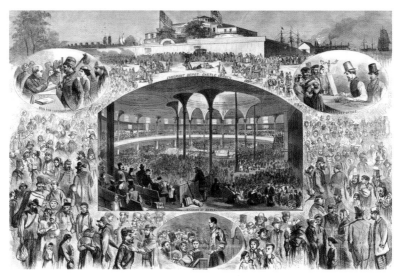

The fort turned concert hall turned immigration depot Castle Garden, in a *Harper's Weekly* illustration from September 1865. Every day, thousands of people from all across Europe filled the main hall, where they registered with officials, underwent a medical checkup, looked for work, and were reunited with friends and relatives who had already made the journey.

W e were ferried over to Castle Garden," wrote Abraham Cahan, a Lithuania-born journalist for the *Jewish Daily Forward*, in his 1917 semiautobiographical novel, *The Rise of David Levinsky*. "One of the things that caught my eye as I entered the vast rotunda was an iron staircase rising diagonally against one of the inner walls. A uniformed man, with some papers in his hands, ascended it with brisk, resounding steps till he disappeared through a door not many inches from the ceiling. It may seem odd, but I can never think of my arrival in this country without hearing the ringing footfalls of this official . . . "

Castle Garden, or the Emigrant Landing Depot, was the major achievement of the Commissioners of Emigration. Opened in August 1855, the building had once been a concert hall for the upper classes who lived along fashionable Bowling Green and State Street (and before that, a never-used fort ready to safeguard the city during the War of 1812).

Run by the state with proceeds from a ship tax, Castle Garden was the nation's first immigrant-processing station. No wonder Yiddish-speaking New Yorkers began referring to any tumultuous place as a *kesselgarden*: just one hundred Castle Garden employees were tasked with registering up to nine thousand arrivals daily. First, customs officials boarded ships docked in New York Bay to take a head count of passengers. They then transported the passengers by barge to the building's interior rotunda, where clerks recorded their names, home nations, and how much money they had brought with them. Doctors examined each newcomer; the sick were taken to Emigrant Hospital at Ward's Island. If a

newcomer was seeking a job in the city, a vibrant labor exchange matched employers with potential workers. Everyone else was free to disappear into the streets of Manhattan.

Castle Garden brought much-needed authority to the immigration process. "The Landing Depot is fitted up with quarters for the emigrants and their baggage, and with various stores at which they can procure articles of necessity at moderate prices," wrote James D. McCabe in his 1872 book, *Lights and Shadows of New York Life*. "As most of them come provided with some money, there is an exchange office in the enclosure, at which they can procure American currency for their foreign money. . . Attached to the establishment is an official, whose duty it is to furnish any information desired by the emigrants, and to advise them as to the boarding houses of the city which are worthy of their patronage."

Until Castle Garden closed in 1890, after which the federal-run Ellis Island immigration center became the entry point for newcomers, an estimated eight million people would go through its doors. Native New Yorkers were unlikely to ever visit, but journalists liked to gave readers a peek. A

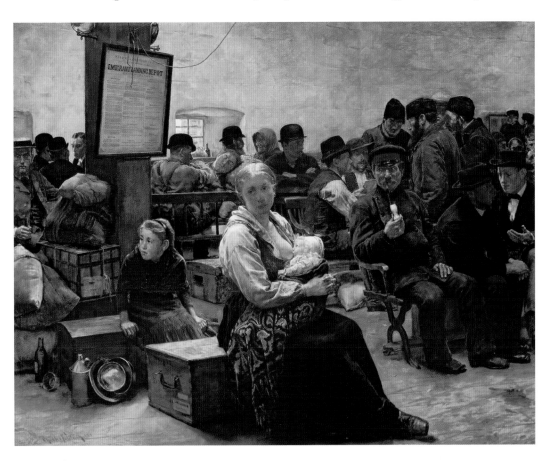

Charles Frederich Ulrich's 1884 painting
"In the Land of Promise, Castle Garden" depicts a cross-section
of new arrivals waiting, wondering, and hoping.

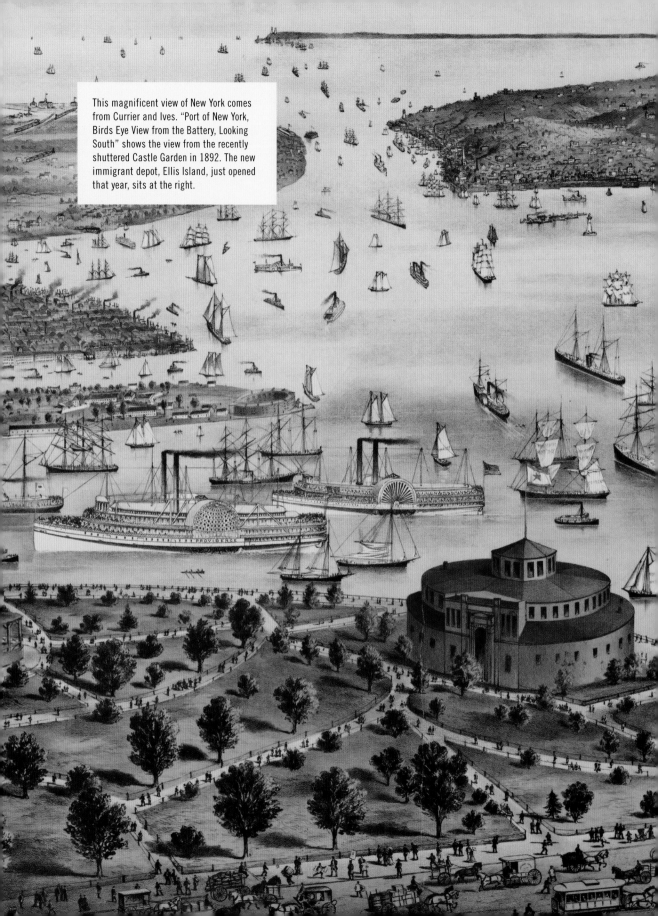

This magnificent view of New York comes from Currier and Ives. "Port of New York, Birds Eye View from the Battery, Looking South" shows the view from the recently shuttered Castle Garden in 1892. The new immigrant depot, Ellis Island, just opened that year, sits at the right.

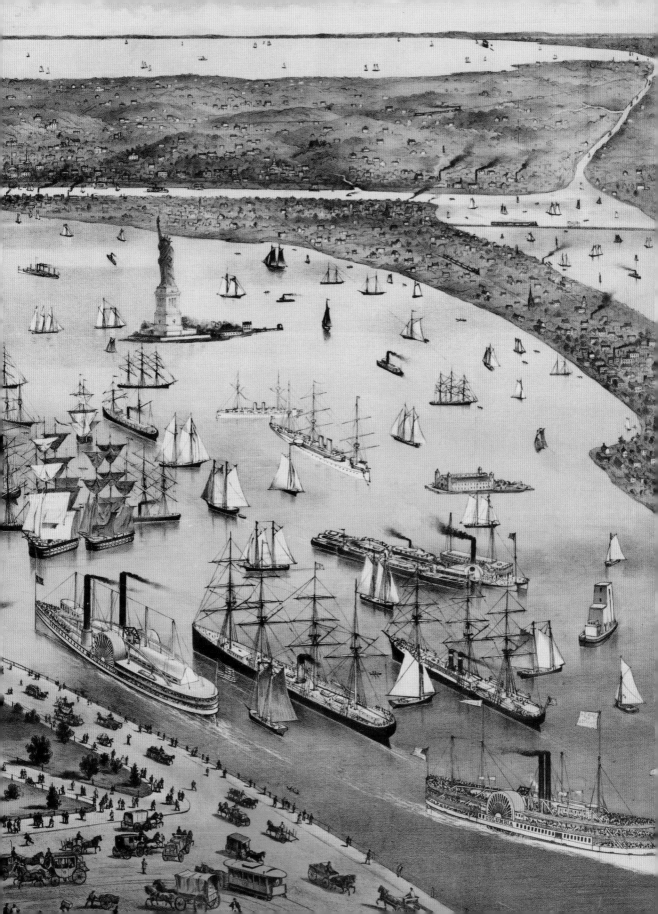

1871 *Harper's Weekly* article, *A Day at Castle Garden Immigration Station*, offered a rich, lively account: "[As we] approached the entrance to Castle Garden we found it almost impossible to make our way through, the passage was so blocked up with vehicles, peddlers of cheap cigars, apple-stands, and runners from the different boarding-houses and intelligence-offices that abound in the neighborhood.

"Passing through the gateway, we have on the left side a roomy and cleanly kept wash-room for females, and on the opposite side one for males, both plentifully supplied with soap, water, and large clean towels on rollers, for the free and unlimited use of all immigrants . . . Father and son, sister and brother, meet here in fond embraces, with tears of joy, after years of absence. What shaking of hands, and assurances of love, and inquiries for those dear to the heart, that are still thousands of miles away . . .

"The lights were shining feebly on the Battery. The lamps are but few and far between, and an almost total darkness prevails at some places. Behind me were the crowds of immigrants still emerging from Castle Garden, whose dome loomed up splendidly out of a sea of darkness—a beacon for the guidance of immigrants who arrive on our shores."

"CASTLE GARDEN IN ASHES"

The first curtain of smoke rising from the floor was spotted by a gate tender on July 9, 1876. An alarm sounded, workers rushed over, and one ripped open the floorboards. At that moment, about 5:00 P.M., great bursts of flames appeared and spread through the upper part of the main building at Castle Garden, the circular former concert hall and fort where thousands of immigrants brand-new to New York waited to be processed and admitted to the nation.

The fire spread down to the docks, where barges ferried passengers from their ships, and also to baggage area, reported the *New York Times* the next day. "During this time the immigrants themselves were doing all in their power to save their own effects, and it was amusing to see their anxiety as they risked their lives to save what to the ordinary observer appeared to be of small value. One old fellow ventured into the blinding smoke and reappeared with what appeared to be a plan of his native village. Two old Bavarian women worked liked slaves in bringing out trunks, chests, and feather beds, belonging to themselves and their more helpless neighbors."

By 8:00 P.M., firefighters had the blaze out—but not before the domed roof of the rotunda caved in and many smaller structures burned beyond repair. City officials decided to rebuild, using the buildings not touched by flames as the makeshift depot. The main center reopened by November. Yet something valuable could not be rebuilt: the names and personal information of those who had arrived at Castle Garden since it first opened in 1855. "All the books and records, excepting the more valuable papers, which were contained in safes, were destroyed," reported the *Times*.

"In and out of Castle Garden," from *Harper's Weekly*, September 1882, shows groups of newcomers waiting through the night and using their baggage for pillows.

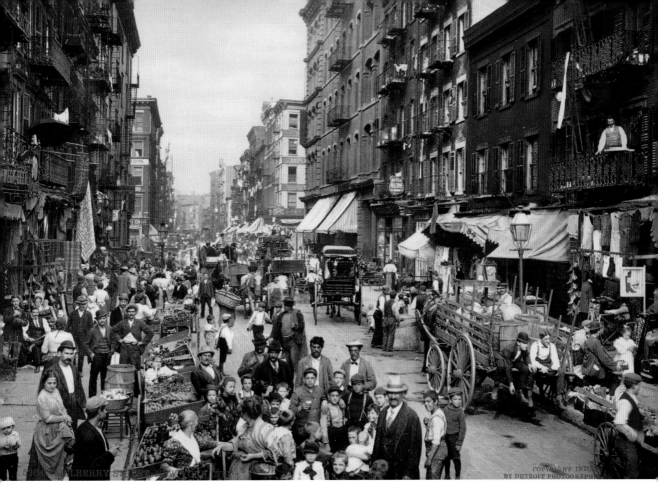

Once a seedy part of Five Points, Mulberry Street by the 1890s had become the "Main Street of Little Italy," transformed by Italian immigrant vendors, merchants, and laborers. They were not warmly embraced by the city, however. On January 8, 1882, the *New York Times* wrote, "The most undesirable of our immigrants in recent years have come from the South of Europe, and of these the Italians are most numerous, nearly 14,000 of whom arrived at Castle Garden during the year past. They are very apt to herd together in the large cities and recruit the lowest ranks of the laboring population. This is due in some measure to the fact that the emigration of criminals and paupers and worthless people generally from Italy have been rather encouraged of late."

TWO GREAT WAVES
OF HUMANITY

On June 2, 1836, Philip Hone, mayor of the city in the 1820s and a successful merchant, wrote in his diary: "There arrived at this port, during the month of May, 15,825 passengers. All Europe is coming across the ocean; all that part at least who cannot make a living at home; and what shall we do with them?"

New Yorkers of Hone's Anglo-Protestant background would be asking that question for decades. The first massive wave of immigrants—a tsunami, really—hit the city's shores from 1840 through the 1870s. Previous arrivals had looked like New Yorkers: white and mostly British. Now, the dominant ethnic groups moving into the city's weathered

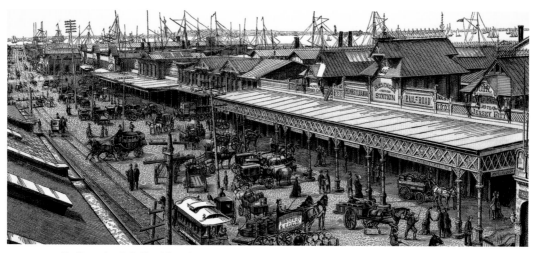

The Pennsylvania Railroad Ferry Station was located near Castle Garden. The ferries took passengers and their luggage over the Hudson River to awaiting trains in New Jersey.

neighborhoods were what qualified as foreign at the time: Irish Catholics and non-English speaking Germans.

The Germans were not a united group. They were farmers and professionals who hailed from various states suffering from crop failures and the upheaval of a botched revolution: Prussia, Bavaria, the Rhineland. Some of the young, mostly single men and women were unschooled and poor; others were educated and middle class. Once in New York, their occupations ran the gamut. They started businesses, worked as craftsmen, ran saloons, found jobs as servants. Like all immigrants, they clustered in enclaves—mainly Kleindeutschland, the "Little Germany" neighborhood bounded by the Bowery and East River from Houston to 14th Streets (Avenue B was known as "The German Broadway" for its music halls and theaters). By 1865, about sixty thousand German-born residents lived in or on the outskirts of Kleindeutschland.

Irish Catholics coexisted on the edges of Kleindeutschland with the Germans, as well as in their own shantytowns all over the city and the fetid, sprawling Five Points slum north of City Hall. They were largely poor, unskilled farmers fleeing poverty and oppression in their native country—and then the deadly potato rot beginning in 1845, which left millions starving. They were disliked and unwelcome. "Our Celtic fellow citizens are almost as remote from us in temperament and constitution as the Chinese," wrote lawyer and diarist George Templeton Strong in 1857.

Employed mostly as servants and laborers through the 1860s, the Irish suffered in New York: they had high poverty, unemployment, and arrest rates. Irish criminal gangs roamed the city, and they were despised by Anglo-Protestants for instigating the deadly 1863 Draft Riots. The Orange Riots of 1870 and 1871 further solidified prejudice against them. The Orangemen were Irish Protestants who held a parade every July 12 to celebrate Protestant rule in Ireland. Spurred on by the marchers' anti-Catholic taunts, Catholic mobs attacked the Protestants, resulting in scores of deaths from both sides for both years.

Yet by the end of the 1870s, Irish Catholics had gained a foothold, filling the rosters of the police and fire departments and other civil service positions—thanks in part to their

loyalty to political patrons such as Mayor Fernando Wood and Boss Tweed, of Tammany Hall infamy. Irishmen also made up the ranks of the workers who helped build the city's infrastructure: its tunnels and bridges, parks and water pipes.

While acknowledging the hardships they endured here, Irish immigrants often urged loved ones back home to make the journey as well. Margaret McCarthy, a twenty-three-year-old who just a year earlier came to New York on her own, wrote the following letter to her family in 1850 (At that time, more than two hundred thousand Irish Catholics made their home in Manhattan): "The immigrants ha[ve] not money enough to take them to the interior of the country which obliges them to remain here in [New] York and the like places for which reason causes the less demand for labor and also the great reduction in wages," wrote McCarthy. "For this reason I would advise no one to come to America that would not have some money after landing here that would enable them to go west in case they would get no work to do here. But any man or woman without a family are fools that would not venture and come to this plentiful country where no man or woman ever hungered or ever will . . ."

By the time the Germans and Irish had established themselves, a second surge of immigrants was on its way to the city. In the 1880s and 1890s, millions of Italians, Bohemians, Hungarians, Romanians, Poles, Finns, Greeks, Turks, and Syrian Christians came ashore—altering the city's demographics so profoundly that by 1910, with a total city population of about 4.7 million, approximately 2 million were foreign-born. Poor and less educated, like the Irish had been,

they were more likely to stay in New York after passing through Castle Garden or Ellis Island.

These new immigrants crammed into squalid areas of Lower Manhattan that were abandoned by Germans and Irish who had moved up the economic ladder. Within their enclaves, newcomers became small merchants, pushcart operators, factory workers, and garment pressers. Entire families often did work at home piecemeal; in dark living rooms that looked out onto grimy airshafts they rolled cigars, sewed garments, and shelled nuts.

For the most part, New Yorkers felt contempt for the new arrivals. But perhaps no group aroused more suspicion than the Chinese. The approximately 1,100 shopkeepers, textile workers, and vendors who settled on the southern edge of Five Points by 1880 had migrated to New York from the West Coast. Viewed as exotic, and worse, "heathen," Chinese laborers were banned from entering the U.S. in 1882 under the Chinese

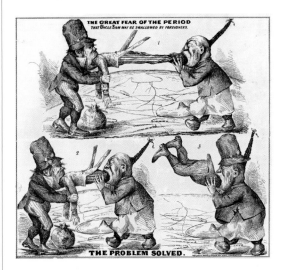

A period cartoon illustrates the fear many New Yorkers had about immigrants—that too many were arriving too fast for the city to absorb them.

Exclusion Act—the only non-wartime law barring a specific ethnic group. The Act also prohibited Chinese immigrants already here from becoming citizens. In 1902, Congress renewed the Chinese Exclusion Act, with the ban extended indefinitely.

CHOLERA BREAKS OUT ON BOARD

In an era before antibiotics, a single case of a serious contagious disease could start a pandemic in the city. With thousands of people entering New York City from all over Europe every day, immigration officials took the safeguards they created seriously. One mandated that before a ship could unload her passengers at Castle Garden (or later, Ellis Island), it had to anchor at a quarantine station in New York Bay and be inspected by a health officer.

In August 1892, the *Moravia*, a steamer carrying Russian Jews from Hamburg, Germany, languished in the harbor, waiting to be inspected. When the health officer boarded, the captain assured him that the ship had received a clean bill of health back in Hamburg. Yet a report by the ship doctor noted twenty-two deaths on board. It wasn't unusual for passengers to die en route, but twenty-two deaths was high, They were determined to be from cholera—a bacterial infection spread via human waste through contaminated water. The original source was a cholera outbreak back in Hamburg. Apparently, the bacteria stowed away on the *Moravia*.

The *Moravia* was immediately sent to a quarantine station off Staten Island. Passengers exhibiting symptoms were brought to Swinburne Island; healthy passengers had to be disinfected at Hoffman Island. In the next few weeks, seven more ships coming from Hamburg were found to have cholera-infected passengers or cholera-related passenger deaths. "Dante has described the wretchedness of Hell; it would take his pen to figure to you the filth, misery, and abject condition of this mass of humanity, packed under the most auspicious conditions for the rapid propagation of an epidemic," stated a scientific paper on the 1892 outbreak.

To make sure no other ships carried cholera, a twenty-day quarantine period for all ships arriving from Europe was established, halting traffic and inconveniencing thousands of passengers. Once the outbreak had been contained by mid-September, 120 people were confirmed dead. Prejudice against Russian Jews, already considered unclean, intensified as well.

The cover of the September 24, 1892, issue of *Harper's Weekly* shows an armed mob on Long Island attempting to prevent the landing of the *Normannia*, a New York–bound ship filled with passengers about to be quarantined on Fire Island as a precaution against cholera. Ultimately the crowd, like others that had tried to stop quarantined passengers from landing at Sandy Hook in New Jersey, was dispersed, and the quarantine carried out. "The disgraceful exhibitions of fear made by the residents of Islip and those of New-Jersey in relation to the establishment of quarantine stations at Fire Island and Sandy Hook warn the people of this city that if cholera should invade the country, it would in all probability spread, as it would be difficult to obtain a sufficient supply of help with the necessary courage to carry out the sanitation laws," a disgusted health official told the *New York Times* the next day.

A MIXED RECEPTION

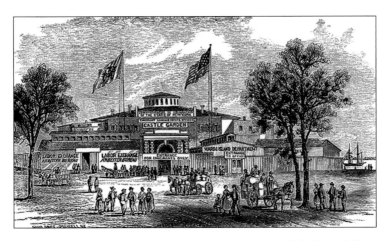

Castle Garden's Labor Exchange, established in 1868, assisted new immigrants with finding work. The year it opened, the commissioner of the Exchange submitted semi-monthly reports. On July 23, 1868, the *New York Times* reported that in one 12-day period, 1,804 people (1,182 men and 622 women) applied for work. All were hired. Requests for laborers came from across the country. On average, men received a monthly wage of $25 and women received $9.

"Notwithstanding the present rush of immigration at this port the demand for labor at the Castle Garden Labor Bureau is greater than the supply," stated the *New York Times* on May 6, 1887. "Each day there are calls for 100 more laborers than can be obtained."

Unskilled labor was crucial to the Gilded Age; the city's powerhouse economy depended on high output from factories. And the growing wealth among residents created a demand for service workers: coachmen, cooks, maids. Labor leaders weren't exactly rolling out the welcome mat though. Poor and working-class New Yorkers feared that immigrants would undercut their wages and steal their jobs. Union organizers compelled Congress to pass the Alien Contract Labor Law. Signed in 1885, it would prevent American businessmen from hiring a contractor to procure cheap immigrant labor.

But the law didn't do much to stop this padrone system.

Newcomers in the second half of the 19th century also faced lingering Nativist sentiment from the 1840s and 1850s. Nativists felt that immigrants, especially Catholics, posed a threat to democracy, because the Nativists believed that Catholics pledged allegiance to the pope. "Surely American Protestants, freemen, have discernment enough to discover beneath them the cloven foot of this subtle foreign heresy," wrote Samuel Morse, inventor of the telegraph and avowed Nativist, in 1835. The Nativist movement was funneled into the Order of the Star Spangled Banner, a secret society founded in 1850 by New Yorker Charles B. Allen. That soon grew into the Know Nothings, a political party that tried, and ultimately failed, to gain national traction in the 1850s.

One political party happy to court the immigrant vote was the Democrats, specifically those affiliated with Tammany Hall. Tammany bosses would offer new immigrants, especially the German and Irish, assistance finding work, living space, and money for food and rent. The idea was for the immigrants to cast their ballots for the Democrats on Election Day—and this implicit exchange scored the Democrats many victories.

Anti-immigrant politics didn't succeed, but swindlers who targeted new arrivals did. "As soon as a ship, loaded with these emigrants, reaches our shores, it is boarded by a class of men called runners, either in the employment of boarding-house keepers or forwarding establishments . . ." recounted Friedrich Kapp. "If they cannot succeed in any other way of getting possession and control over the object of their prey, they proceed to take charge of their luggage, and take it to some boarding-house for safe-keeping . . . The keepers of these houses induce these people to stay a few days, and, when they come to leave, usually charge them three or four times as much as they agreed or expected to pay."

Runners were the least of it. "The blood-suckers and the greedy vampires were waiting outside the Barge Office, seeking to take advantage of immigrants' misery and ignorance, ready to attach themselves to the first unsuspecting greenhorn," one Italian immigrant complained in 1890. "There are several types. There is the pseudolawyer who offers you his unnecessary services with payment in advance. There are those who will send telegrams to relatives and friends in Italy; the telegrams are never received. Money exchangers are ready to give you dollars for your *lire* at a rate many times the actual one. Once away from the docks, a second wave of bloodsuckers descends on the immigrant . . . all of these vampires work the crowd with the aim of relieving the wretched new arrivals of their remaining ready cash."

In the 1880s, fears that foreign countries were sending criminals and the mentally ill to America—reinforced by testimony from social reformers who claimed that newcomers were

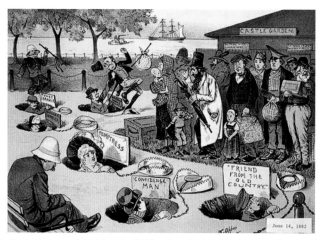

The Castle Garden Immigrant-Catchers, an 1882 cartoon from *Puck*, shows the dangers lying in wait for immigrants as soon as they exit Castle Garden and step foot on Manhattan soil.

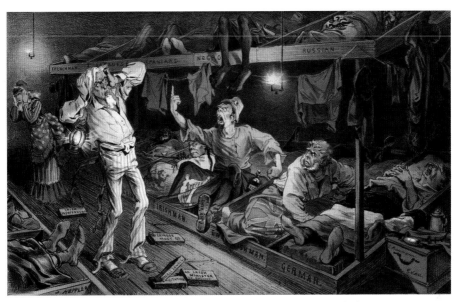

Anti-Irish sentiment lingered, this 1882 *Puck* cartoon reveals; it depicts the Irish as the only ethnic group disrupting Uncle Sam's Lodging House.

filling up insane asylums—led to a series of laws limiting immigration. By 1906, federal legislation blocked a long list of undesirables: convicts and polygamists; anarchists and political extremists; lunatics and those convicted of a "misdemeanor involving moral turpitude."

One group that was often turned away under a late-19th-century law was the sick, or, as the law called them, "persons suffering from a loathsome or a contagious disease." Since Castle Garden had opened, ships were made to wait in quarantine before an officer gave it the all-clear and passengers could disembark. But in the 1890s, with outbreaks of contagious diseases such as cholera occurring, officials built were vigilant about enforcing quarantine rules.

"April 23, 1863, what is now known as the General Quarantine Act was passed . . . establishing a general system of quarantine for the port," stated a *Harper's Weekly* article from September 1879. "Additional powers were conferred by amendments made to this general act in 1864, 1865, 1866, and 1867, under which two small steamers were purchased; the property at Tompkinsville, Staten Island, known as the Marine Hospital Grounds, was sold; and the artificial islands in the lower bay were undertaken and afterward completed—Swinburne Island in 1860, and Hoffman Island in 1873."

Ships headed for the city waited at Hoffman Island for a quarantine officer to arrive. "When the Boarding Officer from the *Illinois* finds any yellow fever or cholera patients on the incoming vessels, a signal is set, and one of the steamers belonging to the quarantine service comes and bears away the sufferers to Swinburne Island," the *Harper's* article continued. "Immediately upon reaching there they are stripped of their clothing, which is at once burned in a furnace constructed for that purpose, and they are placed in the sick wards."

STATUE OF LIBERTY

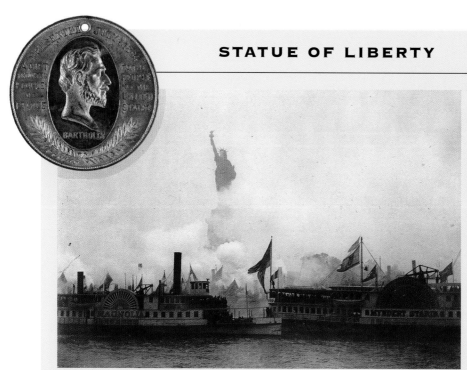

The view on October 28, 1886 from the steamer *Patrol* during the military and naval salute upon the president's arrival for the statue's dedication ceremony. In his speech, President Grover Cleveland stated, "a stream of light shall pierce the darkness of ignorance and man's oppression until Liberty enlightens the world."

A souvenir medal from that day shows the profile of Frederic Auguste Bartholdi.

Lady Liberty has symbolized freedom in New York Harbor for more than a century. But getting her to the city and placing her in the harbor was tricky. It took a sensational city newspaper's help to do it.

In the early 1870s, Frederic Auguste Bartholdi began work on the design of a monumental sculpture honoring American democracy and freedom. While the French were taking charge of building the statue and assembling her in the U.S., the Americans were supposed to create the pedestal she would stand on.

That required fund-raising. Statue officials tried to convince Americans to donate, even displaying the statue's arm and torch in Madison Square Park from 1876 to 1882 to generate excitement. But the Panic of 1873 had left many New Yorkers without a lot of cash to spare.

Then, Joseph Pulitzer, publisher of the popular *New York World*, began a drive to convince Americans to donate $100,000. He chastised the rich for not giving, and he promised to print the name of every person who gave so much as a penny. It was only then that enough money was raised—mainly from hundreds of thousands of individuals, including children, who gave less than a dollar.

With financing complete in 1885, the pedestal itself was finished a year later. A French frigate brought the statue over in June 1885 in 350 pieces. It took four months to reassemble it on a small harbor island then known as Bedloe's Island (later changed to Liberty Island, in 1956). After a morning parade from Madison Square to Battery Park watched by hundreds of thousands of New Yorkers, "Liberty Enlightening the World" was dedicated on October 28, 1886, a decade later than originally planned.

On the rainy morning of the inauguration, troops dressed in French uniforms marched down Fifth Avenue by Madison Square Park. President Grover Cleveland, the statue creator Frederic Bartholdi, and other dignitaries watched the parade from the viewing stand at the Worth Monument. That evening's planned firework display was postponed to November 1st due to the rain.

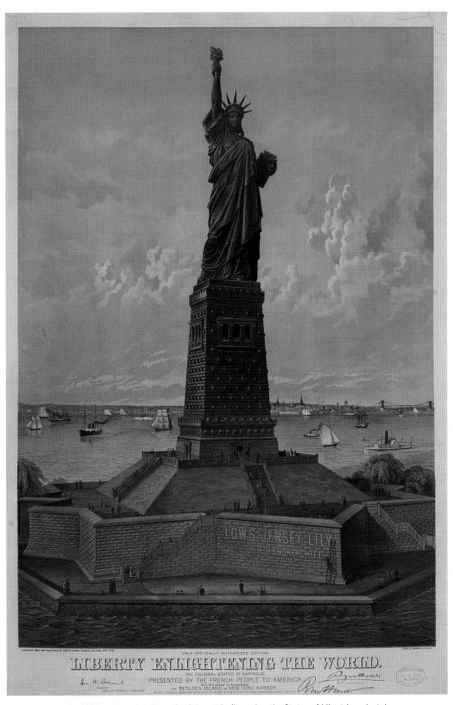

An 1884 poster printed to raise interest in financing the Statue of Liberty's pedestal.
Note that the statue's color is brown. The copper did not turn green until around 1915.

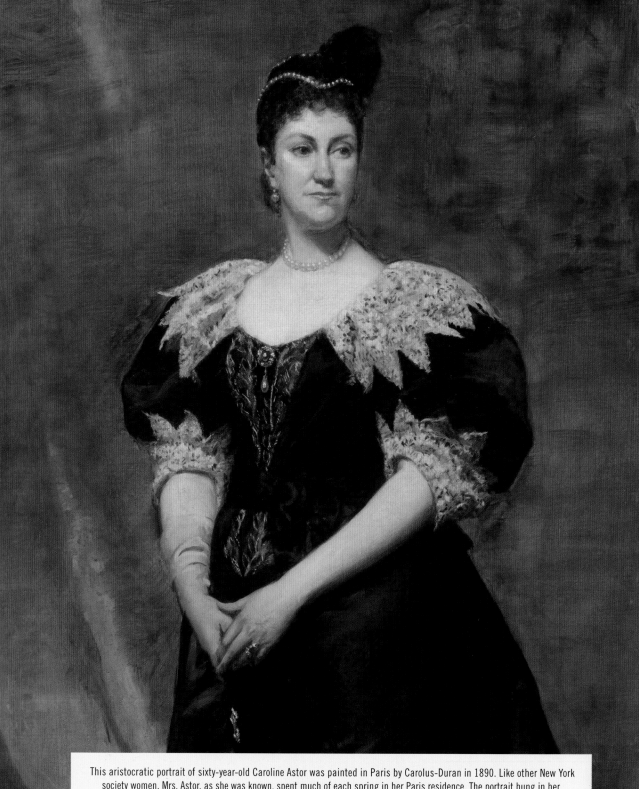

This aristocratic portrait of sixty-year-old Caroline Astor was painted in Paris by Carolus-Duran in 1890. Like other New York society women, Mrs. Astor, as she was known, spent much of each spring in her Paris residence. The portrait hung in her New York mansion; it was her custom to greet visitors while standing alone in front of it.

THE DIVIDE BETWEEN RICH AND POOR

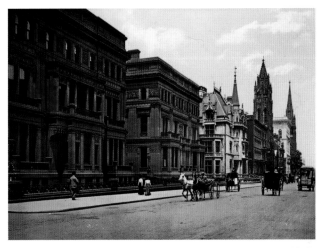

Looking north on Fifth Avenue at 51st Street at the turn of the century is the Vanderbilt family "triple palace," three distinct mansions in one that were home to the families of William H. Vanderbilt and his daughters Margaret Vanderbilt and Emily Vanderbilt. Vanderbilt's son William and his wife, Alva, occupied the Richard Morris Hunt-designed chateauesque mansion across 52nd Street; this was the site of Alva's heralded 1883 masquerade ball.

OLD MONEY VS. THE NEW RICH

"In the Metropolis, more than in any other American city, there are two great and distinct classes of people—those who pass their days in trying to make money enough to live; and those who, having more than enough, are troubled about the manner of spending it," wrote the journalist Junius Henri Browne in his 1869 book *The Great Metropolis: A Mirror of New York*.

New York has always had its rich and poor. But as the Gilded Age progressed, the gap between the two stretched wider—in part because the city's upper classes now possessed such staggering wealth. "Many vast fortunes have been made here; and many enormously wealthy Americans have come here to live and enjoy the fortunes accumulated elsewhere," stated Moses

King in *King's Handbook of New York City*, published in 1892. An estimated "two New-Yorkers are worth more than $100,000,000 each; six more have above $50,000,000 each; more than thirty are classed as worth between $20,000,000 and $40,000,000; and 325 other citizens are rated at from $2,000,000 to $12,000,000 each."

Despite their money and power, the "new rich" were derided as coarse and showy. "They are strangers to the refinements and 'small, sweet courtesies' of life, and for them substitute a hauteur and a dash that lay them open to unmerciful ridicule," wrote James D. McCabe in his 1882 book *New York by Gaslight*. "To be invited to an entertainment of some family of solid repute in the fashionable world, to be on visiting terms with those whose wealth and culture rank them as the true aristocracy, is the height of their ambition."

That ambition was thwarted by the doyennes of the upper crust, who closed ranks and shut them out of society. "The old Knickerbockers, as they style themselves, insist upon it that they should have the first

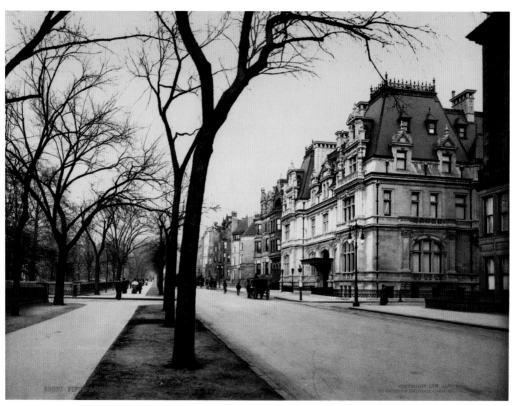

With her mansion on 34th Street overshadowed by the new Waldorf Hotel (built by her nephew William Waldorf Astor) next door, Caroline Astor had a new one built in 1893, at 840 Fifth Avenue at 65th Street facing Central Park. Designed by society's favorite architect, Richard Morris Hunt, it had a four-story ballroom that could hold 1,200. The widowed Mrs. Astor lived there with her son and his family until her death in 1908.

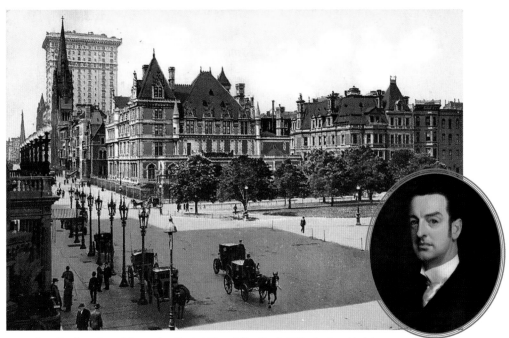

Cornelius (grandson of Commodore Vanderbilt) and Alice Vanderbilt's six-story, block-long mansion at 1 West 57th Street was the largest private residence ever constructed in New York City. It cost $3 million to build and featured 137 rooms, sixteen baths, a private garden, and a private stable.

place in society; and, as most of them inherited real estate from their ancestors, that they were too conservative to sell, and too parsimonious to mortgage, they can support their pretensions by assured incomes and large bank accounts, without which gentility is an empty word, and fashion a mockery and torment," wrote Browne.

The contempt old money had for these *arrivistes*, who "perfumed the air with the odor of crisp greenbacks," one newspaper sneered, caught the eye of Mark Twain. "The old, genuine, travelled, cultivated, pedigreed aristocracy of New York," wrote Twain in 1867, "stand stunned and helpless under the new order of things . . . They find themselves supplanted by upstart princes of Shoddy, vulgar and with unknown grandfathers. Their incomes, which were something

for the common herd to gape at and gossip about once, are mere livelihoods now—would not pay Shoddy's house rent."

The self-appointed queen of this pedigreed aristocracy was Caroline Schermerhorn Astor. Born in 1830 to a colonial-era Dutch family and married to a grandson of John Jacob Astor, Mrs. Astor, as her calling cards read, headed a season of social events from November through February every year, beginning in 1871. With her social arbiter, Ward McAllister, she drew up guest lists for annual horse shows, cotillions, and a ball at her mansion on Fifth Avenue and 34th Street, all of which were open only to those whose wealth went back generations.

The pinnacle events of each season were the Patriarch's Balls. Reporters and illustrators from the press reported the festivities:

While there were three Delmonico's restaurants in New York, the most well-known was on 26th Street and Fifth Avenue. *King's Handbook of New York City,* published in 1892, described its luxury and grandeur: "The gentlemen's cafe is on the Broadway side, and the public dining-room looks across Fifth Avenue into Madison Square. On the floors above are private parlors and dining-rooms, and the elegant banquet and ball room, which is famous as the scene of the Patriarchs' balls, of innumerable brilliant social events, and of nearly all the grand banquets that have been given for a generation. Many of the belles of the 'Four Hundred' have made their debuts at Delmonico's. The place is the social centre of the wealthy and exclusive portion of New York."

the elegant gowns, the flowers, the twinkling golden lights, the white swans brought in from Prospect Park as decoration. By reading the morning newspaper, the entire city could swoon, or scoff, at the glitzy doings of the New York smart set.

"At Delmonico's last night the Patriarchs gave another of those brilliant private balls which have formed such a marked feature of the fashionable season," the *New York Times* wrote on February 10, 1880. "The society, now in its seventh year, was originally founded for the purpose of giving social entertainments of undoubted tone and exclusiveness, and embraces in its membership some forty-five to fifty gentlemen from

the higher social circles in the City."

Yet nothing symbolized high society more than the "Four Hundred"—a list of the only people in the city who mattered socially, at least according to Mrs. Astor and McAllister. "Why, there are only about 400 people in fashionable New York Society," McAllister told the *New York Tribune* in 1888. "If you go outside that number you strike people who are either not at ease in a ball-room or make other people not at ease. See the point?"

McAllister allowed the *New York Times* to publish the list in 1892, just before Mrs.

Astor's ball. At one time, the names (only 319, actually) would have titillated New Yorkers. Now they were greeted with waning interest. Society in the 1890s had begun to open up. The Vanderbilts, once viewed as tawdry upstarts, were among the new families who had wrangled their way in. The New York Social Register, a directory appearing in 1886, expanded the number of the socially relevant to two thousand. The younger generation was less concerned with lineage than extravagance. In the shadow of the Panic of 1893, Mrs. Astor's society came to a close. The new rich had triumphed.

Self-appointed tastemaker Ward McAllister's comeuppance came when he published *Society as I Have Found It* in 1890. In it he wrote, "The highest cultivation in social manner enables a person to conceal from the world his real feelings. He can go through any annoyance as if it were a pleasure; go to a rival's house as if to a dear friend's; 'Smile and smile, yet murder while he smiles.'" The revealing book angered his old-money patrons, who valued privacy and kept their circle closed to outsiders.

CULTURE CLASHES OF THE OLD AND NEW GUARD

The snobbishness on the part of old money New Yorkers toward the new rich played out in the city's most venerable opera hall. That was the Academy of Music, founded in 1854 on 14th Street just east of Union Square. It was the choice venue of the Knickerbocker aristocracy, who contributed money toward building it and thus retained control over the box seats. They staunchly refused to let new-money families like the Vanderbilts and Goulds buy one of the Academy's eighteen prized opera boxes.

So the new money families came up with a plan. Led by Alva Vanderbilt, wife of William K. Vanderbilt, they would fund their own opera house. Opened in 1883, the Metropolitan Opera House, on 39th Street and Broadway, had a prime location in the new theater district and featured thirty-six opera boxes (each valued at a minimum of $10,000!) arranged in a horseshoe along a red and gold interior. The Met, as it was called, quickly overshadowed the Academy of Music and its stuffy old guard.

The Metropolitan Club was founded in 1891 by the "new rich" as a challenge to the established Union Club on 21st Street, which had excluded many prominent New York families. McKim, Mead & White designed the 60th Street building with a reserved marble exterior but ornate interior. This *Frank Leslie's Illustrated Newspaper* article from 1894 shows the intimidating marble foyer and the gilt and bronze lounging room decorated by Gilbert Cuel.

Located on Broadway and 39th Street, the block-long Metropolitan Opera House caught fire in August 1892. Some thought it was an opportune time to redesign the architect J. Cleveland Cady's poorly thought-out interior, which Cady boasted he had designed without having ever being inside a theater before. An 1892 op-ed in the *New York Times* argued, "From the beginning the Metropolitan Opera House was confessedly a failure as a structure . . . The walls remain to remind the passer-by that a temple of art may be inartistic to a painful degree . . . unless the old lines [of the interior] are changed, the fire will certainly not prove to have been a blessing in disguise." Rebuilt in 1893, the interior featured a golden auditorium, a sunburst chandelier, and an arch around the stage with the names of six famous composers inscribed on it.

The opera-house war was just one of the battles waged among the city's rich. There was also the battle of the balls. Every year, Mrs. Astor, the queen of the old-money families, threw a lavish ball at her mansion on Fifth Avenue and 34th Street. She only invited those she and her chamberlain, Ward McAllister, deemed social equals—one of whom was definitely not Alva Vanderbilt.

In 1883, Mrs. Vanderbilt, ambitious and shrewd, decided to host a spectacular masquerade ball of her own in her chateau-like marble mansion on Fifth Avenue and 52nd Street. Twelve hundred old- and new-money New Yorkers were invited—but not Mrs. Astor's daughter Caroline. To ensure that Caroline would be able to attend what was the most buzzed-about ball of the year, Mrs. Astor for the first time called on the Vanderbilts—formally recognizing them in society. Caroline Astor got her invite, and Mrs. Vanderbilt was added to the famed Four Hundred list.

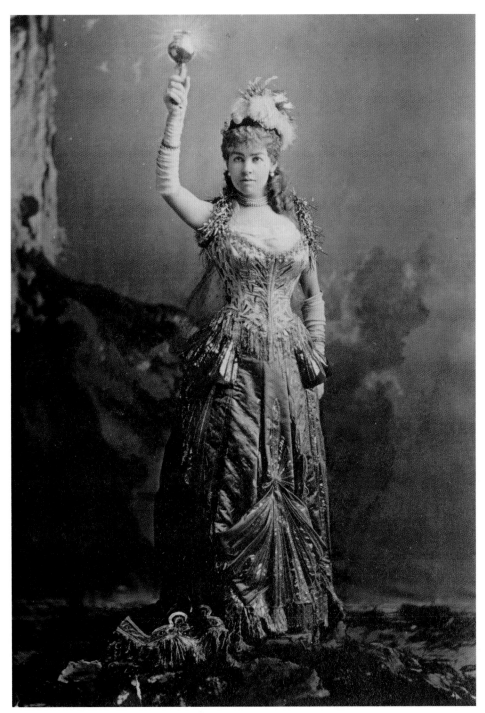

Seamstresses all over the city worked feverishly to create over-the-top costumes for Alva Vanderbilt's opulent 1883 ball at her new French chateau-style mansion at 660 Fifth Avenue. But few could top Alice Vanderbilt's ensemble, "Electric Light." Designed by Charles Frederick Worth, it came with a torch that lit up using batteries hidden in her tinsel-trimmed, gilt-fringed dress with a black velvet train.

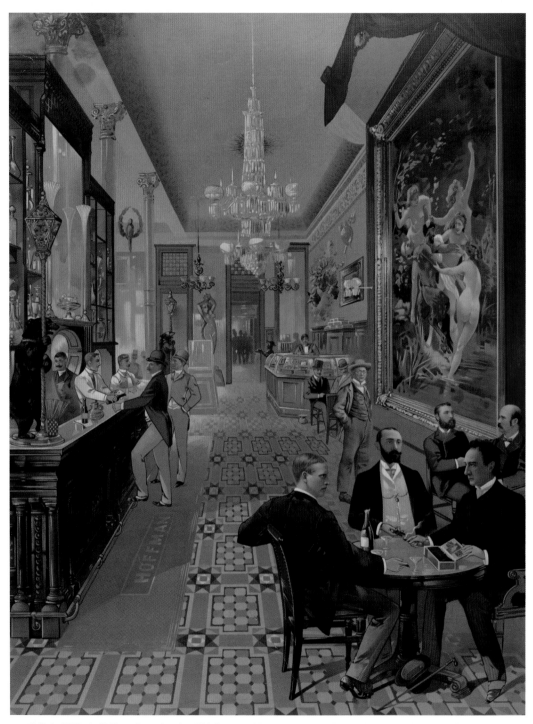

Built in 1864, the Hoffman House hotel on 25th Street and Broadway became famous for its lavish, art-filled grand salon, where the racy William-Adolphe Bouguereau painting "Nymphs and Satyr" was on display. Tourists flocked to gawk at the naked figures, which could be covertly viewed in the large mirror over the bar.

LIVING THE
GILDED-AGE GOOD LIFE

The newly minted millionaires could not easily buy their way into society. But they could buy everything else. Mansions, coaches, servants, and fancy clothes were all for sale—if one possessed the fortune to pay for it.

"[The] expenses of a family in fashionable life are something appalling," wrote McCabe in 1872's *Lights and Shadows of New York Life.* "Fifty thousand dollars per annum may be set down as the average outlay of a family of five or six persons residing in a fashionable street, and owning their residence." Fifth Avenue, dubbed Millionaire's Row, was the cream of the crop. "For those who own their houses, keep a carriage, and do not 'live fashionably,' or give many entertainments, the average is from fifteen to twenty thousand dollars."

Many new rich resided in hotels, such as the Fifth Avenue Hotel at 24th Street. Two chambers and a parlor suite at this bastion of wealth cost $30 a night. A block away on Broadway was the sumptuous Hoffman House, where titans of industry and politicians held court in its art-filled grand salon. "The gentlemen's café and ladies' dining-room share with Delmonico's the patronage of the wealthy and fashionable class," wrote King. A plutocrat could also live in one of the cooperative houses—such as the Osborne and the Rembrandt, both on West 57th Street, and the Dakota on 72nd Street at Central Park—with amenities such as elevators, steam heating, kitchen ranges, and fireproof walls.

Once settled in a first-class enclave, the new rich spared no expense. Homes needed fine furniture, children required nurses, businessmen had dues to pay to belong to elite clubs. A typical household had at least two servants. Women patronized dry goods stores such as Lord & Taylor and Arnold Constable on "Ladies Mile," a trapezoid-shaped shopping mecca from 14th Street and Broadway to 23rd Street and Sixth Avenue. A fashionable woman "must have one or two velvet dresses which cannot cost less than $500 each; she must possess thousands of dollars worth of laces, in the shape of flounces, to loop up over the skirts of dresses, as occasion shall require," wrote McCabe. The recessions

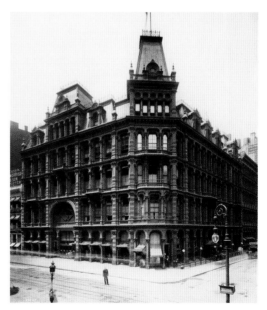

In 1870, Lord & Taylor moved uptown from Grand Street and Broadway to a new five-story, cast-iron building on Broadway and 20th Street. The new mansard-roofed store was designed by the architect James H. Giles and cost nearly $500,000. In the first three days it opened, ten thousand customers used its steam-powered elevator. Lord & Taylor became one of dozens of emporiums in the district dubbed "Ladies Mile."

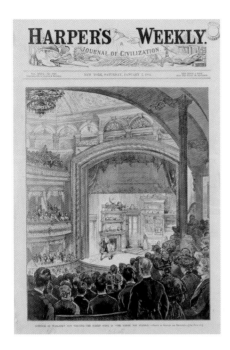

at high-society haunt Sherry's. They installed telephones and electric lights in their homes. They attended events at the Waldorf Hotel, opened in 1893 by William Astor, Mrs. Astor's nephew, next door to her Fifth Avenue mansion. The last word in opulence (as well as the first hotel to admit unescorted women to its public areas), the Waldorf became the Waldorf-Astoria in 1897, when Mrs. Astor moved to a magnificent new palace overlooking Central Park on East 65th Street and an adjoining hotel was built where her old home once stood.

The Waldorf-Astoria hosted an incredible display of prosperity and frivolity in 1897—the Bradley Martin ball. Seven hundred New Yorkers dressed as kings and queens feasted on a midnight champagne supper featuring twenty-eight courses; the press buzzed about it for weeks. Yet in the midst of a recession, such a lavish event struck a sour note with many New Yorkers, including some of the social elite. The city would always have its ostentatious rich, but Gilded Age excess was falling out of favor.

sparked by the Panics of 1873 and 1893 walloped lower-class New Yorkers. But the new rich were less vulnerable when the economy hit the skids. On a typical evening, "Brilliant carriages, with liveried coachmen and footmen and sleek horses, dash up and down the avenues, depositing their perfumed inmates before brilliantly-lighted, high-stooped, brown-stone fronts, whence the sound of merry voices and voluptuous music comes wooingly out, through frequently opened doors, into the chilly night," wrote Browne.

The rich saw A-list actors at Wallack's Theatre. They enjoyed beefsteak suppers

In 1893, William Waldorf Astor opened the thirteen-story Waldorf Hotel at Fifth Avenue at 33rd Street, on the site of his former mansion. The grand hotel was the first to have electricity throughout and private bathrooms in many guest rooms. Four years later, the Waldorf was linked to the seventeen-story Astoria Hotel, built by Waldorf's cousin John Jacob Astor IV on the site of Mrs. Astor's former mansion. The corridor that connected the two buildings, called Peacock Alley, was represented by the "=" in The Waldorf=Astoria.

NAVARRO APARTMENTS: "TENEMENTS FOR THE RICH"

The Dakota wasn't the only gabled and turreted apartment house built in the 1880s to overlook Central Park. Twice the Dakota's size across the park on Central Park South was the Central Park Apartments, better known as the Navarro Flats, a massive, castle-like, ten-story cooperative between Sixth and Seventh avenues.

A wild amalgamation of Moorish, Gothic, and Queen Anne styles, the Navarro was actually supposed to be eight separate buildings in one complex—all featuring red brick and stone-trimmed arches on the exterior. The Spanish-born developer José Francisco de Navarro, who made a fortune in railroad investments, spared no expense: his high-ceilinged, seven-bedroom duplex apartments promised all the exclusive amenities a Gilded Age plutocrat could ask for: an oversize drawing room and library, steam heat, fireproof construction, Central Park views, a huge courtyard garden, a rooftop solarium, even water supplied by a separate well rather than the city water system. In 1882, corner units began selling for $20,000, with common charges of up to $200 a month.

Unlike the Dakota, the Navarro Flats went under in just fifteen years. What went wrong? The mishmash of design styles was roundly criticized; one real estate guide called them "tenements of the rich." Early units sold, but not enough of them. Before the entire complex could be completed, de Navarro filed for bankruptcy, and critics predicted that cooperative apartments would fall apart as well. "The sale of the Navarro Flats under foreclosure for only $200,000 more than the mortgages on them indicates unmistakably that the era of the palatial apartments in New York is already over," wrote the *New York Times* in 1888. The cooperative-apartment system survived and thrived, but buyers were scared off for decades.

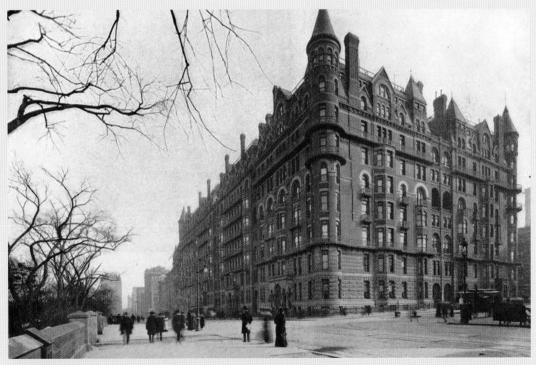

José Francisco de Navarro's gigantic eight-building Navarro Flats complex between 58th and 59th streets and Sixth and Seventh avenues. The separate townhouse-like buildings were supposed to make apartment-style living seem fashionable and appealing to rich New Yorkers, who still viewed a single-family mansion as the most luxurious type of housing. Despite the attention the co-op received, sales were slow, and the Navarro Flats were sold under foreclosure.

THE TWO CASTES OF NEW YORK'S POOR

Just like the rich, the poor were divided into two camps during the Gilded Age. There were the "deserving" poor—people facing poverty through no fault of their own: orphans, the ill, the aged. The other group was the "unworthy" poor, who were thought to have brought their suffering upon themselves. These were the idle, the alcoholics, the gamblers, the tramps, and others beset by vices.

"The deserving poor are numerous," wrote McCabe. "They have been brought to their sad condition by misfortune. A laboring man may die and leave a widow with a number of small children dependent on her exertions. The lot of such is very hard . . . The deserving poor rarely come on the streets to seek aid, but the beggars crowd them, as they know the charitable institutions of the city would at once detect their imposture."

The concept of the worthy and unworthy poor was not new. But it gained support in the late nineteenth-century city. Capitalism was generating many personal fortunes, and there was a sense that opportunity would be available to anyone willing to work hard and avoid moral and character flaws.

New York had great sympathy for those unwillingly destitute. Private charities dedicated to eradicating poverty sprang up—yet they made a point to assure donors that no help would go to the wrong crowd. The *New York Herald*, which launched charity drives in the 1890s, made it clear that it did not give handouts to the unworthy. "Free Distribution of Food in the New Herald Build-

ing," a headline read on January 2, 1894. "New York's deserving poor crowded in, the day long, and received cereals, canned soup, milk, and coffee, and orders for wholesome meat and coal, insuring at least a brighter beginning of the new year."

If you were needy yet able-bodied, you were mostly out of luck. Men who lost their jobs following the Panic of 1873 and gathered at rallies calling for a public-works program were lectured on self-sufficiency. "A spirit of manly courageous self-reliance is the best friend a working-man can have at any time, and especially in a season of industrial depression," stated the *New York Daily Graphic* on November 10, 1873. "There is no use in railing at the rich, nor in scowling at capitalists, nor in condemning corporations, simply because one's pocket is empty and he happens to be dinnerless."

In a city with no real public relief outside of almshouses, police stations, government-financed soup kitchens, and lodging houses, the undeserving poor were left to navigate hunger and homelessness on their own. An unskilled laborer's wages averaged in the neighborhood of $3.50 a day, and there was intense competition among the native born and immigrants for work. "Poverty is a terrible misfortune in any city," wrote McCabe. "In New York it is frequently regarded as a crime. But whether the one or the other, it assumes great here proportions which it does not reach in other American communities. The city is overrun with those who are classified as paupers . . . and their suffering is very great."

TENEMENTS: "NURSERIES OF PAUPERISM AND CRIME"

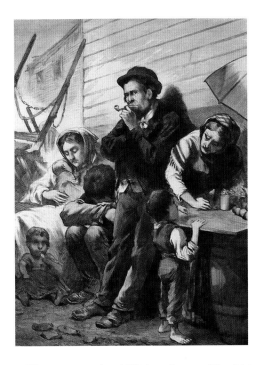

Frank Leslie's Illustrated Newspaper cover from 1873 shows the poor of Five Points on a summer night.

In 1893, Lillian Wald—then a 26-year-old nurse teaching a class to immigrant women on the Lower East Side—was asked by a little girl to help her mother, who was bedridden in their Ludlow Street apartment.

"The child led me over broken roadways . . . over dirty mattresses and heaps of refuse . . . between tall, reeking houses whose laden fire escapes, useless for their appointed purpose, bulged with household goods of every description," she recalled in her memoir, *The House on Henry Street*, published in 1915. "Through Hester and Division streets we went to the end of Ludlow; past odorous fishstands, for the streets were a market-place, unregulated, unsupervised, unclean . . .

"The child led me on through a tenement hallway, across a court . . . up into a rear tenement, by slimy steps whose accumulated dirt was augmented that day by the mud of the streets, and finally into the sickroom. All the maladjustments of our social and economic relations seemed epitomized in this brief journey and what was found at the end of it . . . Although the family of seven shared their two rooms with boarders—who were literally boarders, since

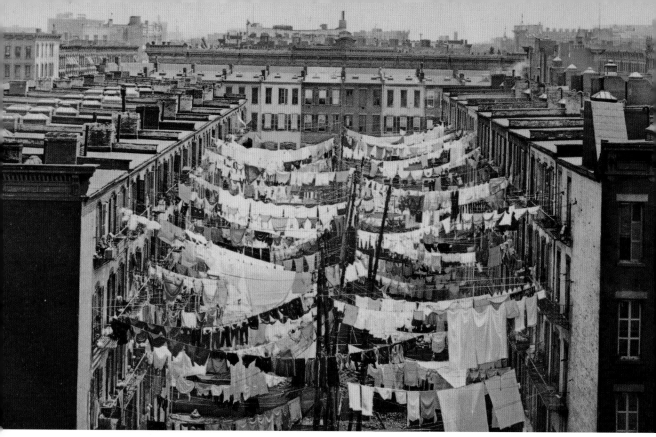

Laundry hangs in the yard behind two rows of tenements between Park Avenue and 107th Street.
Tenements were not required to have running water in every apartment until the Tenement House Act of 1901.
Clothes were often brought to the street in wooden tubs and washed with water from a fire hydrant.

a piece of timber was placed over the floor for them to sleep on—and although the sick woman lay on a wretched, unclean bed, soiled with a hemorrhage two days old, they were not degraded human beings"

Shocked by the conditions the family lived in, Wald decided to make housing reform part of her life's work; she founded the Henry Street Settlement later that year. "This morning's experience was a baptism by fire . . . To my inexperience it seemed certain that conditions such as these were allowed because people did not *know*, and for me there was a challenge to know and to tell."

The first tenements were "tenant-houses": single-family 18th-century homes sliced into small units in the early 19th century. Rooms were often damp and dark, without

running water or indoor toilets. Many were part of a hidden city of back houses—nick-named roosts or rookeries—that stood in the shadows of a front tenement amid a rabbit warren of courtyards and alleys.

In 1833 it is believed, developers put up the first intentional tenement, on Water Street. As immigrants poured into Lower Manhattan, the East Side, and Five Points, thousands of cheaply made dwellings spread across the cityscape. Without any other options, poor and working-class residents crammed into these flat-roofed, five- or six-story structures. The population density, combined with primitive living conditions, bred disease. An 1849 cholera outbreak that swept through Lower Manhattan killed more than five thousand people; in the

1890s, entire streets were dubbed "lung blocks" because so many tenement dwellers had tuberculosis. Made with substandard materials, buildings frequently collapsed or went up in flames.

An 1864 survey conducted by the Council of Hygiene and Public Health found that almost half a million New Yorkers (out of a city population of 726,386) lived in one of approximately 15,000 tenements. Most were occupied by working families, who labored at home doing piecemeal work or toiled in a factory or on the nearby waterfront. "They herd here because the rents of single houses are out of proportion to, or beyond their means, and because they are convenient to work," wrote McCabe in 1872. Social reformers worried that they bred crime. In 1872, reformer Charles Loring Brace, a founder of the Children's Aid Society, wrote about children "swarming in tenement-houses" and the "wretched rooms" where they were taught to beg and steal.

Public concerns about tenement safety and sanitation led to the Tenement House Act of 1867. It was the first city law that mandated change: fire escapes were now required, and for every twenty tenants, there had to be at least one indoor water closet. Cellar apartments were outlawed. A second bill in 1879 limited the size of the tenement to allow more room between buildings. Windows had to open to the outside to improve ventilation. This gave rise to the "dumbbell" tenement, with interior room windows facing dark, putrid airshafts.

The new regulations barely made a dent in the squalor. "The windows on the sides open into the alleys and receive the poisonous gases which arise from them," wrote McCabe in 1882. "Water is laid on each floor. The apartments for a family consist of a kitchen, which is also the living, or sitting-room, and one or more bed-rooms . . . In the winter time it is close and unhealthy, and in the summer the heat of so many cooking-stoves renders it almost unbearable."

The Chairman of the Sanitary Committee presented to the Board of Health his assessment of tenement landlords in 1869: "They make no improvement, except under the greatest pressure, and frequently allow their houses to fall into a state of the most wretched dilapidation . . . Where the number of families living under one owner exceeds ten, it was found that such owner was engaged in the keeping of a tenement-house, or tenement houses, as a business . . . and was seeking a certain percentage on his outlay. . . It is among this class that nearly all the evils of the tenement-house system in New York are found." William Backhouse Astor was one of these rich landlords; he was nicknamed "Landlord of New York" because he owned thousands of tenements.

In 1882, *Frank Leslie's Illustrated Newspaper* published images of old and new tenements. The architect James Ware created the notorious "dumbbell" tenement, so named because of the slender airshafts that bisected the tenement on both sides, as part of a competition by *Plumber and Sanitary Engineer* magazine in 1878. The goal was to improve a typical railroad flat in terms of light, ventilation, sanitation, and fireproofing, as well as to be economically feasible. The airshafts slightly increased the amount of light and air each apartment received, but the shafts became foul, fetid garbage dumps.

Though noxious places to live, tenements were lucrative for landlords. William Astor owned entire blocks of East Side tenements; he made almost three times the money off tenements with several small apartments—and therefore a bigger rent roll—than if his buildings had contained fewer, more spacious units. Trinity Church owned many tenements on the West Side near Hudson and Clarkson streets. The influx of immigrants proved to be a financial boon. "With their coming in masses, shrewd landlords began to put in flimsy rear tenements and, because of the demand, to raise rents until one family

had of necessity to huddle in a single room and even to take in boarders," wrote the *New York Times* on July 30, 1899. Tenants had few rights and landlords few responsibilities.

Calls for additional reform came after the publication of Jacob Riis's *How the Other Half Lives* in 1890. The horrors Riis uncovered—infant death rates as high as one in ten, a dozen adults living in one thirteen-foot room—led to the "New Law" Tenement House Law of 1901. Lot sizes increased to provide more sunlight; all windows had to open to fresh air, not an airshaft; and running water and toilets were mandated in each unit.

The law didn't make unsafe, unsanitary tenements disappear. But it helped improve conditions for the now 2.3 million New Yorkers—an astonishing three-fourths of the city population, as of 1901—who made their homes in the 82,000 tenements spread out in all five boroughs of the newly consolidated metropolis.

A *Harper's Weekly* illustration from August 10, 1889, shows a doctor examining a child in a tenement. The cramped, unventilated dwellings attracted filth and disease.

JACOB RIIS

After immigrating to New York City from Denmark in 1870, Jacob Riis, then 21, struggled to gain a foothold. Alone, penniless, and desperate for work, he found jobs as a carpenter, a bricklayer, and eventually a journalist—finally securing a job as a police reporter for the *New York Herald Tribune* in the 1880s.

His years covering murder and corruption on the night shift took him to New York's most crime-ridden and destitute neighborhoods. Shocked by the conditions he routinely encountered—the filth, sickness, and desperation of the city's poor and working class—he decided to write about what he saw and advocate for reform. An article entitled *How the Other Half Lives* ran in *Scribner's Magazine* in 1889 with many of Riis' own photographs. It was the genesis of his book of the same name, which appeared in 1890.

Social reformers had long railed against the horrible conditions in city slums. But nothing shook New Yorkers like Riis's descriptions and photographs of the men, women, and children who lived in squalid tenements. "The tenements today are New York, harboring three-fourths of its population," he wrote. "When another generation shall have doubled the census of our city, and to that vast army of workers, held captive by poverty, the very name of home shall be as a bitter mockery, what will the harvest be?" Then-police commissioner Theodore Roosevelt was moved to contact Riis and pledged his help. Riis's exposé helped lead to the Tenement Reform Act of 1901.

Excerpt from *How the Other Half Lives*: "Be a little careful, please! The hall is dark and you might stumble over the children pitching pennies back there. Not that it would hurt them; kicks and cuffs are their daily diet. They have little else. Here where the hall turns and dives into utter darkness is a step, and another, another. A flight of stairs. You can feel your way, if you cannot see it. Close? Yes! . . . Here is a door. Listen! That short hacking cough, that tiny, helpless wail—what do they mean? They mean that the soiled bow of white you saw on the door downstairs will have another story to tell—Oh! a sadly familiar story—before the day is at an end. The child is dying with measles. With half a chance it might have lived; but it had none. That dark bedroom killed it."

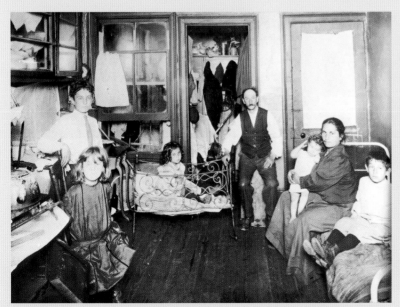

New York City police commissioner Teddy Roosevelt contacted Jacob Riis after reading *How the Other Half Lives*. The two became fast friends. As he wrote later in his autobiography, "The midnight trips that Riis and I took enabled me to see what the Police Department was doing, and also gave me personal insight into some of the problems of city life. It is one thing to listen in perfunctory fashion to tales of overcrowded tenements, and it is quite another actually to see what that overcrowding means, some hot summer night, by even a single inspection during the hours of darkness."

THE FINANCIAL DIVIDE
RESHAPES THE CITY

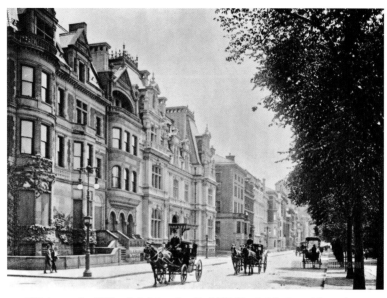

Fifth Avenue, the "Millionaire's Colony," north of 66th Street at the turn of the century.

The mansions began to line Fifth Avenue in the 1860s. By the 1890s, rows of marble or granite capitalist castles—owned by families with names like Vanderbilt, Gould, Fricke, and Carnegie—lined the main drag of the city's "Millionaire Colony" from above 50th Street up to the northern border of Central Park. The avenue that Henry James had once described as "established repose" was now the most dazzling in the city. "To live and die in a Fifth Avenue mansion is the dearest wish of every New Yorker's heart," wrote McCabe in 1882.

Wealth attracted wealth, and if a rich resident couldn't build his mansion on Fifth Avenue, he fanned out east to the upper end of Madison and Lexington, commissioning costly townhouses on these quiet avenues. "The district between 60th and 82nd Streets, Fifth and Madison Avenues, has been so picked out, restricted, and developed that it has become like Murray Hill, only with more expensive mansions," wrote the *New York Times* in 1894. J. P. Morgan built his palace in Murray Hill, which made it still fashionable.

On the west side of Central Park, spectacular cooperatives like the Dakota lured the well-heeled to a part of the city that until the 1880s was a collection of villages: Harsenville, Stryker's Bay, Bloomingdale. By 1900, the rural feel had vanished—save for the occasional wooden shack—replaced by grand mansions and cooperatives on West End Avenue, Broadway, and Riverside Drive.

As the rich migrated northward, middle-

and working-class New Yorkers nipped at their heels, ready to carve older brownstones and mansions in Greenwich Village, Chelsea, and Madison Square into more modest quarters. Lower Manhattan still contained the deepest concentration of poverty of in the city; anyone who could escape this squalid bulge spanning river to river below Houston Street did so.

They headed inward and northward, away from the industrial grit of the rivers. Thanks to the elevated railroads, uptown areas such as Yorkville, Harlem, and the lower Bronx were now more easily accessible. Developers built rows and rows of tenements along Second, Third, Sixth, Eighth, and Ninth avenues all the way to the final stop of each el line. Soon Germans, Irish, Italians, and African Americans moved up and in—clustering in ethnic enclaves similar to the ones left behind.

One part of the city that bridged the divide between classes and ethnicities was Central Park. City officials seemed to plan it that way. "For many years previous to its commencement, the want of a park was severely felt in New York," wrote McCabe in 1872. "There was literally no place on the island where the people could obtain fresh air and pleasant exercise . . . People of moderate means and the laboring classes were required to leave the city to obtain such recreation."

Officially opened in 1859 yet not fully completed until 1872, Central Park has been called 19th-century New York's biggest public works project, with twenty thousand engineers, laborers, stonecutters, and other workers dredging swamps and removing rocky outcroppings to create a mostly pastoral landscape. Upon its opening, however, co-designer Frederick Law Olmsted posted lists of rules— among them bans on picnics, ball playing by anyone but schoolboys, and singing—that made the working class feel unwelcome.

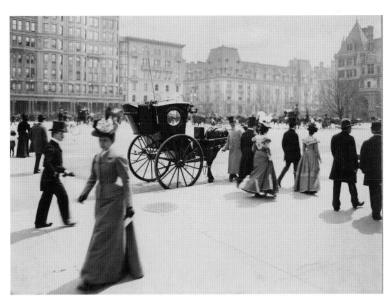

The fashionable stroll along spacious, elegant Fifth Avenue at 59th Street in 1897.

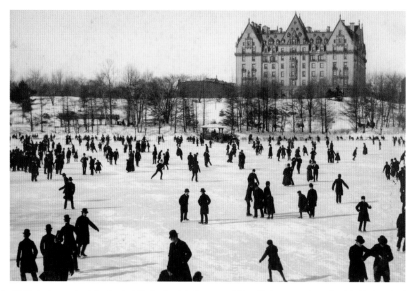

The 1858 design contest for Central Park stipulated one condition: that an area be set aside for ice skating. Frederick Law Olmsted and Calvert Vaux's winning plan included a lake for skating, which opened in December of that year, before the park was completed. Ice skating was immensely popular, especially with couples, who were permitted to hold hands in public while gliding the ice. The western end of the lake was reserved for women and dubbed the "Ladies Pond." When the ice on the lake was strong enough for skaters, a ball was raised near the bell tower, and trolleys flew red flags. On Christmas Day 1859, more than fifty thousand people visited the park, most of them skaters.

The upper classes flocked to the park, enjoying the ice skating, sledding, concerts, carriage rides, trotting races, and afternoon "carriage parades," in which the wealthy drove along the park's leafy paths to see and be seen.

It was Tammany Hall politicians who helped make Central Park a destination for the lower classes. When Boss Tweed and his cronies took control of the city charter in 1870, they relaxed Olmsted's restrictive park rules and added more attractions and amusements—pony rides, free concerts on Sunday (a working man's only day off), a free menagerie (one of the park's most popular venues), a merry-go-round, and boat rentals on the lake. They took kickbacks from corrupt contractors, but they increased park attendance by forty-three percent by 1873, and Sundays were especially popular with the working class.

"The great advantage of the park is, that it is open to all, and that the poor enjoy it more than the rich, who can go where they like, and purchase what the Central gives gratis," wrote Browne.

Crowds throng Central Park's Bethesda Terrace overlooking the lake in 1894. The "Angel of the Waters" Fountain celebrates the 1842 Croton Aqueduct, an engineering marvel that brought fresh water to the city. Unveiled in 1873, the bronze, eight-foot fountain—decorated with four cherubs at its base and topped by a winged angel—was designed by Emma Stebbins, the first woman to receive such a commission in New York City.

FASHION AND COMMERCE COLLIDE IN THE CITY

If you were a fashionable, affluent woman in the Gilded Age with money to spend on fancy clothes and fine furnishings, you did your shopping along Ladies Mile. This renowned district was the city's fashion epicenter in the late 19th century—where sumptuous dry goods stores and luxury emporiums catered to the whims and fancies of a varied clientele.

Starting at A. T. Stewart's, on Broadway and 10th Street, Ladies Mile zigzagged up Broadway, Fifth, and Sixth Avenues to 23rd Street. In between were dozens of what would later be called department stores: B. Altman, Macy's, Siegel Cooper, Arnold Constable, Hugh O'Neill, Stern Brothers, Lord & Taylor, and many more. The district got its start in the 1860s and 1870s, when the slender blocks between Union and Madison Squares formed a wealthy residential enclave. High-end retailers

followed the money, and with the opening of the Sixth Avenue Elevated in 1878, Ladies Mile became the city's finest shopping destination. At the end of the Gilded Age, stores and shoppers moved up to Herald Square.

While prosperous women shopped for their wardrobes on Ladies Mile, their poor- and working-class counterparts earned money sewing the clothes that might very well end up for sale there. Immigrants worked in their tenement sitting rooms sewing piecework, capitalizing on sewing skills they had acquired in their former countries to pay the bills in New York City. Factory owners would outsource labor to immigrants in their homes, where they cut fabric, made patterns, and produced lace, bonnets, and clothing in mini-factories concealed inside tenement walls—often with entire families pitching in.

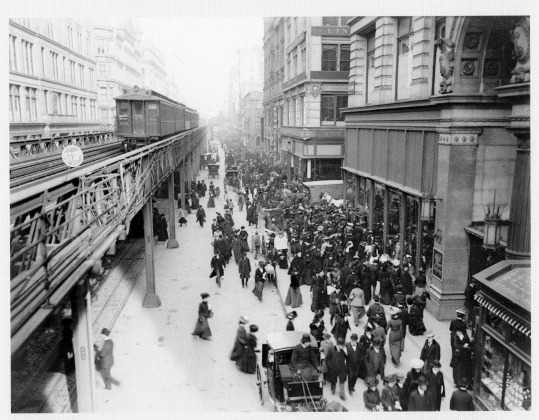

Shoppers on Sixth Avenue, known as Ladies Mile, walk beneath the shadow of the Sixth Avenue El. The entrance to Siegel-Cooper's six-story emporium on 19th Street is seen on the right. When it opened in 1896, it was the largest store in the world. The "big store," as it was called, contained 85,000 square feet and stretched all the way to Fifth Avenue. Its neighbors along this stretch of Ladies Mile included Hugh O'Neill's and Adams & Co., both dry goods merchants.

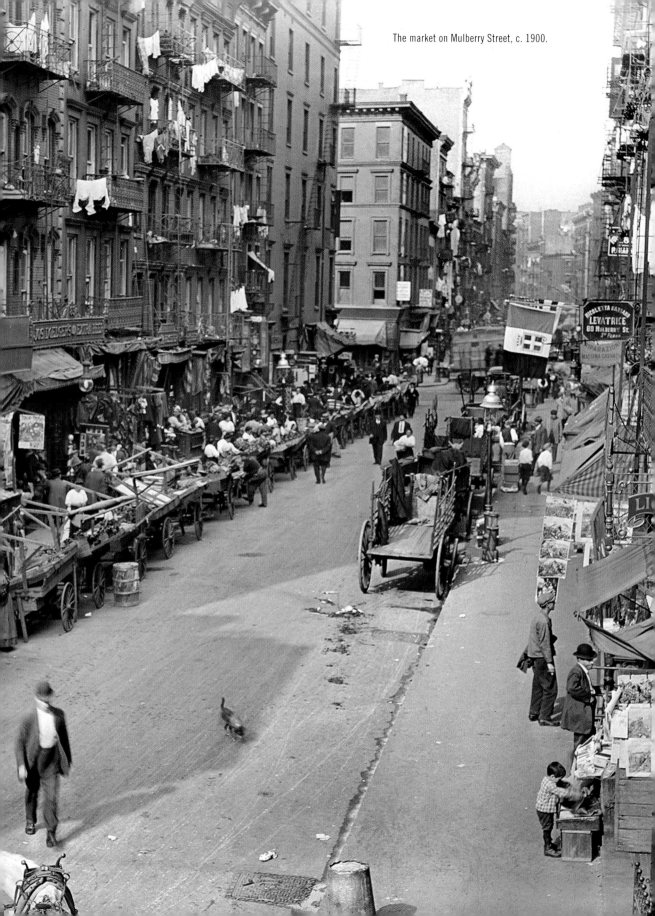

The market on Mulberry Street, c. 1900.

SOCIAL WELFARE

The breadline grew each night until 1:00 A.M., when as many as five hundred loaves (as well as coffee in the winter) were given out to hungry men. "In the early days Mr. Fleischmann was on hand every night," wrote the *New York Times* in 1904. "He talked to the men in line and sought ways of helping them." Fleischmann turned the line into a nightly employment bureau, obtaining work for the jobless and fielding requests for laborers from employers. The line continued until 1918, when the bakery café closed.

THE RISE OF THE BENEVOLENT CITY

On a chilly night in December 1876, Louis Fleischmann noticed a group of ragged men hovering over a steam grate outside his Vienna Model Bakery at Broadway and 10th Street, next door to Grace Church. It was almost midnight. Though the bakery shop had long since closed for the evening to its well-heeled customers, workers in the basement busily baked Fleischmann's heralded rolls and loaves for the next morning. Fleischmann—an Austrian immigrant who had arrived in New York just two years earlier—watched the men on the street inhale the aroma rising from the warm ovens. He went outside and offered them some of the unsold bread from the day. They eagerly accepted.

The next night, more men showed up, forming a line at the back door. Another

VIENNA MODEL BAKERY.

Ladies' and Gentlemen's Café and Restaurant.

Before it became a fashionable bakery and café on Broadway and 10th Street next to Grace Church and opposite A. T. Stewart's posh Dry Goods Emporium, Louis Fleischmann's Vienna Model Bakery was an exhibit at the Centennial Exposition in Philadelphia, in 1876. The exhibit demonstrated to the public the quality of Fleischmann's compressed yeast. It proved so popular that soon after the Centennial ended, Vienna Model Bakeries opened in Philadelphia, San Francisco, St. Louis, and Chicago, as well as in New York.

business owner might have notified the police, fearing his good deed had attracted vagrants to one of the city's most fashionable neighborhoods. But Fleischmann, whose prosperity coincided with the brutal recession brought on by the Panic of 1873, had a different idea. He "decided that he would feed every hungry man who applied, and he directed that the bread which is returned from grocery stores, and which he had been selling for half price, be devoted to that purpose," recalled a September 25, 1904 article in the New York Herald.

For more than four decades, Fleischmann's bakery distributed bread to every man who queued up at the bakery after midnight.

"[Here] is a small fraction of the millions that has not had its supper. Here are men whose lives are not running well—400 small worlds gone to shipwreck," stated a New York Press article in 1902. "Professional charity workers have looked with disfavor on Mr. Fleischmann's manner of giving; it comes under the head of 'pauperizing,'" wrote the Herald. "But the wealthy baker's reply has been: 'If a man will stand on the curb for two or three hours for half a loaf of bread or a few rolls, he's hungry.'"

Fleischmann's breadline was one of many charitable efforts conceived by Gilded Age New Yorkers. "For all who live in a great city like our own, and share its many privileges, there are also many great responsibilities," stated a December 1865 report from the New York City Mission and Tract Society. Inspired by Christian moralizers, the "scientific charity" movement, or simply the sight of so many beggars and tramps on city streets, well-off residents heeded the call to help. By 1892 more than five hundred institutions and benevolent societies in Manhattan offered various types of assistance.

Private charity began flourishing at the right time. By the late 1870s, the city had significantly reduced public aid to individuals. "Indoor relief" still existed; almshouses and hospitals on Blackwell's Island, for example, exemplified this kind of institutional aid. But "outdoor relief"—handouts of coal, food, or even cash given directly to those in need—was drastically reduced. One reason had to do with city finances. After the Panic of 1873, the Commission of Public Charities and Correction was swamped with requests for aid. Yet Tammany Hall politicos in the Tweed era had bilked the treasury of so much cash

that the city government was nearly broke.

Another factor was the growing acceptance of scientific charity—the idea that providing relief to the poor fostered dependancy and hurt them in the long run. Popular sentiment was that city government, already squeezed by recession, should stop distributing direct relief. Seth Low, a Brooklyn reformer who would be elected mayor of New York in 1902, suggested that outdoor relief "saps the habits of industry, discourages habits of frugality, encourages improvident and wretched marriages, and produces discontent." Josephine Shaw Lowell, a Civil War widow who started the Charity Organization Society of New York City (also called Associated Charities) in 1882, maintained that almsgiving led to idleness. The New York Association for Improving the Condition of the Poor—which saw a fivefold increase in the number of needy applicants from 1873 to 1874—questioned the effectiveness of direct financial aid alone.

Fortunate New Yorkers donated generously to these two organizations, both of which conducted home checks of applicants to make sure they were truly in need and often required recipients to put in a day's

In 1893, four of the city's most prominent charities moved into the Renaissance-style United Charities Building at East 22nd Street and Fourth (now Park) Avenue: the Charity Organization Society, the Association for Improving the Condition of the Poor, the Children's Aid Society, and the New York Mission and Tract Society. Designed by R. H. Robertson and paid for by banker John S. Kennedy, the building was created to offset high office rental costs for charitable organizations.

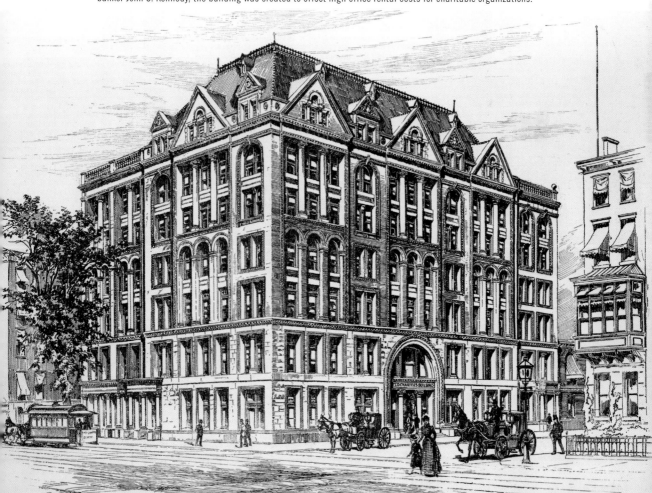

Men who were down on their luck could go to the Bowery Mission, where they were offered free coffee, lodging, and help securing a job. The mission was established in 1879 by Reverend Albert Gleason Ruliffson and his wife, who ministered to the hungry and homeless by offering prayer and social services.

work chopping wood or doing some other task before obtaining aid. "Thousands of our wealthy and generous families have found that the cessation of miscellaneous almsgiving at their doors and elsewhere, and the substitution therefore of the present charity, has not only been more effective, but has materially reduced able-bodied vagrancy," wrote Junius Henri Browne in 1869's *The Great Metropolis: A Mirror of New York*.

Some New Yorkers viewed helping the poor as a religious mission, giving rise to the mission house movement. One of the first neighborhood missions appeared in 1850 in Five Points, and by the 1880s, dozens had been established in the slums to inspire hope and purpose in the poor. Supported by Christian ministries, they offered meals, schooling, clothes, lodging, Bible study, and regular sermons to anyone who asked for aid. Other missions included the Bowery Mission, which catered to men; the Eighth Ward Mission (on Charlton Street); the St. Paul's Mission House (on Cortlandt Street); the McAuley Mission, founded in 1872 on Water Street by Irish immigrant and ex-convict Jerry McAuley; the Howard Mission; and Home for Little Wanderers, on the Bowery.

The 1880s, neighborhood missions were supplanted by a new kind of charity: settlement houses. Here, young, educated men and women "settled" among tenement dwellers and factory workers. In 1886, the Neighborhood Guild, on Forsyth Street, was the first to open. Lillian Wald founded the Henry Street Settlement in 1893; Mary Simkhovitch started Greenwich House on Barrow Street in 1902. They provided schooling, day care, literacy and citizenship classes, libraries, health care, and even bathing facilities. Stripped of religious overtones, they were funded by philanthropists such as Jacob Schiff and J. P. Morgan. Rather than focusing on the individual problems of poor residents, settlement houses advocated social reform as a way to eradicate poverty. They organized residents to push for better housing, more parks, and strong labor laws.

"New York is munificent in its charities and means of relieving incapables," said James B. Reynolds, the head worker of the University Settlement, in an 1895 *New York Times* article. "Nothing could be more orderly than the system of the Associated Charities. But a similar scheme is needed to bring together the supply and demand for labor. To help people to help themselves is better than to wait till they are no longer able to help themselves. Following the awakening of interest in the political welfare of the city must come an awakening to the demands of social reform, and this cause demands urgency quite as much as the other."

PROTECTING THE
"MUTE SERVANTS OF MANKIND"

An 1872 illustration shows ASPCA founder Henry Bergh examining thin, weak horses unable to pull an overloaded streetcar. "The horse, what does he get for prodigious services to us, more than blows, neglect, and starvation," said Bergh.

Henry Bergh first made his case on February 8, 1866, during a well-attended lecture in front of the Manhattan's elite at Clinton Hall on Astor Place. Animals, primarily horses, did the city's hard labor, pulling streetcars and transporting goods. Yet too often, the estimated 200,000 workhorses in the city were overworked and abused, and often left to die in the streets. England had established a society protecting animals. New York should do the same, urged Bergh, the 53-year-old scion of a shipbuilding family.

With the support of prominent residents such as financier August Belmont, Cooper Union founder Peter Cooper, and John Jacob Astor Jr., Bergh founded

In the 1870s, the ASPCA initiated a program to make cool, clean drinking water available to city horses. In the early 1900s, straw horse "sombreros," seen on the horse on the right, were distributed to shade their eyes from the sun.

the American Society for the Prevention of Cruelty to Animals, the first animal welfare group in the nation, later that year. Laws prohibiting animal mistreatment were quickly passed by the city. Bergh himself would often go on patrol, riding in a red wagon pulled by a horse. He typically encountered horses being whipped and starved by owners and drivers; dogfighting rings; cats being set upon, pigeons shot and left to slowly die; and other examples of abuse. The ASPCA quickly grew and added services: ambulances for injured horses debuted in 1867, and drinking fountains were installed for thirsty horses across the city.

"Sick and broken-down or crippled horses are taken from their drivers on the streets, and sent to the hospital of the Society, where they are properly cared for," wrote James D. McCabe in his 1882 book *New York By Gaslight*. "In aggravated cases [Bergh] does not stop with reliving a tortured animal, but causes the arrest and punishment of the perpetrator of the cruelty." After first turning his attention to abuse against horses and livestock, but by the turn of the century, Bergh and his group focused on small animals and pets.

Bergh also co-founded, eight years later, the New York Society for the Prevention of Cruelty to Children, which was modeled after the ASPCA. Incredibly, until 1874, animals had more protection from abuse under the law than children did.

HELPING THE SICK, THE OLD, THE YOUNG, THE ALONE

The rise of Gilded Age benevolence in New York coincided with medical advancements: the pioneering of surgery, infection control, and medicine. As a result, grand hospitals and dispensaries went up all over Manhattan, especially along the new, wide uptown avenues—where city officials often gave away land to charitable institutions to encourage development.

"There are nearly eighty of these 'inns on the highway of life where suffering humanity finds alleviation and sympathy,' and many of them are among the largest and most magnificent buildings in the city," wrote Moses King in 1892's *King's Handbook of New York City*. "The wealthy patient may command all the luxuries a fine private home could give, and the poor man un-

able to pay may enjoy comforts impossible to him in his own narrow dwelling. Fully 100,000 patients are treated yearly in these curative institutions, more than three-quarters of them without any payment for the care and skill which restore them to health or smooth the pathway to the grave; and the death-rate is less than eight percent."

Bellevue, the city's oldest public hospital, located on First Avenue and 26th Street, was a leader in emergency care. Roosevelt Hospital, opened in 1871 by descendants of the old New York family, earned distinction as "the most complete medical charity in every respect," according to one surgeon. And the Sloane Maternity Hospital and the Vanderbilt Clinic, dedicated in 1887, was endowed by one of Manhattan's richest families. Protestant, Jewish, and Catho-

In 1866, Bellevue Hospital became home to New York City's first morgue and developed the city's first sanitary code.

In 1873, Bellevue Hospital launched the nation's first children's clinic, seen here in 1897.

lic organizations started medical centers and neighborhood hospitals. Even doctors founded hospitals; J. Marion Sims, who developed a technique to repair fistulas caused by childbirth, launched the New-York State Women's Hospital on Park Avenue and 50th Street in the 1860s and then the New York Cancer Hospital, on Central Park West and 106th Street, in 1884. His efforts restored the health of thousands of women, and he charged nothing.

Facilities for the old also became part of the cityscape. Moses King described them as "half-a-dozen comfortable and well-maintained homes for aged women, as well as for aged couples, and for men and women suffering from friendlessness and penury."

The New-York Society for the Relief of the Ruptured and Crippled was one of the many hospitals founded by physicians. Dr. James Knight, a surgeon, opened the facility with the help of generous New York philanthropists and offered free treatment for patients suffering from hernias and various deformities. The hospital's second building, constructed in 1870 at Lexington Avenue and 42nd Street, can be seen in a photo from *King's Handbook of New York*. As many as nine thousand patients were treated yearly.

The Little Sisters of the Poor, a Catholic order of nuns, operated two homes for nearly five hundred "inmates." A *New York Evening Telegram* reporter visited one on January 26, 1886 and quoted the Mother Superior: "We often have fifteen applicants in a day and are forced to turn them away because we have no room for them," she said. "We would like to have another wing to our Home and to have steam heating apparatus. In the very cold weather we cannot keep our building warm enough, and our old people suffer very much . . . "

Religious groups also built city orphanages. While such institutions always had been present in New York, in the Gilded Age the need for them grew. Thousands of New York City soldiers who perished on Civil War battlefields left behind children who often couldn't be properly cared for by widowed mothers. And the harsh recessions of the 1870s and 1890s left parents with no option but to place a child in a home. Not everyone believed orphanages were the best place for youngsters, though—Charles Loring Brace, head of the Children's Aid Society, vehemently tried to keep destitute children out of institutions. But desperate parents had few choices.

Their names were typically gentle and soft: The Sheltering Arms, The Children's Fold, St. Christopher's Home. They housed from dozens to hundreds of kids up to age seventeen who attended school in the orphanage and were often taught a trade. St. Christopher's, on Riverside Drive and 112th Street, was founded in 1882 as a home for "destitute and orphan Protestant children" from age two to ten. "About 100 inmates

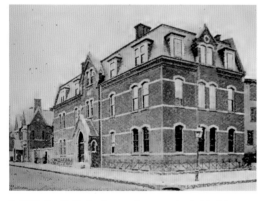

In 1874, the Sheltering Arms orphanage relocated to this building on Amsterdam Avenue and West 129th Street. Created in 1864 as a haven for "children in the midst," the home offered 120 destitute children at a time the kind of care their parents could not provide.

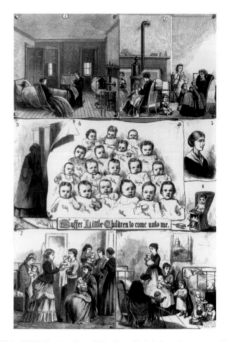

This 1871 illustration of the New York Infant Asylum at 24 Clinton Place shows the lying-in ward, the nursery, the mother, portraits of the babies, the matron, reception day, and the sleeping room. The asylum took in and cared for unwanted babies until they were found a suitable home. Obstetrical care was given to unwed or indigent women for their first pregnancy only—the Board of Managers felt it was merely human to make one mistake but making two was immoral.

are received yearly, who are taught some useful occupation to enable them to obtain self-supporting employment," wrote Moses King. "Admission is free to those whose parents or friends are unable to contribute to their support." Fewer than half of the children in orphanages were actually parentless; their guardians often used the orphanages as a temporary care center while they were going through rough times.

Perhaps no charity institution exemplified the social problems of the late nineteenth century city as did the Foundling Asylum. Infant abandonment had become a serious problem in postwar New York. If found alive on a street corner or stoop, a

baby would be taken to the almshouse at Blackwell's Island, where the chances of survival were poor. In October 1869, hoping to better those odds, three nuns put a wicker cradle on the front steps of their East 12th Street brownstone, and announced that they would care for all unwanted babies. That very night, a newborn was left in the cradle. By the end of the month, forty-five babies had appeared on their doorstep.

Pinned to their blankets were often heartbreaking notes from despairing mothers. "My dear good Sister," read one, "Please accept this little outcast son of mine trusting with God's help that I will be able to sustain him in your institution. I would not part with my baby were it in any way possible for me to make a respectable living with him, but I cannot, and so I ask you to take my little one . . . His name is Joseph Cavalier." The Foundling Hospital grew so quickly that the sisters moved to larger quarters, on Lexington Avenue and 68th Street, in the 1870s. Its name changed to The Foundling Asylum in the 1880s.

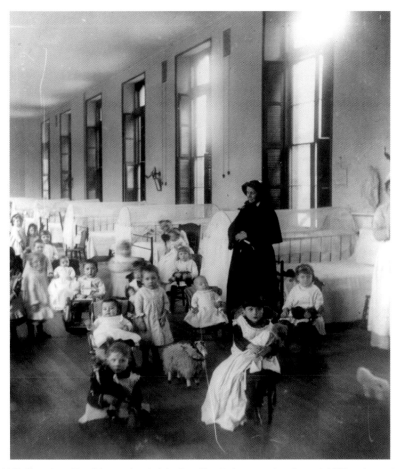

In 1869, Sister Irene Fitzgibbons cofounded the Foundling Asylum, a modest Greenwich Village home where desperate mothers could drop off new babies they were unable to raise. By the 1880s, the asylum had cared for and found permanent homes for thousands of abandoned babies. In this 1888 Jacob Riis photo, Sister Irene stands with some of her young charges at the New York Foundling Hospital on East 68th Street.

Smaller, specialized charities ministered to the margins. A home for needy actors operated near Madison Square. The Needlework Guild sewed clothes for the institutionalized. St. Bartholomew's Chinese Guild, on St. Mark's Place, was devoted to the "spiritual elevation" of Chinese immigrants. The Working Women's Protective Union sought "to stand between the female wage-earner and the employer who would defraud her of her scanty wage," wrote Moses King.

Individual citizens, like Louis Fleischmann, contributed greatly. Nathan Straus, a co-owner of Macy's department store, gave away millions. In addition to establishing low-cost lodging houses, coal warehouses, and grocery stores on the Lower East Side after the Panic of 1893, Straus set up the first of eighteen pasteurized milk stations. Children were encouraged to drink milk because it was nutritious, but without pasteurization to kill bacteria, milk routinely sickened and even killed those who drank it. By investing in sterilization and distributing the clean milk in city-park milk depots, Straus made it safe.

In April 15, 1894, when asked by the *New York Times* about his efforts, Straus replied, "I am entirely satisfied with the result of the work . . . I can see, and I do not hesitate to say, that an immense good was accomplished, but it was not charity, it was merely justice to the poor."

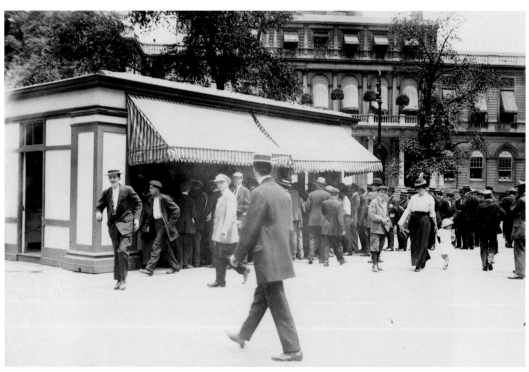

In 1894, the *New York Times* described department store magnate-turned-philanthropist Nathan Straus's Milk Depot in City Hall Park, where a glass of milk was sold for a penny: "There so long as the milky tide serves (it runs dry, alas! twice a day) may be seen the odd spectacle of all sorts and conditions of men and women and girls and boys elbowing and shoving each other for their cent's worth of ice-cold milk. Each arrival from headquarters of a laden wagon brings ten cans of milk that has been scientifically sterilized in the big home kettles, and each can yields over 100 glasses of the fluid. It is easy to see, therefore, that the trim little booth in the park yields 2,000 glasses of milk every blessed day of the week except Sunday, when the demand diminishes."

THE HOUSE OF INDUSTRY SETS UP
IN FIVE POINTS

In the nineteenth century, an evangelical zeal to aid the poor swept through New York. Methodist clergyman Lewis Morris Pease was one of these Christian reformers. In 1850, he ventured into the squalid, lawless Five Points district and established the Five Points Mission, one of the city's first mission houses, offering lodging, food, clothes, and schooling to poor residents.

After parting ways with the Mission in 1851—Pease realized he was more committed to offering the poor hands-on help rather than pressuring them to convert to Protestantism—he founded a mission just across Worth Street called the Five Points House of Industry.

By 1853, the House of Industry included five separate houses, "which he filled with the occupants of the wretched hovels of the vicinity," wrote James D. McCabe in 1872. "He procured work for them, such as needle-work, basket-making, baking, straw-work,

shoe-making, etc. . . . The expenses of the Mission were then, as now, paid from the profits of this work, and the donations of persons interested in the scheme. Five hundred persons were thus supported. Schools were opened, children were taught, clothed, and fed, and religious services were regularly conducted." In later years, the House of Industry focused on children's welfare; an infirmary and dispensary were added and twelve hundred local children attended the House school. As the nineteenth century drew to a close, Five Points—though still poor—was no longer the horrific slum it had been decades earlier. By 1913, the House of Industry had moved out, its old quarters set to be razed to make room for a new county courthouse. All traces of the city's worst slum, and the missions that eased its suffering, would soon meet the wrecking ball.

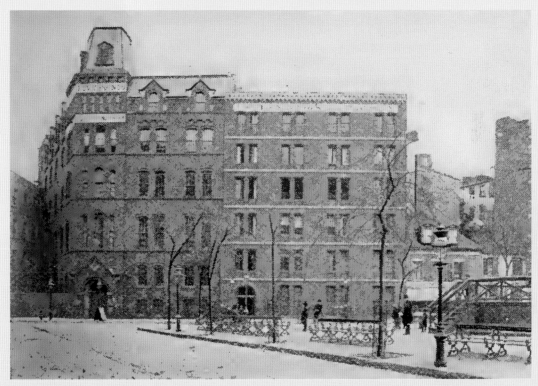

In 1861, the Five Points House of Industry celebrated its tenth anniversary. A *New York Times* article detailed numbers from the institution's annual report: "1,633 persons have received partial or entire support from this charity during the past year, 835 of whom were children; 285,215 meals have been distributed, gratuitously during the year, at an average cost of 2 1/2 cents per meal; 864 children have been enrolled on the school register, and the average daily attendance has been 254."

SAVING WOMEN AND CHILDREN

According to one minister, The Florence Night Mission for Fallen Women, at 21 Bleecker Street, was perfectly situated "between the uptown feeders and the downtown cesspools which they supply." The mission offered prayer sessions and social services for prostitutes and homeless women.

"Several meetings have been held recently in our churches with reference to the formation of 'midnight meetings for fallen women,' such as have been opened in London for the benefit of this unfortunate class," wrote the *New York Times* in January 28, 1867. "It is always ungracious to criticize a new organization of charity . . . It must be remembered, in the first place, what these 'unfortunate women' are. They are mainly, as is well known, young husseys of foreign birth who are too lazy to work . . . or who have come to love dances and liquor But few of them comparatively are the innocent 'victims of man's deception,' or are driven to this course by circumstances such as are overwhelming."

The *Times* had little enthusiasm for the efforts to help prostitutes, unwed mothers, and other unchaste single females. But "the lost sisterhood" was considered one of the lowest vices in late nineteenth century New York, and as a result, these women were the recipients of much Gilded Age benevolence. Some "Magdalene" missions appeared as early as the 1830s, but an increasing number were founded in the 1870s and 1880s. Their names gave away their purpose: The House of Mercy, The Midnight Mission, the New-York Magdalen Asylum, and the Florence Night Mission for Fallen Women.

The latter, housed in a humble structure on Bleecker Street near the Bowery, opened in 1883. "Any mother's girl wishing to leave a crooked life, may find friends, food, shelter, and a helping hand by coming just

HORROR IN A CITY LUNATIC HOSPITAL

"Who is this insane girl?" asked a *New York Sun* article on September 25, 1887. The story told of a "modest, comely, well-dressed girl of nineteen, who gave her name as Nellie Brown, [who] was committed by Justice Duffy of Essex Market yesterday for examination of her sanity." The unknown girl was then taken to Bellevue, and though doctors were sure she was insane, they were puzzled as to who she was and where she was from.

Ten days later, they and the rest of the city would find out. The "insane girl" was Nellie Bly, the pen name of Elizabeth Jane Cochran, a 23-year-old investigative reporter sent by Joseph Pulitzer's sensational *New York World* to get herself committed to the Women's Lunatic Asylum on Blackwell's Island and write a story about the conditions she encountered there.

Various city newspapers had covered the disturbing, criminal conditions at the asylum over the years since it opened in 1839. But it was Bly's experience that prompted an outraged city to demand change. Her series of articles chronicled ten days in the rat-infested building, eating rotten food, "showering" with buckets of cold water, and enduring forced isolation.

"What, excepting torture, would produce insanity quicker than this treatment?" she wrote. "Take a perfectly sane and healthy woman, shut her up and make her sit from 6 A.M. to 8 P.M. on straight-back benches, do not allow her to talk or move during these hours, give

Nellie Bly

her no reading and let her know nothing of the world or its doings, give her bad food and harsh treatment, and see how long it will take to make her insane. Two months would make her a mental and physical wreck."

Responding to criticism triggered by Bly's searing articles, the city drastically increased funding to the Commission of Public Charities and Corrections so that upgrades would be made at the Asylum. Bly herself was invited to tour the facilities a month later, and she reported that many of the worst offenses had been corrected. The Lunatic Asylum closed for good in 1894, its patients transferred to a facility for the insane on Ward's Island.

Nellie Bly's series of articles about the New-York Asylum for the Insane on Blackwell's Island (left) in the *New York World* was later published as a book, *Ten Days in a Mad-House.*

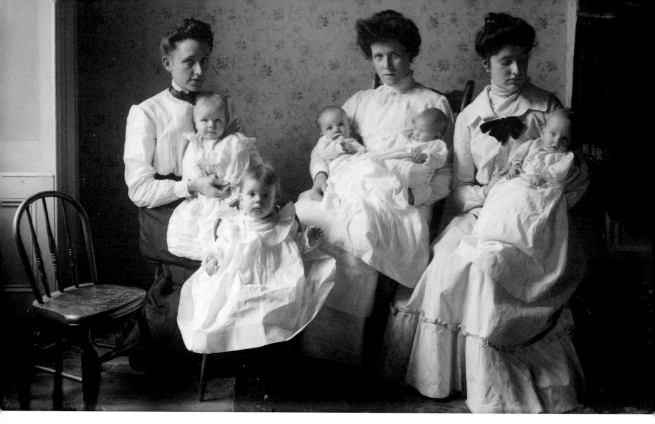

Caregivers and babies in 1908 at the Children's Aid Society, New York's oldest private charity, founded in 1853 "to ensure the physical and emotional well being of children and families, and to provide each child with the support and opportunities needed to become a happy, healthy, and productive adult."

as she is, to the Florence Night Mission," read the mission's card, which was handed out along the gritty streets nearby. Hundreds of women and girls did seek aid there, at least temporarily. Whether any of the women were "reformed," or simply spent a few nights before returning to their old lives, is hard to know.

"Now and then a father or mother who has heard of the mission work comes and begs that they help find a long-lost daughter," wrote Helen Campbell, missionary and coauthor of the 1895's *Darkness and Daylight*. "A photograph is sent, or a minute description is given, and the missionary looks critically at the throng of faces assembled in the Mission room, hoping that he may find the one for whom home is waiting." In an era when a woman's chastity could determine

her fate, social reformers viewed restoring her "virtue" as noble work.

Equally noble in the eyes of reformers was improving the lives of children. Thousands of youngsters lived on the streets, scratching out a meager living as bootblacks, newsboys, sweatshop workers, or thieves. Child labor laws and a compulsory school law (requiring all kids from ages eight to fourteen to attend fourteen weeks of school per year) were routinely ignored. One groundbreaking piece of legislation, the Children's Law of 1875, made it illegal for the city to condemn homeless children to adult almshouses. Charles Loring Brace's Children's Aid Society advocated for the passing of this law, hoping to keep destitute kids out of wretched poorhouses, funneling them instead to local

foster families or aboard "orphan trains" to new homes across the country.

The Children's Aid Society was the main agency taking up the cause of child welfare. Brace and his colleagues pioneered kindergartens and opened twenty-two industrial schools. They couldn't end all child labor, but they did construct five lodging houses specifically for working boys (and one for working girls) by 1890. In these refuges, children were guaranteed a warm bed, decent meals, and the opportunity to attend night classes. By 1895, an estimated 250,000 children had passed through the lodging houses that dotted the poorer sections of Manhattan, from Rivington Street on the Lower East Side to West 18th Street in Chelsea to Avenue B at Tompkins Square Park.

"What sort of home is it that their money helps to provide?" asked Campbell of the Children's Aid Society's newest lodging house, on Duane and Chambers streets. "The cleanliness is perfect, for in all the years since its founding no case of contagious disease has occurred among the boys. Their first story is rented for use as shops. The next has a large dining-room where nearly two hundred boys can sit down at table The next story is partitioned off into a school-room, gymnasium, and wash-rooms The two upper stories are large and roomy dormitories, each furnished with from fifty to one hundred beds or berths, arranged like a ship's bunks, over each other." Boys paid six cents a night for one of these bunks and ten cents for a private room.

In 1874, the Society for the Prevention of Cruelty to Children joined the Children's Aid Society in the battle for child welfare. The Society focused on establishing laws

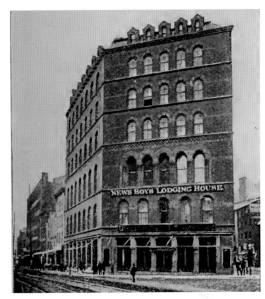

When the *New York Times* visited the Children's Aid Society's Newsboys' Lodging-house in December 1860, the reporter found "boys who sell papers, black boots, run on errands, hold horses, pitch pennies, sleep in barrels and steal their bread. Boys who know at the age of twelve more than the children of ordinary men would have learned at twenty, who can cheat you out of your eye teeth, and are as smart as a steel-trap."

that prevented mistreatment; at the time, it was not illegal for parents to physically abuse their children. In the first months of its existence, the Society investigated hundreds of complaints of child abuse. Other laws protecting children hit the books: a 1886 act barred children under age fourteen from

In 1881, *Frank Leslie's Illustrated Newspaper* published this image of the opening day of New York public schools. The day began with calisthenics.

toiling in sweatshops and factories for more than sixty hours per week. And a revamped statewide school law, effective in 1895, required that all children from eight to sixteen years old attend school from October to June, with some exceptions if a child of at least twelve was "lawfully engaged in any useful employment or service."

Children were still turned out to the streets and forced to work. And after age twelve, they didn't have to be in school. But the new laws were small victories. The fight for further reforms to child labor and education would continue after the turn of the century.

WHEN HOMELESS KIDS BOARDED "ORPHAN TRAINS"

In 1848, Charles Loring Brace, a young divinity student, visited Manhattan. What he found shocked him: hordes of vagrant children, dirty and ragged, working and living on the streets. That year, city officials estimated that about three thousand "street Arabs" eked out a living as newsboys, bootblacks, vendors, prostitutes, or criminals. More appalling to Brace was that police could arrest these homeless boys and girls and condemn them to live in adult asylums.

Incarceration wasn't the answer, Brace felt; nor were orphanages. "The child must have sympathy, individual management, encouragement for good conduct, pain for bad, instruction for his doubts, tenderness for his weakness, care for his habits, religious counsel and impulse for his particular wants," he wrote. "He needs, too, something of the robust and healthy discipline of everyday life . . . How can all this be got in an asylum or orphanage?"

After founding the Children's Aid Society in 1853, he came up with an idea that would remain controversial for decades: sending New York's street children to towns and cities across the country, hoping that farm families would take them in and provide a good home away from the vice of city slums.

The first "orphan train" left New York in 1854. For the next 75 years, at least 100,000 children—some abandoned by parents, others signed over by alcoholic or destitute mothers and fathers—went east, west, and south. Most didn't actually go far; a third found homes in New Jersey, upstate New York, and Pennsylvania. Historians who later tracked down some of the children discovered that, by and large, they lived ordinary lives with their new families. In a 1910 report, the Children's Aid Society estimated that 87 percent had benefited from being removed from the city.

Throughout his life, Brace questioned whether sending children away—and never seeing their birth families again—was the right move. "When a child of the streets stands before you in rags, with a tear-stained face, you cannot easily forget him," he wrote. "And yet, you are perplexed what to do. The human soul is difficult to interfere with. You hesitate how far you should go."

"To sleep in boxes, or under stairways, or in hay-barges on the coldest winter nights, for a mere child was hard enough; but often to have no food, to be kicked and cuffed by the older ruffians, and shoved about by the police, standing barefooted and in rags under doorways as the winter storm raged, and to know that in all the great city there was not a single door open with welcome to the little rover—this was harder," wrote Children's Aid Society founder Charles Loring Brace in his book, *The Dangerous Classes of New York and Twenty Years' Work Among Them* (1872).

A CLEANER, SAFER, BRIGHTER MANHATTAN

Before 1901, when New York City built its first municipal bathhouse, city dwellers could visit one of the floating bathhouses along both the East and Hudson rivers, including this one in Battery Park. The first two were inaugurated in 1870, and by 1890, the city was operating fifteen free baths, serving an average of 2.5 million men and 1.5 million women a year. Bath houses were used at first for cleansing, but over the years they gradually became more like the recreational swimming pools of the early twentieth century.

For a metropolis filled with so much forward-thinking benevolence, much of its infrastructure—sidewalks, streetlights, and transportation options—were not quite so progressive. True, New York had an abundance of clean water, thanks to the Croton Aqueduct, an engineering wonder opened in 1842. And the elevated trains made getting uptown and downtown faster and easier. But other factors affecting the health and welfare of the city desperately needed to be brought up to speed.

An 1866 report by the newly formed Metropolitan Board of Health had this to say about the city's sanitation: "The streets were uncleaned; manure heaps, containing thousands of tons, occupied piers and vacant lots; sewers were obstructed; houses were crowded, and badly ventilated, and lighted; privies were unconnected with the sewers, and overflowing; stables and yards were filled with stagnant water, and many dark and damp cellars were inhabited. The streets were obstructed, and the wharves and piers were filthy and dangerous from dilapidation; cattle were driven through the streets at all hours of the day in large numbers, and endangered the lives of the people"

Board officials had their hands full. Over the next decades, they investigated cases of transmissible disease, quarantined the afflicted, and waged public campaigns against tuberculosis, diphtheria, cholera, typhoid, and other deadly diseases spread by contaminated water and waste, especially in crowded, filthy tenements. The Department of Public Works built fifteen outdoor baths for the poor in different city neighborhoods; the Association for

Improving the Condition of the Poor opened "peoples' baths" that charged five cents to use the facilities. In an 1894 Tenement House Commission report, commissioners wrote that "several hundred thousand people in the City have no proper facilities for keeping their bodies clean."

Homes and privies were connected to sewers, and the feral swine—New York's garbage patrol since Colonial days—were banned south of 85th Street so that a professional Department of Sanitation could take over. Street sanitation was slow going at first. Rudyard Kipling complained during a visit to the city in 1892 that New York was "bad in its paving, bad in its streets, bad in its street-police, and but for the kindness of the tides would be worse than bad in its sanitary arrangements."

New York's streets were cleaner for another reason in the 1890s: horse cars were being replaced by electric-run cable cars, which did away with piles of waste and the flies they attracted. In his short 1902 sketch "In the Broadway Cars," Stephen Crane described the sound made by these hygenic, quieter vehicles as the "uninterrupted whirr of the cable." The elevated railroads, meanwhile, continued to spit smoke into the air below their trestles. But city officials were making plans to put much of the railways underground, along with telegraph and telephone wires.

In the early 1880s, the city's gaslights—flickering illumination that gave off a noxious odor—had begun to be replaced by electric streetlights, first between Union and Madison squares on Broadway, and then, before the turn of the century, throughout the city. Offices, shops, and homes were also using electricity, creating a greater sense of safety and a glow to much of the nighttime city.

"In the stores and business places throughout the lower quarter of the city there was a strange glow last night," commented the *New York Herald* in September 1882. "The dim flicker of gas . . . was supplanted by a steady glare, bright and mellow, which illuminated interiors and shone through windows, fixed and unwavering."

What a difference professional street cleaning made on some city blocks. These photographs, published in *Harper's Weekly* in 1895, show the dirt and grime on East Houston and Fourth Streets, before the Sanitation Department came in. Two years and many cleanings later, both streets practically gleam.

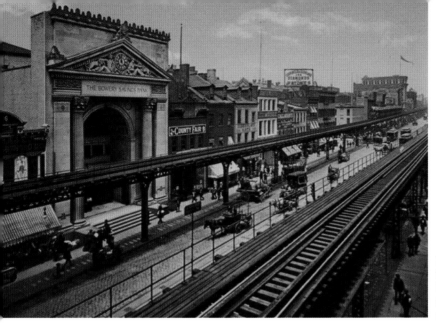

The rumble and ash created by the elevated train cast a darkness over the Bowery, shown here in 1900, hastening its descent into a skid-row district. Carriage and cable-car traffic made it one of the city's busiest thoroughfares.

THE WHITE WINGS TAKE TO THE STREETS

New York City's Department of Sanitation was established in 1881—but streets were still filthy. Trash was routinely tossed out tenement windows; ashes, animal waste, and food piled up, attracting flies and vermin. Something had to be done to clean up the modern city.

In 1894, newly elected mayor William Strong—who had campaigned as a reformer who would clean up city government—hired sanitation engineer Colonel George Waring to head the department. Waring wasted no time. He drew on his military background to organize the street cleaners and sweepers into a corps of men who wore police-like caps and all-white uniforms,

to communicate sanitation and cleanliness.

Nicknamed the White Wings, his army of cleaners swept and washed sidewalks and streets, emptied garbage and ashcans, and transported debris, snow, and anything else clogging the streets to garbage dumps or the rivers. Waring not only cleaned the city, but made it safer and healthier. "It was Colonel Waring's broom that first let light into the slum," wrote Jacob Riis in his 1900 book on progress in the slums, *A Ten Years' War*. "Colonel Waring did more for the cause of labor than all the walking delegates of the town together, by investing a despised but highly important task with a dignity, which won the hearty plaudits of a grateful city."

George Waring brought respect, professionalism, and dignity to New York's sanitation workers, who were tasked with the difficult job of keeping the city clean. His "White Wings" were easy to spot, thanks to their bright, militarylike uniforms and hats. "A distinguishing and conspicuous uniform is necessary to keep some of the members of the force at work . . . There are some men, even among the noble army of sweepers, who would prefer a pack of cards and a warm corner to a windy street in cold weather, and I am informed that this was in old times a rather common practice," wrote Waring.

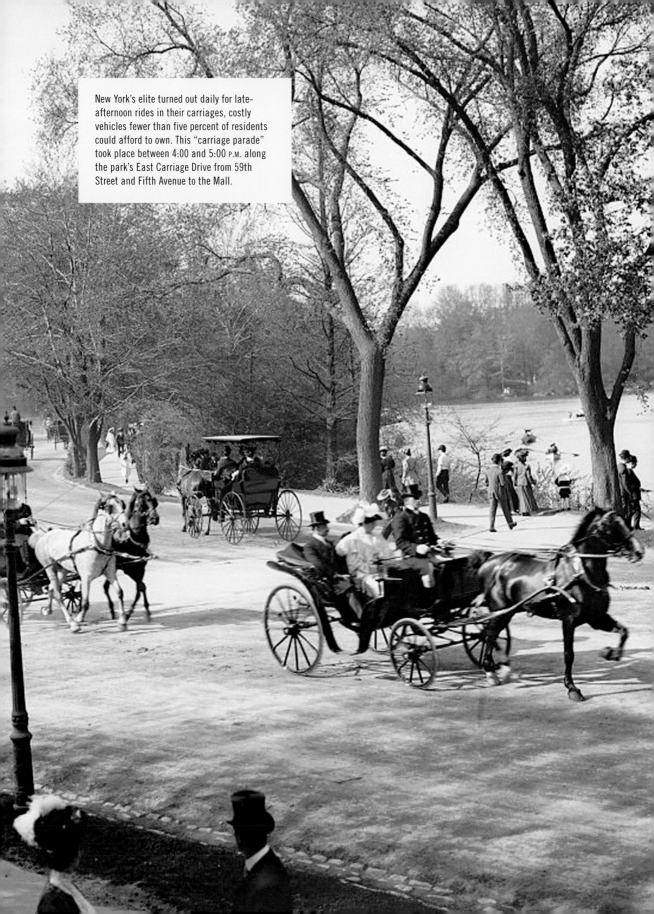

New York's elite turned out daily for late-afternoon rides in their carriages, costly vehicles fewer than five percent of residents could afford to own. This "carriage parade" took place between 4:00 and 5:00 P.M. along the park's East Carriage Drive from 59th Street and Fifth Avenue to the Mall.

THE RISE OF LEISURE TIME

When Central Park opened in 1859, its grounds included few areas for children to play in. The park was designed to mimic nature and, as such, had only a "kinderberg" (children's mountain) and ball fields for boys set aside for for the city's young. That began to change, and by the mid-1880s, park officials began issuing permits for children's May Day parties. By 1886, more than one hundred maypoles "with red, white, and blue streamers fluttering joyously in the wind were stuck in the soft turf."

NEW YORK AT PLAY AND AT REST

May 3, 1890, was a lovely, sunny spring Saturday in the city. Thousands of New Yorkers celebrated the spectacular weather the same way: by taking in the delights of Central Park.

"Central Park was literally alive with pleasure seekers yesterday," the *New York Times* wrote. "There were dozens of May Day parties that brought out the children, and the soft spring air, the warm sunshine, and the budding trees proved sufficiently attractive to insure the presence of countless older people. The bridle paths were filled with men and women on horseback, the drives were crowded with gay equipages, and the promenades were so thickly peopled that pedestrianism was a wearisome labor."

The city's "big playground," as the *Times* dubbed it, offered recreation for everyone.

A menagerie was not part of Olmsted and Vaux's original plan. But through the 1860s, bears, swans, and other animals owned by circuses, carnivals, private citizens, and hunters were donated to the park. Victorian-styled structures to house them eventually were built behind the arsenal. The menagerie became very popular—as many as seven thousand people visited daily in 1873. By 1887, there were monkeys, polar bears, and an elephant.

Several riding clubs held a parade in the afternoon, which attracted a cavalcade of riders, horses ("groomed until their coats glistened like satin in the sunshine"), and cheering spectators at the starting point at "The Circle" at Eighth Avenue and 59th Street. "Nearly every one on the line of march stopped to watch the parade, and hundreds of people had taken the precaution to secure in advance excellent points for the inspection at different places along the line of march," detailed the *Times*.

An authentic Italian-made gondola, given to the park by a city lawyer in 1862, enhanced the romantic atmosphere of the lake. Rowboats, available to park goers, became a very popular attraction.

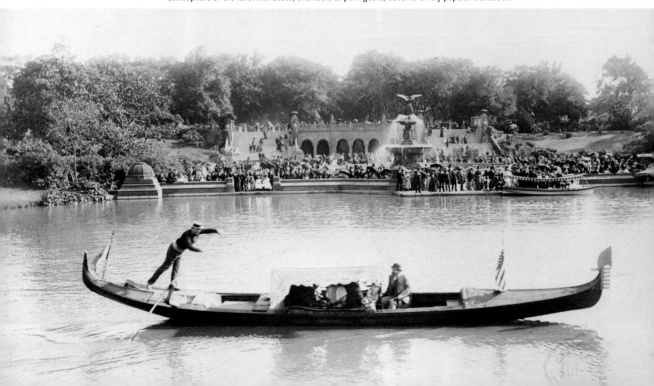

"Gaudy Maypoles dotted the sward of Central Park in all directions, and dozens of May queens reigned coyly in white dresses, long veils, and crowns of spring flowers. Games of baseball were indulged in by the boys, and the babies had a merry time rolling on the grass and picking the yellow dandelions. The boats of the lakes were liberally patronized, and the menagerie was crowded, the monkey cage, as usual, holding the place of honor in the affections of the little ones." The Seventh Regiment Band played Beethoven and "The Star Spangled Banner" on the mall: "All in all, New-York derived a great deal of enjoyment from Central Park yesterday."

The instant popularity of Central Park, finally completed in 1873, was one of many factors that sparked a massive wave of park building all over the city. For starters, working people had more leisure time to visit them. Labor movements had succeeded in shortening the standard workday to eight hours on average, and though many workers already had Sunday off, half-day Saturdays were catching on. The development of the elevated railroads allowed everyone, especially residents boxed into tight, dank quarters, to escape what Walt Whitman called "the swarmingness of the population" for a few hours and enjoy a picnic along the East River or head to one of the new seaside attractions in Brooklyn.

At the same time, social reformers argued that a lack of exposure to nature triggered crime and poverty. More green spaces, they pressed, would elevate the lower classes and boost physical and moral health. "It is a scientific fact that the occasional contemplation of natural scenes . . . is favorable to the health and vigor of men," wrote Frederick Law Olmsted in 1865. Olmsted and Calvert Vaux created Central, Riverside, and Morningside parks in the city and Brooklyn's Prospect and Fort Greene parks. "The want of such occasional recreation where men and women are habitually pressed by their business or household cares often results in a class of disorders the characteristic quality of which is mental disability . . . incapacitating the subject for the proper exercise of the intellectual and moral forces," Olmstead wrote.

The planners of New York's 1811 street grid designated few open spaces. To remedy this, the new Department of Parks secured some of the last stretches of Manhattan's undeveloped land. A hilly ridge overlooking the Hudson was purchased in 1872; it opened as Riverside Park three years later. Piece by piece, land was acquired in the 1890s to create slender Highbridge Park, named for the 1848 High Bridge that carried Croton Aqueduct water over the Harlem River to Manhattan. Department officials oversaw the revamping of Washington, Union, and Madison squares.

Goat carriage rides for children were introduced to Central Park in 1869. The carts, which resembled miniature hansom cabs carried up to six youngsters at a time. The team of goats could often be seen munching on the park lawns while waiting for their next passengers.

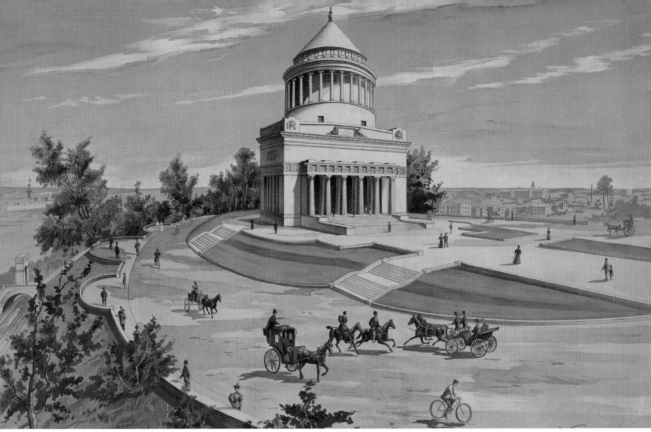

An 1897 illustration shows Grant's Tomb in the upper part of Riverside Park, where it opened after a dedication ceremony in April of that year. The mausoleum contained the remains of Civil War hero and former president U.S. Grant (and later his wife). The plaza surrounding it quickly became a popular place for cyclists and pedestrians.

The 1887 passing of the Small Parks Act allowed the department to carve out park plots in squalid tenement districts for Mulberry Bend Park, Hudson Park, and DeWitt Clinton Park.

Olmsted and Vaux's original vision for Central Park was to mimic the tranquility of nature as closely as possible. But a boom in outdoor recreation led park officials to do more than design pastures and promenades. They created ball fields, wide walking paths, roller-skating areas, ponds for sailing model boats, and more lakes for winter ice skating. In the summer, "floating pools" were docked off the Hudson and East Rivers, offering a place to cool off. Filled with river water, they were packed on sweltering days—until the rivers were

deemed too polluted. In their place, the city built two real swimming pools in 1908, at public bathhouses on East 23rd Street and West 60th Street.

No recreational activity swept the city like cycling. Men and women took to the biking craze in the 1880s and 1890s, forming riding clubs that rode en masse through streets or conducted endurance races inside velodromes, or racing tracks. With so many New Yorkers giving bicycling a try, distinct lanes were a necessity. Brooklyn led the way, opening the first bike path in the nation in 1894, 5.5-miles long, from Prospect Park to Coney Island. Manhattan soon accommodated bikers by designating paths in Central Park and Riverside Park.

"The delights of winter cycling were

appreciated and enjoyed by a host of wheelmen and wheelwomen yesterday," wrote the *New York Herald* on January 11, 1897. "From early morn till dusk they appeared in a never ending stream in the streets and roads best equipped for the sport. Central Park and its environs, the Boulevard, Riverside Drive, and all of the asphalted streets were thronged with riders of all sorts and conditions, mounted on wheels which had seen various degrees of service . . . Riverside Drive was in splendid condition and lined with people viewing the handsome turnouts and the myriad of wheelmen, who invariably wended their way up to and by Grant's Tomb to the Claremont, where the wants of the inner man were catered to, apparently to their satisfaction."

Parks also began to feature playgrounds. Before the 1880s, play areas for children, called "sand gardens," were usually attached to schools or settlement houses. But social reformers argued that play was imperative to a child's well-being. The

The sheet music for this 1896 song blended the cycling trend with the dizzying popularity of Coney Island. Lyrics include: "Now for a song as we go wheeling on / And for the glorious "bike" we'll shout / It's up to date in all that's new and great / This wonder that we sing about. "

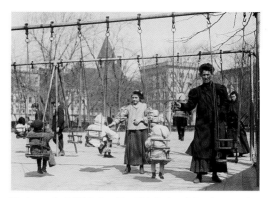

The Lower East Side's Hamilton Fish Park and its playground were completed at the same time in 1900. The playground was one of the first ever constructed by the city.

New York Society for Playgrounds and Parks formed in 1891; it considered its mission "a moral movement not a charity." The Outdoor Recreation League, led by Henry Street Settlement co-founder Lillian Wald and Parks Commissioner Charles Stover, joined the fight to make playgrounds more accessible by including them in the plans for city parks.

By 1905, under the social-reform mayor Seth Low, nine playgrounds had been constructed; they featured maypoles and sand boxes, marble pavilions, running tracks, petting zoos, and even rows of rocking chairs for weary mothers. One of the first to open was at Seward Park, a patch of green amid the grimy tenements surrounding Canal Street and East Broadway. On opening day in 1903, twenty thousand rain-soaked children mobbed the gates, disrupting a ceremony attended by Jacob Riis, who was instrumental in the city playgrounds movement.

"As anxious as I was to get the children into this park, I am more anxious at this moment to get them out," quipped Riis according to the *New York Herald.* "I came here to talk to the children, but I will wait until a fair day."

A CITY GONE SPORTS-CRAZY

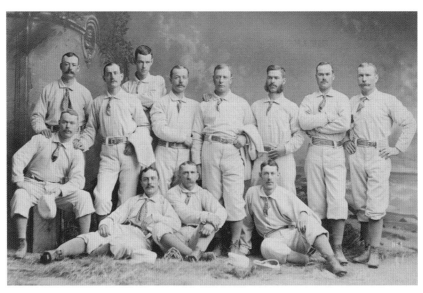

The Metropolitan Club played in New York from 1880 to 1887. This photo was taken the year before they joined the American Association. They were the first team to play at the original Polo Grounds. Their white uniforms featured formal neckties.

On weekday afternoons in the 1840s, young men often met after work to throw a ball around a field near the northwest corner of Madison Square. At this little-developed enclave on the outskirts of the city, where omnibus companies kept stables for their horses, the men formed teams, ran bases, and hit the ball with a bat. No one had any idea that the game, called "base ball," would take the city by storm by the end of the century.

By many accounts, modern baseball can be traced to Alexander Cartwright Jr., a twenty-five-year-old bank clerk and volunteer firefighter who was one of the men who played near Madison Square. He codified the loose rules the players used into fixed regulations and supposedly umpired the first game the newly coined New York

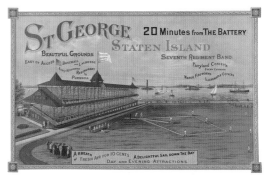

The St. George Stadium in Staten Island, located only 300 feet from a free ferry, was a popular venue with New Yorkers when it opened 1886. That April, the New York Metropolitans began their season against the Philadelphia Athletics, playing their first game in front of seven thousand people. The *Times* wrote, "The grand stand overlooks the bay, and a cool, refreshing breeze adds to the comfort of the onlookers. The playing grounds are neatly sodded, and altogether the Metropolitans can boast of one of the best parks in the country." Fans also enjoyed their view of the construction of the Statue of Liberty.

Knickerbockers played in Hoboken, New Jersey, in 1846. (They were trounced, 23-1, by another group that called themselves the New York Nine.)

The sport caught on quickly, and clubs formed all over Manhattan and Brooklyn. Its popularity spread to other northeast cities; Union soldiers taught it to one another during the Civil War. In 1880, one of the first professional teams, the New York Metropolitans, turned a polo field on Lenox Avenue and 110th Street into its home turf. By the 1890s, they had evolved into the New York Giants, who packed crowds at their new stadium, the Polo Grounds, on 155th Street and Eighth Avenue, at the bottom of Coogan's Bluff.

Men of all classes, and some women, visited the new stadium. After a meeting in 1894, William Steinway, a partner in his family's successful piano business in Queens, wrote in his diary about "[driving] to the Polo Grounds" and seeing "a most interesting baseball game between Cincinnati and New York. At least 15,000 spectators are there." Fans followed the scores in the new sports sections of newspapers. Celebrity players such as Giants Roger Connor and Christy Mathewson were cheered on when they won—and took heat when they lost. "The baseball season has ended, and New York

THE BATHTUB OF WASHINGTON HEIGHTS

The first polo grounds really were polo grounds—a field with no official name on Lenox Avenue between 110th and 112th streets. In 1880, the New York Metropolitans, a professional-level team, made it their home field. The team folded into another, the New York Gothams, who continued playing there. With baseball fever rampant in the city, games drew as many as twelve thousand fans, half of whom had to stand because there weren't enough seats.

In 1888, the owner of the team, now called the Giants, had had enough. The city had plans to build over the polo field anyway, so he commissioned a real stadium at Eighth Avenue and 155th Street for his increasingly popular team. Called the Polo Grounds, the wooden structure with grandstand seating and a carriage drive in the outfield was wedged between a steep cliff known as Coogan's Bluff and the Harlem River.

A mysterious fire destroyed it in 1911; another Polo Grounds rose at this same location in 1913. It was called "the bathtub" because of its long shape; locals often gathered at the top of Coogan's Bluff to watch games for free. It was a quirky jewel box of a stadium, but the Giants did well there, winning ten pennants by 1924.

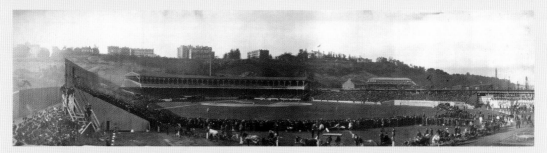

The World Series of 1905 at the Polo Grounds matched the New York Giants against the Philadelphia Athletics.
The Giants won four out of five games, thanks in part to the ace pitching of Christy Mathewson, a beloved city sports hero and one of the first five players to be inducted into the Baseball Hall of Fame.

has not won the pennant," wrote the *Sun* on October 4, 1891. "The team in the gentle springtime was expected to walk away with the bunting, while the other teams looked on in helpless astonishment. The result has not justified those rosy expectations."

Meanwhile, at Hilltop Park on Broadway and 168th Street, the New York Highlanders—the name contrasted with the team playing under the bluff just a few blocks away—were also cultivating a devoted fan base. Their stadium, with its covered grandstand and open-air bleacher seats, could fit sixteen thousand; in 1913, they were renamed the Yankees. And a team in Brooklyn called the Bridegrooms would by 1895 be nicknamed the Trolley Dodgers, a term used to refer to anyone from Brooklyn, because of the city's tangled web of streetcar lines.

From the very beginning, the Trolley Dodgers, who played in Eastern Park in the Brownsville section of the city, were embraced by the city. "The opening of the base ball season in Brooklyn at Eastern Park yesterday was a noteworthy event in many respects," wrote the *Brooklyn Daily Eagle* on May 2, 1895. "There were fully fifteen thousand people in attendance and it may be questioned whether better order or a more genial spirit could have been duplicated in any assemblage of equal magnitude. The character of the gathering was the best tribute to the popularity of base ball as a clean and wholesome amusement, and the fact that it is not an expensive one makes its claim more deserving."

Baseball was booming, but other sports continued to hold their own. Boxing had a long history among the city's lower classes, who came to see pugilists such as Bowery resident Owney Geoghegen, who toiled in the gasworks along the East River by day but by night was a lightweight champion in the 1860s.

Boxing was not legal in New York from 1859 to 1896, but there were ways to get around the law—for example, a bout could be held in a private athletic club. No wonder bars suddenly called themselves "sportsman clubs." These were rough-and-tumble dens in downtrodden areas, like one Geoghegan ran on the Bowery, or a notorious club on Water Street, where Irish gangster Kit Burns opened his "Sportsmen's Hall." Here, men came to watch bare-knuckle boxing as well as dog vs. rat fights in an enclosed pen (the latter until Henry Bergh's ASPCA cracked down in 1870.)

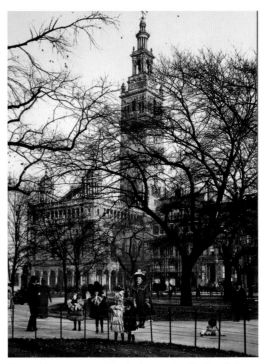

After a thirty-seven-year ban, boxing was legalized again in New York from 1896 to 1900. Fans flocked to matches held at Madison Square Garden, seen here in 1901. Boxing was outlawed again (except in sportsman's clubs) in August 1900 with the passage of the Lewis Law, The Garden's last legal fight until 1911 saw James J. Corbett knock out Kid McCoy in five rounds (out of a possible twenty five).

One of the most popular clubs was Harry Hill's on Mulberry Street. While it was more of a dance hall, it hosted boxing bouts in small rooms. "At one end is the bar, from which liquors and refreshments are served, and at the other, is a stage, upon which low variety performances and sparring matches are given," wrote James McCabe in 1882's *New York By Gaslight*. "The room is ablaze with light and heavy tobacco smoke. Tables and chairs are scattered through it . . . From eight o'clock until long after midnight the place is filled with a motley crowd." More well-heeled patrons came to Madison Square Garden, on Madison Avenue and 26th Street. To evade the boxing ban, Madison Square Garden billed bouts as "exhibitions" or "illustrated lectures."

The upper classes also rallied around racetracks. Jerome Park, built by financiers and racing enthusiasts Leonard Jerome and Augustus Belmont, opened in 1866 in the Bronx and marked the return of thoroughbred racing to New York. A favorite of the newly rich and titans of industry, it wasn't the only track in the city: There were horse tracks in Sheepshead Bay (funded by Jerome), Brighton Beach, and in Queens. And the Harlem River Speedway, opened in

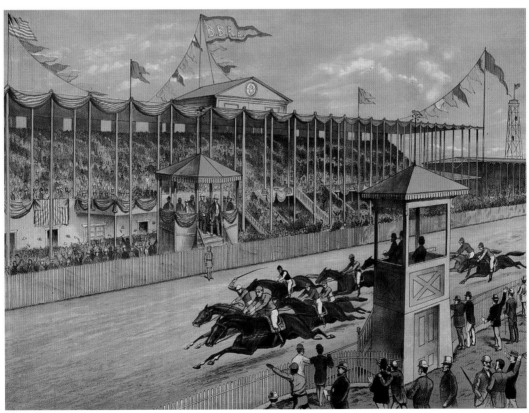

The Brighton Beach Race Course opened in 1879 next to the Brighton Beach Hotel, on the more refined eastern end of Coney Island, an upper-middle-class enclave of accommodations and attractions more genteel than those of its noisy, colorful neighbor to the west.

1898 beside the High Bridge, hosted carriage races. Racing was a wealthy man's pastime, but anyone could go to the track and gamble, which many New Yorkers, particularly young men with little money, apparently did in droves.

"Each racing-day the attendance is from ten to thirty or forty thousand," stated a 1905 article from *The Cosmopolitan*. "There is in the crowd a sprinkling of really respectable people, lovers of outdoor sport; there is a sprinkling of more or less reputable people directly and indirectly connecting with racing . . . And then, there is the crowd—thousands of young and youngish men, neglecting their work, wasting their small earnings, preparing themselves for that desperate state of mind in which accounts are falsified, tills tapped, pockets picked and the black-jack of the highwayman wielded."

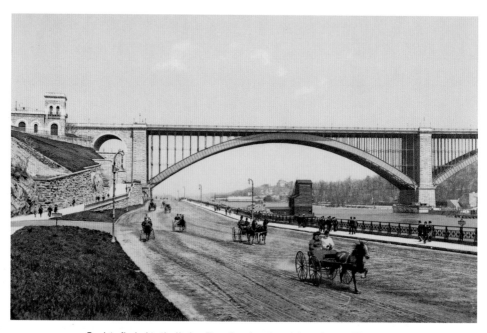

Tourists flocked to the Harlem River Speedway to watch carriage and boat races, and visit the nearby Highbridge and Fort George Amusement Parks.

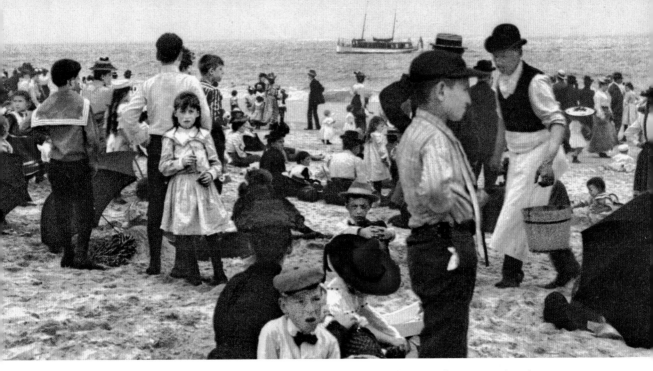

Decades before the arrival of the boardwalk and amusement parks, Coney Island was a small summer resort popular with beachgoers from Brooklyn and Manhattan. As editor of the *Brooklyn Daily Eagle* in 1848, Walt Whitman used to visit the "long bare unfrequented shore . . . Where I loved after bathing to race up and down the hard sand, and declaim Homer or Shakespeare to the surf and seagulls by the hour."

SODOM BY THE SEA

Until the 1870s, Coney Island, a ribbon of land jutting off the southern end of Brooklyn into the Atlantic Ocean, was a summer resort area with a tawdry edge. Named for the rabbits that used to live there (*konij* is Dutch for rabbit), it was dotted with a few hotels and restaurants. An enclave called Norton's Point at the western end consisted of small number of bars, gambling houses, and brothels. Steamboat service linked it to Manhattan.

Everything changed when the trains arrived. Railroad magnates saw dollar signs and began developing the beachfront, advertising to city dwellers that they could leave Manhattan and be on the boardwalk in an hour. On the eastern end, Brighton Beach and Manhattan Beach were marketed to the upper middle class: the Brighton Beach Hotel, Oriental Hotel, and Manhattan Beach Hotel, all open by 1880, were immense wooden, Victorian-style structures that featured bathing pavilions, verandas, several restaurants, fireworks, and entertainers such as John Philip Sousa. The Brighton Beach Racetrack was a new and huge draw.

While the eastern end nurtured refinement, the developers of the western end went after larger crowds and cheaper thrills. Railroad head Andrew Culver was among the money men who built hotels, bathing pavilions, and restaurants that could accommodate thousands, such as the West Brighton Hotel, the Sea Beach Palace, and Charles Feltman's Ocean Pavilion, which had room for twenty thousand guests and a ballroom that held

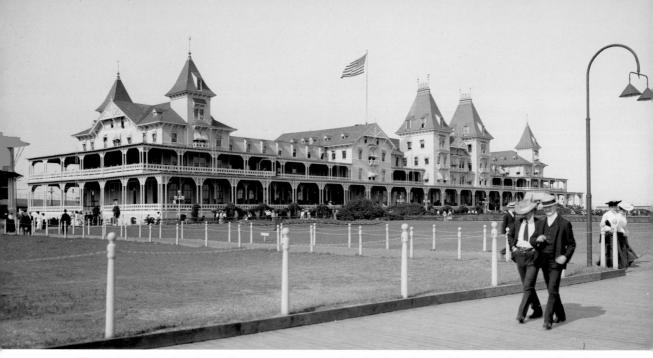

When the Brighton Beach Hotel opened in 1878, its accessibility to the railroad made it immediately popular. This ornate, three-story resort housed five thousand, and it could feed twenty thousand guests a day. Ten years later, beach erosion threatened the hotel's beachfront location, so it was moved 520 feet farther inland on flat train cars pulled by six steam engines.

eight thousand. The Elephant Hotel, built in 1882 in the shape of a massive pachyderm, ushered in a sense of frivolity and carnival. Sideshows, boardwalk games, freakish curiosities, lions, tigers, and elephants were all brought in to keep the throngs amused.

"Sodom by the Sea," as Coney Island was nicknamed, was off to a very popular start. It coincided with the growth of a working and middle class that craved release from the restraints of the industrial era's nine-to-five economy. With hotels open from May to September, millions flocked to enjoy lowbrow culture. A traveler writing in the London *Times* in 1887 reported: "They spread over the four miles of sand strip with . . . bands of music . . . in full blast; countless vehicles moving; all the miniature theatres, minstrel shows, merrygo-rounds, Punch and Judy enterprises, fat women, big snakes, giant, dwarf, and midget

exhibitions, circuses and menageries, swings, flying horses, and fortune telling shops open; and everywhere a dense but good-humoured crowd, sightseeing, drinking beer, and swallowing 'clam chowder.'"

Coney Island wasn't the only amusement destination for New Yorkers. North Beach, on a bay in Astoria, Queens, was financed by William Steinway in 1886. A steamboat ride across the East River gave Manhattanites access to its rides, restaurants, and entertainment. Queens also had the Rockaways, a resort and amusement park on a peninsula south of Coney Island. And Fort George Amusement Park, overlooking the Harlem Speedway, was dubbed "Harlem's Coney Island" when it opened in 1895, boasting three roller coasters, two Ferris wheels, hotels, restaurants, shooting galleries, and music halls.

But these resorts couldn't top the spectacular amusement parks that began open-

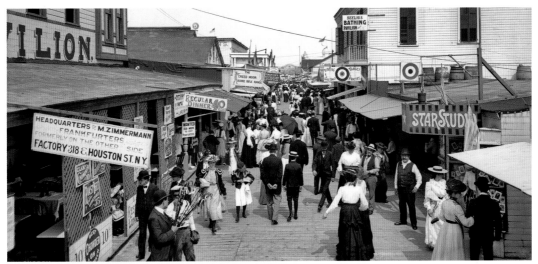

The Bowery of Rockaway Beach in Queens in 1905. The *New York Times* wrote on July 16, 1904: "A pretty sight at night on the boardwalk is the crowd in dainty summer attire under the glow of thousands of electric lights, or in the numerous dancing pavilions, tripping to the tunes of band or orchestra."

ing at Coney Island in the late 1890s. Sea Lion Park featured the Flip Flap Railroad, an upside-down roller coaster, and the Shoot-the-Chutes water flume. Forty trained sea lions and a cage of wild wolves thrilled the crowds. Steeplechase Park had scale models of world landmarks such the Eiffel Tower, and the Trip to the Moon attraction, which imagined a rocket ride. Dreamland appeared in 1904 and spared no expense: One million electric lights attracted visitors to its miniature railroad, fake Venetian canals, and equally fake Swiss alpine peaks. Three hundred dwarfs lived in its Lilliputian Village; a one-armed lion tamer commanded the big cat enclosure; and premature

babies were displayed in incubators.

No place made an impression like Luna Park, which took over Sea Lion Park in 1903. New York had never seen anything like it: a city within a park lit up by even more electricity than Dreamland, with spires, domes, minarets, and other fairy-tale-like architecture. Elephants and camels strolled the grounds amid hundreds of attractions, wild animal shows, and the Trip to the Moon ride, which had relocated from Steeplechase.

Coney Island was a popular topic for thinkers and writers at the time, who attempted to explain what its popularity said about American culture. "Coney Island

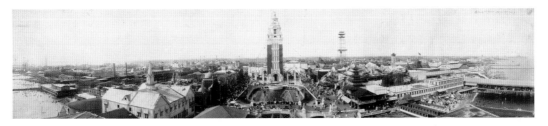

Luna Park, decorated with hundreds of thousands of colored lights, opened on the night of May 16, 1903—the last of the big Coney Island amusement parks to make its debut. With more than sixty thousand people surging through the gates on opening night, the park ran out of change and let people in for free. Single rides cost a nickel; $1.95 scored admission to every attraction. That July, Luna Park saw more than 140,000 visitors in a single day.

exists, and will go on existing, because into all men, gentle and simple, poor and rich—including women—by some mysterious corybantic instinct in their blood, has been born a tragic need of coarse excitement, a craving to be taken in by some illusion, however palpable," wrote British journalist Richard Le Gallienne in 1905. "So, following the example of those old nations, whose place she has so vigorously taken, America has builded for herself a Palace of Illusion . . . and she has called it Coney Island. Ironic name—a place lonely with rabbits, a spit of sandy beach so near to the simple life of the sea, and watched over by summer night; strange Isle of Monsters, Preposterous Palace of Illusion, gigantic Parody of Pleasure—Coney Island."

"STEEPLECHASE—THE FUNNY PLACE"

It wasn't the first enclosed amusement park at Coney Island. That honor goes to Sea Lion Park, which opened in 1895. But Steeplechase Park came next, in 1897, on fifteen acres overlooking the beach. Coney Island native George C. Tilyou filled his new park with fantastical, spectacular rides: the Barrel of Love, the Trip to the Moon, a human roulette wheel, a human pool table, and even a human zoo, where visitors were placed in cages.

The park's namesake ride was an ode to Coney Island's horseracing tradition. The Steeplechase Race featured six double-saddled mechanical horses that took riders more than one thousand feet along a downhill track, simulating a real race and powered by gravity, with attendants standing by who dressed in jockey uniforms standing by. "Steeplechase—the Funny Place," the park's full name, attracted as many as ninety thousand thrilled customers on hot summer days.

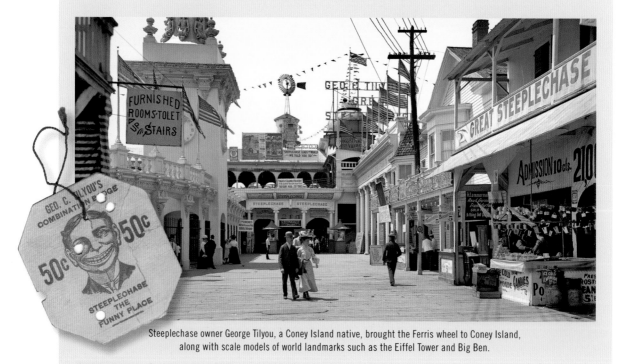

Steeplechase owner George Tilyou, a Coney Island native, brought the Ferris wheel to Coney Island, along with scale models of world landmarks such as the Eiffel Tower and Big Ben.

THE DIN AND DAZZLE
OF BROADWAY

Like everything else in New York in the nineteenth century, the theater district crept northward as the city grew. Manhattan's stages once had been centered at Broadway at Park Row; by the 1870s, dozens of venues—from the high-culture Academy of Music to the variety shows at Tony Pastor's—cropped up around Union Square. In the 1880s, many relocated again, this time to the new

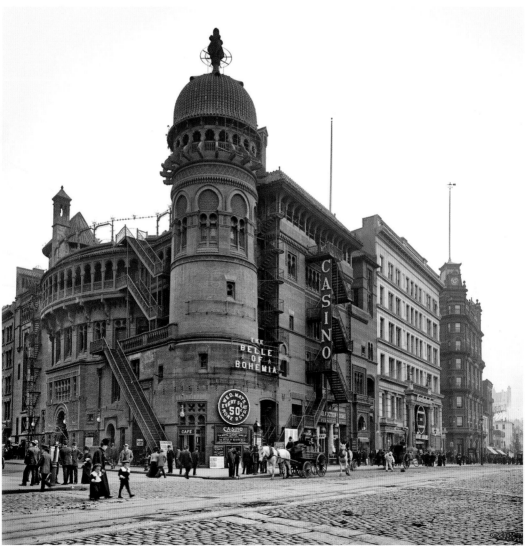

The Casino Theatre, on Broadway and 39th Street, opened in 1882. The first theater in New York to be lit entirely by electricity, it was also the first to boast a roof-top garden.

EDWIN BOOTH TAKES THE STAGE

His first role, in 1849, was in a production of Shakespeare's *Richard III*. Edwin Booth, the Maryland-born son of an English actor who named his first-born after the actor Edwin Forrest, traveled the country and the world, earning raves for his performances. He worked in New York City on and off between 1855 and 1860, returning to Gotham in 1962 for a production of *Hamlet* at the Winter Garden Theater on Broadway and West 3rd Street.

When Edwin Booth learned in April 1865 that his brother had assassinated President Lincoln, he experienced deep shame and grief. Edwin Booth, John Wilkes Booth, and their actor brother Junius B. Booth Jr. had just put on a sold-out benefit performance of *Julius Caesar* at the Winter Garden Theater in November 1864. "While mourning in common with all other loyal hearts, the death of the President, I am oppressed by a private woe not to be expressed in words," wrote Booth. John Wilkes Booth's actions led Edwin to retire from the stage, but he returned to the Winter Garden a year later, mostly out of financial pressure.

In 1869, he opened Booth's Theater, on Sixth Avenue and 23rd Street. It was "one of the leading playhouses of the city for 14 years," wrote Moses King. Booth did a run of *Julius Caesar*, but he also invited other actors to perform, including Sarah Bernhardt, who made her American debut here.

His last performance, in *Hamlet*, was at Brooklyn's Academy of Music in 1891. Two years later, he died at the Players' Club on Gramercy Park South, a social club he helped found. Booth's funeral was held at the Little Church Around the Corner, on East 26th Street, just a few blocks from the statue erected in his honor in 1918. The statue, in the center of private Gramercy Park, depicts Booth as Hamlet.

Edwin Booth played Hamlet in more than one hundred performances at the Winter Garden Theatre in 1865 before temporarily retiring from the stage after his brother assassinated Abraham Lincoln. When he returned, in 1886, he received sympathetic applause and cheers lasting several minutes.

theater district nicknamed "the Rialto," on Broadway between 23th and 42nd streets. The 42nd Street area of Longacre Square (it wouldn't be Times Square until 1904) was still a dusty outpost, home to the carriage trade. Not everyone thought audiences would venture that far uptown for a play.

The doubters were wrong. By the end of the decade, elegant theaters and concert halls that lined both sides of the Rialto would be known around the country. Businesses that thrived off the glitz and glamour of the theater world, such as hotels and restaurants, helped create the city's newest en-

Wallack's Theatre, on 13th Street and Broadway, was one of the most famous playhouses in the country. Co-owner John Lester Wallack was the proprietor, manager, and leading actor. As many theaters relocated to the new Rialto district uptown, Wallacks moved too, to 30th Street and Broadway, in 1882.

tertainment area. "All America looks to New York for its dramatic entertainment," wrote Moses King in 1892's *King's Handbook of New York City*. "The people of the city and its visitors pay upward of $5 million a year for theatrical amusement In the business aspect of the drama New York is the first city in America. The purely artistic aspect is inseparable from the business phase."

About fifty theaters kept New Yorkers and tourists entertained. There was the Metropolitan Opera House, the new-rich haunt funded in part by the Vanderbilt family, and the Lyceum, another playhouse popular with the wealthy and whose electric lights were personally installed by Thomas Edison. Daly's and Wallack's, two venues that presented serious drama at Union Square, were now on opposite sides of 30th Street; rich patrons even could order tickets to Daly's over the telephone. The Standard engaged audiences with Gilbert and Sullivan operettas, and the

Moorish-style Casino, with its incredible roof garden—soon to be imitated by other theaters and hotels—featured light opera.

Broadway wouldn't become "the Great White Way" for several years. But the electric lights that blazed on marquees and twinkled in theater interiors made it New York's most fashionable entertainment enclave. Middle- and upper-class residents—women in smart, fancy dresses and men in the new tailless tuxedos—packed the sidewalks day and evening. Sleek carriages formed a nightly procession, dropping off and picking up theatergoers. The Gilded Age city was so enthralled by Broadway that a handful of theaters even remained open during and after the crippling Blizzard of 1888.

Part of the thrill of a night at the theater involved dining in an elegant or trendy restaurant. Delmonico's and Sherry's, which moved into a Stanford White–designed space at Fifth Avenue and 44th Street in 1898, were the most luxurious for either a pre-theater dinner or late supper. Close on their heels were the new "lobster palaces," such as Rector's on Broadway and 44th Street, and Café Martin, which settled into the space on 26th Street vacated by Delmonico's, after its move to Fifth Avenue. Dinner at one of these fancy eateries could cost up to $3 per person, noted Moses King.

Most of the theaters catered to the bourgeois tastes of the middle and upper classes. A few were more tawdry or had a sexual, suggestive edge. The Casino switched to vaudeville in the mid-1890s, and other theaters and music halls—such as Koster and Bial's Music Hall on Sixth Avenue and 24th Street, close to the vice-ridden Tenderloin district—featured more risqué shows. For

THE RICH AND POOR DINE OUT

At C .K. G. Billing's horseback dinner in 1903 at the luxurious restaurant Sherry's, diners reportedly ate from trays attached to their saddles. The entire dinner cost $50,000.

After Louis Sherry opened his first restaurant on 38th Street and Sixth Avenue, his novel eatery, inspired by the latest food fads from Paris, quickly became a favorite of the city's old New York social elite. Mrs. Astor and the other members of the so-called "400" flocked to his establishment for lunches and dinners, giving Sherry's a reputation as a haunt of the rich and powerful.

His second location, a Stanford White-designed structure at Fifth Avenue and 44th Street, "was the scene of many of the most elaborate dinners, dances, debutante presentations, and other functions," wrote the *New York Times* in 1926. "In the large ballroom were given some of the most important public dinners of that period." One such event was the infamous dinner on horseback hosted by uptown millionaire C. K .G. Billings in 1903. The guest list consisted of thirty six of Billings's closest male (and rich) friends. Sherry's dining room was made to look like a forest, and each man's horse was brought up to the dining area in an elevator. Champagne was served from rubber tubes, and Billings and his guests dined in various courses as the press snapped photos.

If Sherry's was an example of Gilded Age excess, then Childs was proof that New York had a growing working and middle class who wanted to eat in restaurants just like their wealthier counterparts. The first

Childs got its start on Cortlandt Street in 1889. Operated by brothers Samuel and William Childs, the spare, functional establishment sold fast, inexpensive meals served by waitresses (not waiters, as was the norm in most restaurants) in crisp white uniforms, to emphasize cleanliness. Childs made a profit, and the brothers opened more locations. They introduced a cafeteria-style setup in 1898. The most expensive menu item in 1900 was a "Mexican Omelet"—just thirty cents.

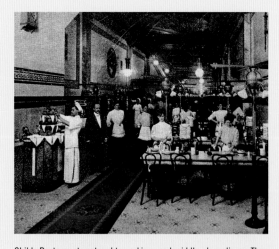

Childs Restaurants catered to working- and middle-class diners. The fast-growing national chain had several New York City locations that emphasized cleanliness and low cost, earning a loyal following.

real low-brow entertainment, New Yorkers headed to venues along the Bowery. "The third-class theaters are situated principally on the Bowery," wrote James D. McCabe in 1882. "The price of admission is low, and the performance suited to the tastes of the audience."

The popularity of theater in the Gilded Age made it the era of the "professional beauties." From chorus girls to starring actresses, the women of Broadway became famous and envied, thanks to the new profession of press agents, and devoted audiences who couldn't read enough about these new celebrities. Lillie Langtry, Lillian Russell, and Mary Anderson were among the most venerated. Their lives were followed by the voracious New York newspapers, their hairstyles and clothes imitated by adoring women, their images used to hawk soap and other products, and their love lives chronicled—especially that of Lillian Russell. Dubbed "the most beautiful creature since Helen of Troy" and known for her saucy personality, Russell's companion for decades was financier James Buchanan "Diamond Jim" Brady. Together, these two larger-than-life characters formed *the* celebrity couple of the Gilded Age.

Born Helen Louise Leonard, Lillian Russell made her New York City debut in 1880 at Tony Pastor's Union Square variety theater. She was extremely popular in musical theater and was one of the top singers of operettas in the country.

THE CITY'S FAVORITE HOLIDAYS

"All the holidays are observed in New York with more or less heartiness," wrote James McCabe in 1872, "but those which claim especial attention are New Year's Day and Christmas." In colonial days, New Year's commanded the bigger celebration. But as the nineteenth century progressed and old Dutch traditions faded, December 25 supplanted January 1 as the most festive day.

McCabe revisited Christmas in New York a decade later. "Warm hearts beat under the warm clothing of the holiday makers," he wrote. "Broadway, from Bleecker Street to 34th, Sixth, Eighth, and Third Avenues almost along their entire length, 23rd, 14th, and Grand Streets, and the Bowery are all driving a thriving trade Huge piles of Christmas trees stand on the corners, and find ready purchasers, and wagons loaded with trees and evergreen decorations, wreaths, stars, festoons, and the like, pass along the uptown streets, disposing of their wares from house to house.

"At night Broadway, 14th Street and Fifth Avenue are ablaze with electric light. The stores are all open and thronged with buyers Men, women, and children, loaded with merchandise, struggle along the packed sidewalks . . . Here is a woman with a bundle of toys in her arms, surmounted by a huge turkey for the Christmas dinner. There goes a man struggling under the weight of a Christmas tree, and sweeping his way through the mass with its thick, sharp branches. [The poor] will not be forgotten on this morrow. New York opens its great heart and its big pocketbook at this blessed

In the 1870s, R. H. Macy was the first dry-goods-emporium owner to create eye-catching Christmas displays in his store windows. Established in 1858 on Sixth Avenue and 14th Street, and later on 18th Street, his store pioneered innovations such as the money-back guarantee and made-to-order clothes sewed in an on-site factory.

time, and to-morrow huge tables will groan with good things, and tall Christmas trees stagger under the weight of toys and trinkets, for the children of the poor."

After trimming the tree on Christmas Eve, New Yorkers attended midnight or an early-morning church service. "Had a most satisfactory and delightful morning," wrote Maria Lydig Daly, the wife of a prominent judge, in her diary on Christmas Day 1865. "Went to 8 o'clock mass, saw the sun just rising above the buildings and park as I crossed Waverly Place, the sky as bright and clear as spring. I thought of the words of the old carol, 'Royal day that chasteth gloom.' And I went to St. Joseph's where the congregation was mostly poor people; I like to go to church with the poor, particularly on Christmas."

The remainder of Christmas Day would be spent unwrapping presents and perhaps taking in a matinee show at a theater. A great turkey dinner was standard, whether one lived in a Fifth Avenue mansion, a poor tenement house, or one of the institutions that housed thousands of the poor, sick, and friendless. Even prisoners were not forgotten. In an 1887 write-up of how various quarters of the city heralded the holiday, the *New York Times* wrote that "at Ludlow-Street jail, where New-York tries to house all her criminal aristocracy, some forty-five gentlemen enjoyed turkey, stewed chicken, cranberry, and mince pies."

Christmas may have overshadowed New Year's Day by the late nineteenth century, but January 1 was still a day for the upper classes to enjoy New Year's "calling." All businesses were closed, carriages thronged the streets, and men paid social calls to the homes of family, friends, and female acquaintances, where they were "received"

and treated to delicacies, wine, and punch. From 10:00 A.M. until 9:00 in the evening, doorbells rang, liquor was sipped, and New Year's greetings were exchanged. Ladies vied to secure the most callers, and young men pooled their lists together to visit as many woman's homes as possible.

"The Christmas festivities are scarcely over, when New York again puts on its holiday attire, and prepares to celebrate in hearty style its own peculiar day—the first day of the New Year," wrote McCabe in 1882. "Since the settlement of the colony of the Dutch, the first of January has been set apart by the dwellers in the metropolis for social observance, for renewing former friendships, strengthening old ones, and wishing each other health and happiness for year just opening." Already dwindling during the Gilded Age, by the turn of the century, the tradition of New Year's "calling" was on its last legs.

There were other days to mark with patriotism and parades: Independence Day, Decoration Day (later Memorial Day), and Evacuation Day—commemorated every November 25, the day the British left New York after the Revolutionary War ended in 1783. Thanksgiving, an official holiday only since 1863, had been celebrated at New York dinner tables for years with turkey (or pigeon, duck, or partridge) as the main course; dessert meant pumpkin or squash pie. Restaurants, such as the one at the Plaza Hotel, served lavish Thanksgiving dinners with many courses as well.

Easter also was celebrated with a festive, joyful parade. After attending Easter Sunday services at one of the fashionable Fifth Avenue churches, residents would promenade up the avenue from Washington

Square to Central Park, a loose procession that was part fashion show and part celebration of the holiday and the end of winter that anyone could join.

In the 1880s, a curious new holiday caught the attention of some New Yorkers, who began making yearly pilgrimages to Mott and Doyers streets to take in the colorful paper lanterns, flags, and lights of Chinese New Year. "Chinese flags and banners, intermingled with the Stars and Stripes, were seen waving from windows and stretched across the streets, which were densely packed with white people, who crowded the sidewalks and roadways, jostling against one another, but all good-humored," wrote the *New York Times* in 1896.

The Easter Sunday parade in front of St. Patrick's Cathedral, which the *New York Times* wrote in 1900 "is situated in the very heart of the fashionable district, was the Mecca for a tremendous throng of worshippers and sightseers Stylish gowns and masterpieces of millinery pass in bewildering review"

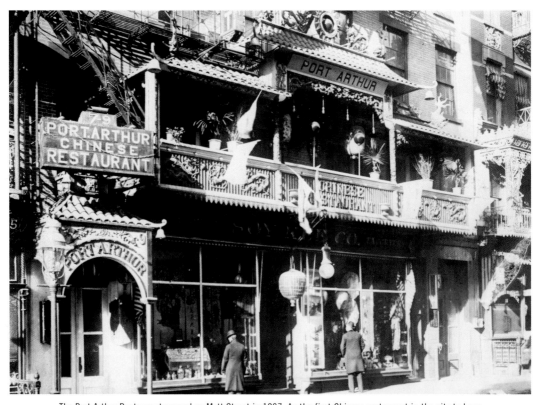

The Port Arthur Restaurant opened on Mott Street in 1897. As the first Chinese restaurant in the city to have a liquor license, it was a favorite spot for tourists looking to celebrate Chinese New Year.

NEW YORK INVENTS THE CHRISTMAS TREE

A 1903 Christmas tree market existed at the foot of Barclay Street on West Street beside the Hudson River. Prices ranged from five cents to $30.

Considering that New York's patron saint is St. Nicholas, it's no surprise that the city is the birthplace of a host of contemporary Christmas traditions. Clement Clarke Moore's 1823 poem "A Visit from St. Nicholas" introduced the nation to a bearded man in a suit delivering a sackful of presents; *Harper's Weekly* cartoonist Thomas Nash in the 1860s put Santa Claus in a red suit and gave him big belly, as well as a twinkling smile. The city can also lay claim to the first Christmas tree market, at the Washington Market on the western end of Chambers Street. Here, an upstate farmer brought down a stack of fir and spruce trees to sell to city dwellers who, since the 1830s, had embraced the German tradition of a Christmas tree festooned with candles. He sold them for a dollar each—and quickly ran out of inventory.

His idea launched a tradition. "Every year now, at Christmas time, for two or three weeks, Vesey Place, from Greenwich to Washington Street, is occupied, by special permission, by the roughly constructed booths of the evergreen dealers," wrote the *New York Times* on December 23, 1876. "On their hastily built stands they display in the most attractive manner bundles of wreathing, made of feathery princess pine, boughs of crisp or glittering holly or laurel, and bunches of bright red berries that may be mingled effectively with the green in the work of decoration."

Another New York invention was electric tree lights. Candles affixed to tree branches were responsible for many fires, so Edward H. Johnson, a partner in Thomas

Edison's Illumination Company, put strands of red, white, and blue electric lights together and wrapped them around the tree in his family's home in 1882. Electric lights were safer and offered an enchanting glow. But they didn't catch on until 1895, when President Grover Cleveland decorated the White House Christmas tree with hundreds of multicolored electric bulbs.

Madison Square Park was home to America's first outdoor community Christmas tree. The tree's three thousand lights were turned on in front of a crowd of twenty thousand on Christmas Eve in 1912.

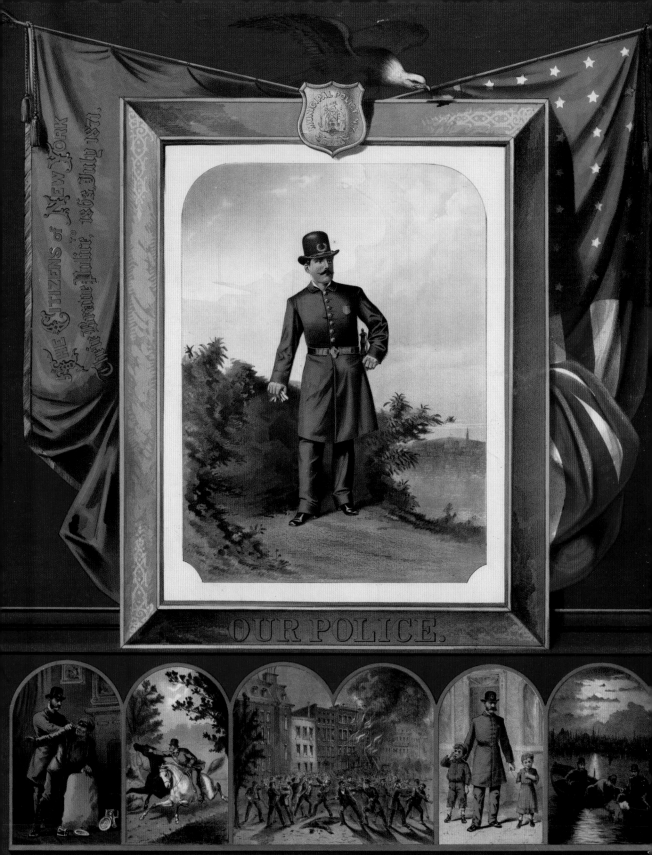

CRIME AND VICE

The badge of George Washington Matsell, the first Chief of Municipal Police in New York City.
Matsell led the Municipal force in the fight against the Metropolitan Police at City Hall in 1857.
After that incident, known as the Police Riot, he retired and edited the *National Police Gazette*.
He returned to service in 1873 as the Superintendent of the Board of Police. The eight-pointed star
badge—representing the eight original paid watchmen who policed the city during colonial times—
was worn by all Municipal Police officers.

POLICING THE 19TH-CENTURY CITY

"**A**t half-past ten last evening, [Franklin Huges] Delano, wending his way home from a dinner at John Astor's, was set upon and robbed by three men on the corner of Fifth Avenue and Eleventh Street," the lawyer George Temple-ton Strong wrote in his diary on January 25, 1870. "Of course there was no arrest. Crime was never so bold, so frequent, and so safe as it is this winter. We breathe an atmosphere of highway robbery, burglary, and murder. Few criminals are caught, and fewer punished."

An 1873 tribute to New York City police. "The uniform of the force is a frock coat and pants of dark blue navy cloth, and a glazed cap," wrote James D. McCable in 1872's *Lights and Shadows of New York Life*. "In the summer the dress is a sack and pants of dark blue navy flannel. The officers are distinguished by appropriate badges. Each member of the force is provided with a shield of a peculiar pattern, on which is his number."

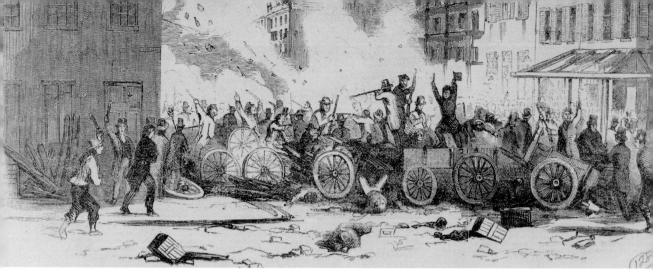

An 1857 illustration from *Frank Leslie's Illustrated Newspaper* of a Dead Rabbit barricade on Bayard Street during a deadly two-day gang fight with bitter rivals the Bowery Boys.

Strong's disgust with rising crime and inattentive police would have resonated with Gilded Age New Yorkers, who inhabited a city in which the police department reflected deep-seated governmental corruption.

The first recruits hit the streets in 1845. Called the Municipal Police, these eight hundred men replaced a loose band of night watchmen, constables, and marshals no longer able to protect a metropolis whose crime rate was burgeoning along with its prosperity and population (515,547 in 1850). Modeled after the military-style London police, the Municipals were identified by their eight-point-star copper badges, which earned them the nickname "coppers." Under the Democratic-led city of the 1850s, the department also earned a reputation for misconduct and inefficiency.

In 1857, the Republican-controlled state government, eager to grab power from the city Democrats, abolished the Municipal Police and replaced them with the new state-run Metropolitan Police. Mayor Fernando Wood refused to disband the Municipals, and for a few months, the city had two warring departments. This was great news for criminals, who would be arrested by one force and then released by the other. Station houses became battlegrounds. Ethnic factions defined the two patrols: immigrants, in particular the Irish, dominated the Municipals, while the Metropolitans were mostly American born.

The contention between the opposing police forces culminated in the bloody Police Riot of June 1857. While Mayor Wood barricaded himself inside City Hall, the two groups clubbed and pummeled each other on the building's front steps. With the police in disarray, crime raged; a deadly two-day fight between bitter rival gangs, the Dead Rabbits and the Bowery Boys, rocked Baxter Street on July 4 and 5. Order was restored by the National Guard, and after the State Court of Appeals upheld New York state's right to create the Metropolitan police force, Mayor Wood reluctantly disbanded the Municipal Police. Thirteen years later, Boss Tweed and his Democratic cronies took back the police from state control and established the Police Department of the City of New York.

By 1870, the city was in charge of its police again, abeit with Tweed and his cohorts

A police officer in 1891 on Maiden Lane. Home to the city's jewelry and precious-stone district from the 1840s through the 1920s, the street was often targeted by thieves.

holding the reins, the department was riddled with patronage. Positions on the force were doled out to or bought by political allies and loyalists. Patrolmen supervised ballot boxes on Election Day. Officers accepted free beer sent to station houses by local saloons. Bribery swelled: to look the other way as a ballot box was stuffed, to leave a brothel alone, or to undo an arrest was commonplace. Armed with wood nightsticks, police were often accused of brutality.

When the police did make an arrest, it was usually for drunkenness, disorderly conduct, assault and battery, or street crimes such as pickpocketing. But increasingly, newspaper accounts of bank heists and violent assaults panicked New Yorkers. The elite hired private watchmen. "Maiden Lane, the headquarters of the jewelry trade, is guarded at night by a regularly organized company of watchmen, supported by the Jeweler's Association," wrote Moses King in his 1892 *King's Handbook of New York*. "In Upper Fifth Avenue and vicinity there are some two-score watchmen thus employed by Gould, Sage, the Vanderbilts, the Rockefellers, the Astors, and others of their class. These watchmen

are strong and brave men, several of them ex-policemen. They are well armed; and by night they practically constitute a subsidiary police force for that part of the town."

The job of a policeman was trying. In 1872, a patrolman earned a meager starting salary of less than $1,200 per year for days-long shifts; some were assigned to specialized units that guarded the harbor, Grand Central Depot, or Broadway. The typical officer was responsible for keeping the peace, looking out for criminals, quelling riots, assisting pedestrians across streets, guiding lost children, and dodging injurious traps laid out by street gangs. "They have abundant opportunities to do good, and when temptation the other way is not too strong, or nature too weak, they obey their better selves," wrote Junius Henri Browne in 1868's *The Great Metropolis*. "Not infrequently they prove themselves heroes in guarding honesty and innocence, and have yielded their lives to protect the defenseless and succor the distressed."

Bad cops regularly made headlines. Matthew T. Brennan, dubbed "the felon's

In the 1880s, policemen picked up nearly three thousand lost children a year. They were taken to the nearest station house, and if unclaimed by 7:00 P.M., brought to lost children's room at police headquarters. There they were kept awake until midnight, waiting to be claimed. If they were not, a matron put them to bed. "The next morning, if they are still unclaimed, they are sent to court to be committed by a police magistrate to a charitable institution," stated a June 29, 1891 *New York Times* article. "These are rare cases, however."

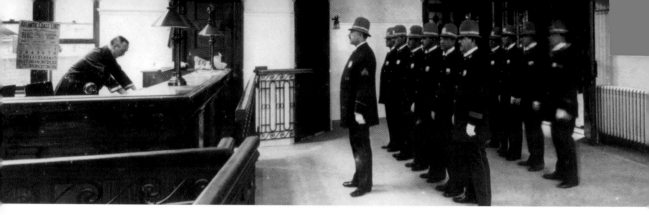

The squad receiving orders at the new police station in the Tenderloin district in 1908. The Tenderloin stretched west of Broadway to Eighth Avenue between 23rd and 42nd streets; its vice-ridden streets were packed with saloons, brothels, gambling dens, and music halls.

friend" by the *New York Times* in December 1873, was one of several police commissioners arrested for aiding loyalists who plundered the city treasury. Alexander "Clubber" Williams was a precinct captain in the 1870s in the Gas House district whose aggressive tactics earned him a fierce reputation and then a transfer to the seedy district west of Union and Madison Squares. "I have had chuck for a long time, and now I'm going to eat tenderloin," he said when asked about his new position. The name "tenderloin" stuck for this neighborhood of vice, where Williams collected huge sums in protection money from brothel keepers and gamblers.

Changes finally came to the police department after the Lexow Commission addressed charges of corruption in 1894. The next year, Theodore Roosevelt, a progressive Republican, became a police commissioner. Roosevelt brought a reformer's zeal to his new position and vowed to professionalize the force. He banned political appointments, enforced disciplinary rules, rewarded good conduct and bravery, and adopted a civil-service model for hiring and promoting officers. He brought standards and ethics to the department. Though he couldn't completely rid the department of its infrastructure of corruption, he is credited with setting a more honest tone for the 20th century.

In his 1913 autobiography, Roosevelt described his fight to clean up the force. "Every discredited politician, every sensational newspaper, and every timid fool who could be scared by clamor was against us. All three classes strove by every means in their power to show that in making the force honest we had impaired its efficiency; and by their utterances they tended to bring about the very condition of things against which they professed to protest. But we went steadily along the path we had marked out. The fight was hard, and there was plenty of worry and anxiety, but we won."

Theodore Roosevelt was sworn in on May 6, 1895, as one of New York's four police commissioners. He said in a speech a few months later, "I wish to make every honest and decent member of the force feel that he has in me a firm friend and that I shall wage a merciless war on corruption."

CHARLES PARKHURST
AND THE LEXOW COMMISSION

On February 14, 1892, Charles Parkhurst had had enough. From his pulpit at the elite Madison Square Presbyterian Church on East 24th Street, Rev. Parkhurst alleged in a fiery sermon that Tammany Hall and the police department had conspired together to protect purveyors of crime and vice in the city: the brothels, the gambling halls, the taverns, the opium dens. He charged that they refused to enforce the excise laws or keep the city morally clean.

"In its municipal life our city is thoroughly rotten . . . every step that we take looking to the moral betterment of this city has to be taken directly in the teeth of the damnable pack of administrative bloodhounds that are fattening themselves up on the ethical flesh and blood of our citizenship," thundered Parkhurst, who was also president of the Society for the Prevention of Crime. "While we fight inequity they shield and patronize it."

His sermon made headlines. Challenged by a grand jury to deliver proof that city government and the police were in cahoots, he took his own tour of the city's red-light districts looking for evidence. What he found in the Tenderloin, on Greene Street, and on

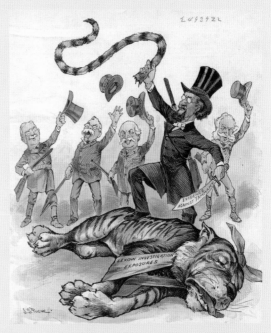

The cover of this 1894 issue of *Puck* magazine shows a triumphant Charles Parkhurst, who has slain the ferocious Tammany tiger with the help of the Lexow Committee, which found extensive corruption among Tammany officials and the police.

Charles Parkhurst, minister at the Madison Square Presbyterian Church, worked to expose corruption in New York' City's police department and the force's collusion with the city's Democratic political establishment. In a famous sermon in 1892, he said, "Any one who, with all the easily ascertainable facts in view, denies that drunkenness, gambling, and licentiousness in this town are municipally protected, is either a knave or an idiot."

Bleecker Street shocked and repulsed him. He had enough documentation of open, unpoliced sex and sin that his campaign led state senators to investigate. In 1894, the Lexow Committee, its name taken from the state senator who chaired it, included ten thousand papers linking the police to extortion, bribery, election fraud, and other illegal activity in the city's red-light districts, all for the purpose of keeping Tammany Hall in power. The details of the Lexow Committee were a national sensation; the committee concluded that Parkhurst was right and recommended police department reforms.

Under Theodore Roosevelt's command, police reform was taking place. But in 1897, with Tammany leaders elected to the top rungs of city government for four more years, celebrations rang out in the Tenderloin. Crowds blew horns and shook rattles and shouted the refrain, "Well, well, well, reform has gone to hell!"

THE RISE AND FALL OF CRIMINAL GANGS

A typical Bowery Boy, in his signature top hat, and a Dead Rabbit in 1857.

The first organized street gang, the Forty Thieves, began stealing and fencing goods in seedy Five Points in 1826. Edward Coleman started the gang in the back room of a groggery disguised as a vegetable stand on Centre Street. Coleman (who would earn distinction as the first man hanged in the Tombs—in 1839, for killing his wife) ran it on a quota system: Members had to steal a certain number of items or they were kicked out. The Forty Thieves consisted mostly of young Irish immigrant men with few prospects, who joined the gang to secure a better social status within their own community in a city that despised them.

Similar gangs formed in and around Five Points in the first half of the 19th century: the Kerryonians. Chichesters, Patsy Conroys, Shirt Tails, and Roach Guards. (They later became the Dead Rabbits; "rabbit" was slang for a tough guy, and "dead" referred to "best.") They decked themselves out in distinctive colors and clothes, staked out turf, and stole merchandise. Some forged alliances with Tammany Hall and established junior gangs of younger boys who were taught to pickpocket. They used clubs, brickbats, and hobnail boots to battle one another as well as Nativist gangs such as the True Blue Americans, American Guard, and Bowery Boys. The latter were working-poor, American-born men who dressed as dandies but fought like savages.

In the years following the Civil War, these criminal gangs, loosely organized and serving in part as social clubs, became larger, more sophisticated organizations extending

past neighborhood boundaries. Like the legitimate businesses of the postwar boom years, the gangs were aggressively focused on making money. They extorted cash from saloons and stores, robbed banks, and ran gambling, counterfeiting, and prostitution rings. The Whyos dominated from the 1860s to the 1890s, rising from the ashes of older Five Points gangs. "A bad lot of them live in Pell Street, and they have a fondness for dropping bricks from the roofs on policemen," stated an article in the *Sun* in September 15, 1884. One Whyo, Piker Ryan, reportedly carried a list of gruesome acts he would commit for the right price (a punch in the face cost $2; "doing the big job," $100).

"[Gang members] lived off crooked politics, receiving money for voting a score and more times and for using strong-arm methods to keep decent citizens from voting," wrote Herbert Asbury in a July 20, 1919 *Sun* article. In 1928, Asbury would publish his book *Gangs of New York*, a seminal history of the city's gangs. "They would do any sort of criminal job for hire. Murder was cheap and maiming was cheaper."

Dozens of Gilded Age gangs expanded all over Manhattan. The Gophers terrorized Hell's Kitchen, looting the New York Central Rail Yards on the West Side. They battled the Hudson Dusters, who congregated in the lower West Side. The Charlton Street Gang members were river pirates. "For many years the members of this ruffianly horde had

Bottle Alley off of Baxter Street was the headquarters of the Whyo Gang, a powerful criminal organization in the post-Civil War city that grew out of the earlier Five Points street gangs. Jacob Riis wrote in *The Battle with the Slum* in 1902: "In fifteen years I never knew a week to pass without a murder there, rarely a Sunday. It was the wickedest, as it was the foulest, spot in all the city . . . The old houses fairly reeked with outrage and violence."

preyed upon the shipping in both the North and East Rivers, along the Staten Island, Brooklyn, and New Jersey shores, and Hoboken as well," wrote George Walling in his 1887 book *Recollections of a New York Chief of Police*. "'Dead men tell no tales' was their motto, and many a poor seafaring wanderer has been foully murdered by them, within sight of the home from which he had been so long absent, for daring to defend his property."

The police had some success over the years in tamping down on gang activity. But it wasn't until the 1890s, under police chief Thomas Byrnes, that the Whyos and other large-scale operations dissapated in the city. Many gangs fell apart on their own, replaced by criminal outfits that reflected changes in immigration in the 1880s and 1890s. Edward "Monk" Eastman, a Jewish former pet-shop owner, ran the Eastman Gang of two thousand men on the east side of the Bowery. His main rival was Italian-born Paul Kelly, leader of the Five Points gang, which ruled the west side of the Bowery. Both were allied with Tammany Hall and battled over neutral territory. Meanwhile, just to the west, brutal tongs the On Leongs and Hip Sings fought for control of Chinatown's gaming houses.

Organized crime plagued 19th-century New York, but it was also romanticized. By the end of 1890s, the mythology began ebbing. "[The gangster] can dance with the prettiest blonde in the dance halls. He can obtain credit at the saloons, and he is known to thousands as he walks along Allen, Rivington, Hester and Stanton Streets," wrote the *New York Press* on September 27, 1903. "He may organize a gang of his own. His henchmen will steal for him and report the proceeds of a day's work as faithfully as if they were accounting for the returns from a legitimate business. He can 'control' votes for Election Day and become a political power . . .

"Only the most imaginative person could surround such a character with the halo of romance. Sordid, unmagnetic, every act the result of cold-blooded calculation, one's pulse is not quickened upon hearing of the thug's exploits. Chivalry he has none. Of bulldog grit when it comes to saving his own skin and evading the penalty of his own misdeeds he has enough and to spare."

Born Paolo Vacarelli in Sicily in 1876, Paul Kelly was a former boxer turned gang leader in Five Points. A sophisticated dandy, Kelly was one of the first "celebrity" gangsters, and he recruited men who would later become feared gangsters in the early 20th century, such as Al Capone, Lucky Luciano, and Meyer Lansky.

THE PIONEERING DETECTIVE WORK OF THOMAS BYRNES

Aside from Theodore Roosevelt, perhaps no one professionalized the police force and drove down crime rates more than chief Thomas Byrnes.

"Byrnes was a 'big policeman,'" wrote Jacob Riis, who befriended Byrnes as a reporter in the 1880s. "We shall not soon have another like him, and that may be both good and bad. He was unscrupulous, he was for Byrnes—he was a policeman, in short, with all the failings of the trade. But he made the detective service great. He chased the thieves to Europe, or gave them license to live in New York on condition that they did not rob there. He was a Czar, with all an autocrat's irresponsible powers, and he exercised them as he saw fit."

Born in Ireland in 1842, Byrnes became a city patrolman in 1863, quickly securing promotions and then gaining fame as the captain who cracked the infamous $3 million bank heist at the Manhattan Savings Institution in 1878. Yet it was after his 1880 appointment to inspector and head of the detective bureau—and then his tenure as chief from 1892 to 1895—that he really made his mark.

Besides increasing the number of detectives from twenty-eight to forty men, Byrnes

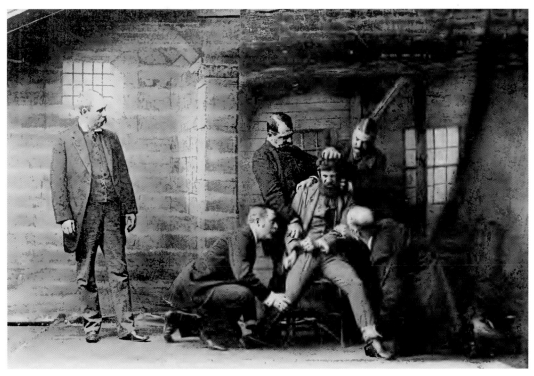

An image from his 1886 book *Professional Criminals of America* shows Thomas Byrnes watching as police restrain a suspect in order to take his photo for the Rogue's Gallery.

greatly expanded the Rogue's Gallery, a data bank that catalogued criminals' arrest photos along with details of their histories and other information that could be used to identify a crook before or after he committed a crime. Byrnes also coined the term "dead line," a boundary he placed on Fulton Street at the edge of the financial district. If a policeman spotted a known crook below this dead line, he could arrest the suspect immediately, even if the suspect hadn't been engaging in criminal activity. Byrnes's dead line probably wasn't legal. But in Gilded Age New York, when Wall Street banks and Maiden Lane jewelry stores were popular targets for thieves, no one raised a fuss. In fact, Byrnes focus on protecting Wall Street won him praise (and rumored payouts) from the city's bankers.

Additionally Byrnes pioneered an interrogation tactic called "the third degree" to pressure suspects into coming clean: The first degree meant questioning, the second intimidation, and the third physical pain. "Take, for instance, the case of [Mike] McGloin, the Bowery tough, a lad of eighteen, who was accused of the murder of Michel Hannier, an old Frenchman," stated the *New York Times* on September 21, 1902. "Failing to secure a confession by ordinary means, Superintendent Byrnes is said to have had the prisoner placed in a cell from which a view of the courtyard could be had. At midnight, the lad was suddenly aroused. Before him in the brilliant moonlight that flooded the yard stood what seemed to him to be

the ghost of his victim, but which in reality was a cleverly disguised detective. The boy shrieked in terror, confessed to everything, and was hanged in due course."

His other innovation was the Mulberry Street Morning Parade. Each day, Byrnes would release recently arrested suspects from their holding cells and march them past his detective squad. Ideally, the squad members would recall the suspects having committed other crimes. Furthermore, Byrnes's 1886 book, *Professional Criminals of America*, contained a rundown of every kind of street crime along with names and mug shots of those who committed them. The schemes and strategies of bank robbers, forgers, sneak thieves (burglars who didn't use violence), safe crackers, shoplifters, pickpockets, and con men and women were laid out in detail.

Byrnes left the force in 1895, pushed into retirement by Theodore Roosevelt, the incoming head of the police department, because his suspiciously close associations with Wall Street didn't fit Roosevelt's new ethnical guidelines. "He made life in a mean street picturesque while he was there, and for that something is due him," wrote Riis. "He was the very opposite of Roosevelt—quite without moral purpose or the comprehension of it, yet with a streak of kindness in him that sometimes put preaching to shame. Mulberry Street swears by him today, even as it does, under its breath, by Roosevelt. Decide from that for yourself whether his presence there was for the good or the bad."

THE MUG SHOTS
OF THE ROGUES GALLERY

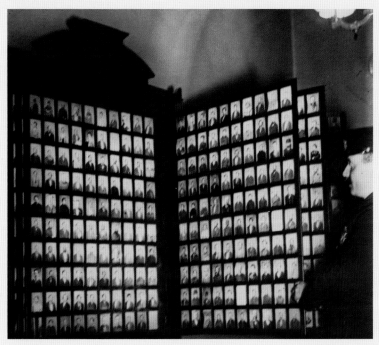

A policeman reviews the more than one thousand photos in the Rogue's Gallery, housed on the first floor of Police Headquarters on Mulberry Street between Houston and Bleecker streets.

The first Rogue's Gallery was a collection of daguerreotypes of criminals known to the police in New York City. Established in 1857, it grew to several hundred images within a year, and each file also contained descriptions of a crook's appearance and specific details about his or her height, age, and build. The idea was for officers to look through the Rogue's Gallery and memorize faces, so if they happened to come across one of these criminals on the street, they could make an arrest on the spot.

In the 1880s, detective Thomas Byrnes expanded the Rogue's Gallery and set it up on the first floor of police headquarters on Mulberry Street. He came up with the idea of taking photos of every suspect, from pickpockets to sneak thieves to bank robbers to murderers—many of whom tried to hide their true faces by eye rolling, grimacing, and making other distorted expressions while posing for the camera. Byrnes published a book, *Professional Criminals of America*, which was essentially a portable Rogue's Gallery, with two hundred photos and descriptions of

Pugsey Hurley, a member of the Patsy Conroy gang, was arrested for masked burglary in 1874. After his incarceration, he tried multiple times to escape from prison, finally succeeding in 1882. He was caught on the corner of Liberty and Washington streets in New York by the police, after which this photo was taken.

the nation's most prolific bad guys. Crime dropped, and crooks and gangsters left town, during Byrnes' years on the force. But it's hard to determine whether his photographic roster of criminals drove crime rates down, or if any of Byrnes' other strategies—such as his "dead line" or method of interrogation called "the third degree"—had more influence.

POLICE COURTS, PRISONS, AND "HALLS OF JUSTICE"

"What is this dismal-fronted pile of bastard Egyptian, like an enchanter's palace in a melodrama?" asked Charles Dickens in his book *American Notes*, which chronicles his trip to America in 1842. Dickens had come across the four-year-old New York Halls of Justice, colloquially known as "the Tombs," which got the nickname thanks to its "gloomy and funeral appearance and associations," wrote Moses King in 1892. This hulking, granite, Egyptian-style building on Centre Street at the edge of Five Points housed one of the city's six police courts and a principal jail during the Gilded Age.

The Halls of Justice, built on Franklin and Centre streets, at the edge of Five Points, in 1838, was an imposing courthouse and prison modeled after an Egyptian mausoleum. It was more commonly known as the Tombs; up to fifty thousand prisoners, including women and boys, were confined in its overcrowded quarters annually.

Connecting the two was a footbridge known as "the Bridge of Sighs," because men condemned to the gallows crossed it on their way to an interior courtyard, where they were hanged out of view of the public.

The Tombs wasn't the first stop for a man or woman suspected of committing a crime in late 19th-century New York. First, a suspect would be brought to a station house. If the offense was minor—drunkenness, for example, or petty thievery—he or she could pay a fine (or perhaps a bribe) and be released. If the crime was more severe, he or she was transported to one of six police courts. Besides the court at the Tombs, the Jefferson Market Court House, on Sixth Avenue and 10th Street, and the Essex Market Courthouse, on Essex Street, were also way stations for assailants, drunkards, vagrants, and thieves.

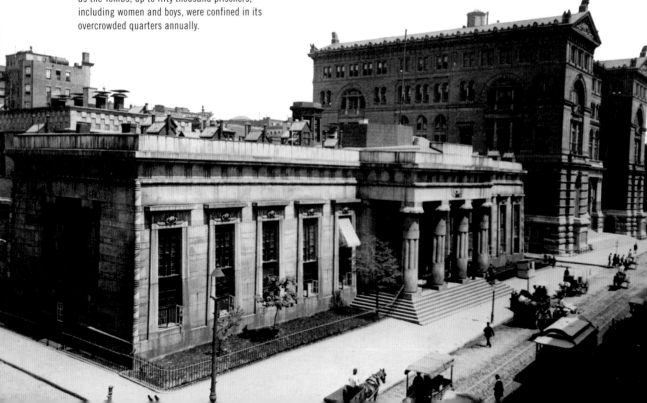

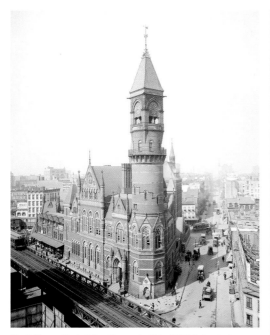

The Jefferson Market Courthouse, built in 1877, is located on Sixth Avenue and 10th Street. The police court, one of six in Manhattan, where suspects were brought for arraignment, was on the first floor. The civil court was on the second floor.

Mark Twain described a night he spent in a station house in an 1867 letter to the California newspaper that employed him as a traveling correspondent. "I was on my way home with a friend a week ago—it was about midnight—when we came upon two men who were fighting," wrote Twain. "We interfered like a couple of idiots, and tried to separate them, and a brace of policemen came up and took us all off to the Station House.

"We offered the officers two or three prices to let us go (policemen generally charge $5 in assault and battery cases, and $25 for murder in the first degree, I believe) but there were too many witnesses present, and they actually refused," Twain continued. "They put us in separate cells, and I

enjoyed the thing considerably for an hour or so, looking through the bars at the dilapidated old hags, and battered and ragged bummers, sorrowing and swearing in the stone-paved halls, but it got rather tiresome after a while . . .We sat on wooden benches in a lock-up partitioned off from the Court Room, for four hours, awaiting judgment— not awaiting trial, because they don't try people there, but only just take a percentage of their cash, and let them go without further ceremony."

Twain was released that morning. But if he had been convicted, he may have been sentenced to a short stint at the Penitentiary or Workhouse, both on Blackwell's Island. At these institutions, thousands of convicts, men and women, lived in cells and labored

"Murderers Row" in the Tombs in 1890. Until that year, men sentenced to death awaited their appointment with the gallows there. Starting in 1890, the state took over executions and began using the new electric chair at Sing Sing prison.

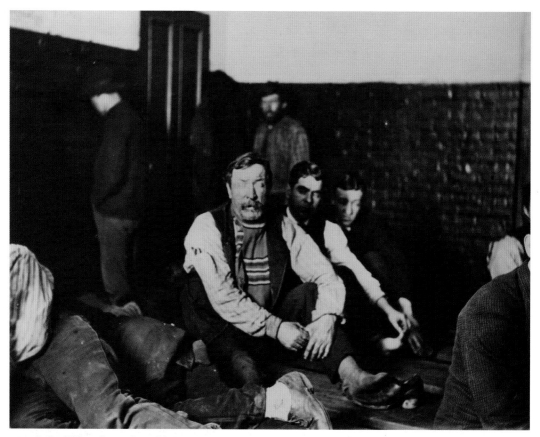

By the 1870s, police stations offered overnight lodging to anyone who showed up, typically indigent jobless men with no other options. In 1890, Jacob Riis wrote that 147,634 "lodgers" slept in the police station lodging houses that year, where the bed was "the soft side of a plank."

indoors or outside, cutting stone, doing masonry, sewing, or cleaning. Underage criminals convicted of a misdemeanor were placed in the House of Refuge, which was established on Randall's Island in 1854. Federal criminals served their sentences at the Ludlow Street Jail. Boss Tweed was sent here, but luckily for him, prisoners with money could pay to be housed in a superior cell and eat better food than poorer convicts.

The Tombs, too, had a class system within its walls. Though it was mainly a prison where the accused waited until they were tried, some convicted criminals served their sentences there as well. Each of its four floors housed a different type of criminal, wrote former police chief George Walling. Lunatics and sentenced criminals were housed on the first floor, while murderers, highway robbers, and burglars resided on the floor above. The third floor housed those arrested for grand larceny, and the fourth for small misdemeanors. Most inmates were men, but about four hundred women lived in a separate women's prison, and a small ward was set aside for boys as well.

THE HANGMAN'S GALLOWS
OF NEW YORK CITY

New Amsterdam's earliest executions took place in public. Men and women were hanged, shot, or burned at the stake for murder, sodomy, and kidnapping, often in front of a huge audience at various makeshift spots in Manhattan—among them an island in Collect Pond and a field near Peter Stuyvesant's Bouwerie.

By the 1830s, public execution was considered cruel, and an 1835 law mandated that hangings be done in private. The city decided to build a gallows in the courtyard of the new Halls of Justice—known by city residents as the Tombs. This enormous, dreary, faux-Egyptian building, opened in 1838, contained a small yard hidden between a courthouse and the city prison. When a prisoner's execution date arrived, officials set up the gallows, brought the condemned to the yard over a footbridge known as the Bridge of Sighs, and then meted out the punishment.

The first city man executed there was Edward Coleman, founder of the Forty Thieves; the Five Points resident had brutally beaten his wife to death after suspecting her of infidelity. The last man to go to the gallows in the Tombs was Henry Carleton, in 1888, convicted of killing a policeman. The death penalty wasn't abolished; hanging had simply been replaced by something new in 1890, the electric chair, which from now on would be administered by the state. The infamous gallows at the Tombs, the site of at least fifty executions, often several at one time, would never be used again.

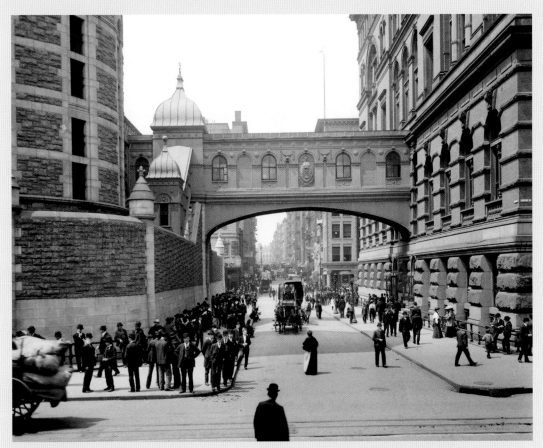

A new "Bridge of Sighs," seen here in 1905, connects the new Tombs, built three years earlier, with the Manhattan Criminal Courts Building. The new building looked nothing like the Egyptian-style mausoleum it replaced, but the nickname stuck.

Jacob Riis's colleague, Richard Hoe Lawrence, took this photo of a well-dressed man being pushed into a cell in 1895.

from looking at the entrance," wrote Walling. "The floor is of cement, and gets damp and cold. There is a hard, uncomfortable iron bed, one or two necessary articles of furniture; and these are all. Here, as in Ludlow Street Jail, if one wants luxuries he has to pay for them, and the messengers are said to make a very good thing of it. They offer to get cigars, tobacco, fruit, etc., for them and then charge them double prices. The prisoners cannot rebel, and their persecutors have absolute power.

Walling continued, "the dull monotony of existence continues until the prisoner's term expires. Occasionally he sees visitors, who are allowed to talk to him at the cell door. Perhaps he is confined in the Tombs only temporarily before being conveyed to Blackwell's Island. When his time comes to start he is hustled out with a dozen or more other prisoners, all of whom are packed into the 'Black Maria' (a police wagon used to transport prisoners) and driven rapidly over the pavements toward Blackwell's Island."

What was it like to be condemned to the dank, dreary, overcrowded Tombs, before it was replaced by a newer facility in 1903? "The cell is narrow and small, but is rather better, on the whole, than one would think

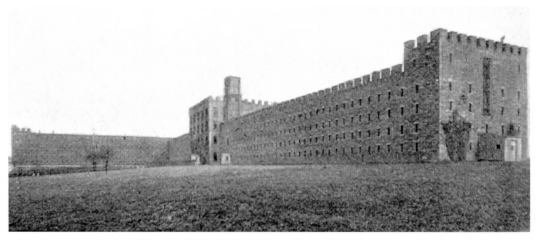

According to *King's Handbook of New York* of 1892, the Penitentiary on Blackwell's Island averaged one thousand prisoners a day. Due to its island location, however, few guards were needed—just twenty in total, along with thirty-five keepers. Only one prisoner had escaped in ten years. Steamboats transported prisoners from the Tombs to the Penitentiary daily.

WRINGING THE CITY'S
RED-LIGHT DISTRICTS DRY

Sin could be easily found in many pockets of the Gilded Age city. On Greene Street south of Houston Street, the metropolis' red-light district before the Civil War, several brothels still operated in the shadow of a precinct house. Immigrant women offered their services on the streets of Chinatown, Little Italy, and sailors' dives of Water Street. The African American neighborhood along Bleecker Street near the Minettas was filled with working girls, while Bleecker itself was home to all-male bars, such as the Slide and the Black Rabbit, that doubled as sex clubs.

"It is a fact that 'the Slide' and the unspeakable nature of the orgies practiced there are a matter of common talk among men who are bent on taking in the town or making a night of it," wrote the *New York Herald* on January 5, 1892, in an article headlined

Bare-knuckle boxer Owney Geoghegan opened a number of dives on the Bowery after he retired in 1863. One was the Hurdy-Gurdy, described by the *National Police Gazette* as a place "where thieves, prostitutes and blacklegs hold nightly revel—unadulterated deviltry unchecked by the police."

One way a prostitute could cheat her clients was the "badger game." She would lure a man into her room, only to have her "husband" burst in, furious. Her "husband" would threaten to tell everyone the man had visited a prostitute unless the "husband" was paid a huge fee.

"Depravity of a Depth Unknown in the Lowest Slums of London or Paris Can Here Be Found." "In comparison to 'the Slide' an ordinary concert hall is a place of worship," the article added.

By the end of the 19th century, the city had two major pleasure playgrounds: the Tenderloin and the Bowery. The former, whose name came from precinct captain Clubber Williams' famous comment, was a byproduct of the new theater district. From the 1870s to 1900, Broadway between 14th and 34th streets was lined with legitimate stages and concert halls, as well as posh restaurants and hotels. On the side streets stretching west to Eighth Avenue and north through the 30s and into the 40s, houses of prostitution, gambling dens, and saloons sprang up, eager to take advantage of the crowds and excitement that raged all night under the new electric lights that illuminated Broadway.

During the day, the grand emporiums of Ladies Mile catered to wealthy shoppers. By evening, ladies themselves were for sale. The Seven Sisters brothels on West 25th Street between Sixth and Seventh avenues catered to well-dressed men with money. Exotic French prostitutes could be found on West 39th Street, dubbed "Soubrette Row" (a "soubrette" was a flirtatious young woman). Streetwalkers visited dance halls such as Koster and Bial's, on Sixth Avenue, where the salacious can-can was performed. They also met customers at the Haymarket, on 30th Street, a combination restaurant, dance hall, and variety show that counted Diamond Jim Brady as a regular. The police took kickbacks to leave the pleasure houses alone; they were clients as well. Occasionally Thomas Byrnes would order a raid, just to get moralizing ministers such as Charles Parkhurst and Thomas Talmage temporarily off his back.

While the Tenderloin attracted a higher-class clientele and plenty of tourists, the Bowery in the late 19th century was a working-class man's paradise. Cheap hotels, beer gardens, concert halls, "resorts," and third-rate theaters brought single males and garishly dressed prostitutes to this commercial sex center under the gritty elevated train tracks. Silver Dollar Smith's, across from the Essex Market Court House, was a popular haunt, with its sparkling chandelier and silver dollar coins affixed to the floor. At Lyon's restaurant, open around the clock, cops sat with pickpockets who sat with Tammany men. McGurk's Suicide Hall was a dance hall with prostitutes awaiting customers upstairs.

The ten thousand bars in the Tenderloin, along the Bowery, or in any corner of the rest of the city paid scant attention to the state's 1866 Sabbath and Excise laws, which required bars to close at 1:00 A.M. until sunrise the next day and refrain from selling alcohol on Sundays. But even if they did follow the law, it wouldn't have kept crusaders such as Parkhurst, Talmage, and Anthony Comstock, the self-appointed head of the New York Society for the Suppression of Vice, from going after the saloons. By the 1880s, groups specifically dedicated to temperance, such as the Anti-Saloon League, had descended on Manhattan, attempting to dry up the nation's most sinful city. They had on their side Theodore Roosevelt, the new police commis-

sioner, who tried to enforce the Sunday law as soon as he came into office.

"The saloon was the chief source of mischief," wrote Roosevelt in his 1913 autobiography. "It was with the saloon that I had to deal, and there was only one way to deal with it. That was to enforce the law. The howl that rose was deafening. The professional politicians raved. The yellow press surpassed themselves in clamor and mendacity. A favorite assertion was that I was enforcing a 'blue' law, an obsolete law that had never before been enforced.

"As a matter of fact, I was only enforcing honestly a law that had hitherto been enforced dishonestly. There was very little increase in the number of arrests made for

"Big Bill" Devery worked his way up from patrolman to the first Chief of Police after the consolidation of New York City in 1898. In a career the *New York Times* called "most picturesque and stormy," he was "indicted several times" and "faced charges of extortion, blackmail and oppression," but was never convicted.

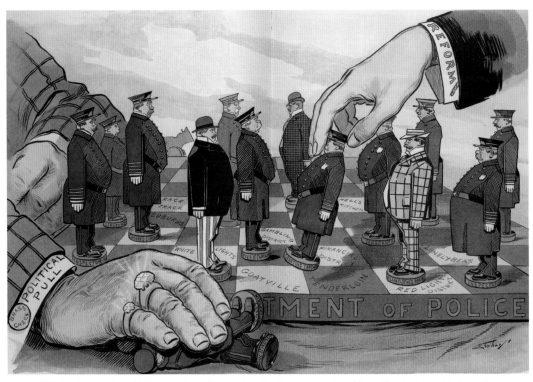

This *Puck* cartoon from 1906 shows the endless push and pull over the control of the police department between the politically connected who stood to benefit from graft and corruption. and those who wanted reform.

violating the Sunday law. Indeed, there were weeks when the number of arrests went down. The only difference was that there was no protected class. Everybody was arrested alike, and I took especial pains to see that there was no discrimination, and that the big men and the men with political influence were treated like every one else. The immediate effect was wholly good. I had been told that it was not possible to close the saloons on Sunday and that I could not succeed. However, I did succeed. The warden of Bellevue Hospital reported, two or three weeks after we had begun, that for the first time in its existence there had not been a case due to a drunken brawl in the hospital all Monday."

Roosevelt's efforts to enforce the Sabbath Excise Law earned him few fans outside of the drunk tanks of Bellevue. He alienated working men and the city's huge German immigrant population, which congregated at taverns and beer gardens, especially on Sundays—the most lucrative day of the week, in fact, for barkeepers. Temperance supporters felt emboldened, however, and they managed to get a bill called the Raines Law passed by the state in 1896. This legislation banned Sunday alcohol sales . . . except in restaurants or hotels with at least ten beds.

Of course, New York's clever saloonkeepers quickly figured out a way to get around the Raines Law: They began serv-

ing meals—which could be as little as one pretzel or something inedible called a "brick sandwich," with two pieces of bread and a real brick in the middle. They also rented out spare rooms in the back and second floor of bars. Technically, they were now

hotels, and these new cheap lodging places encouraged prostitution—something the temperance crowd had not foreseen. By the early 1900s, the Raines Law was deemed a failure. The temperance folks, however, were not giving up just yet.

THE QUEENS OF THE UNDERWORLD

The members of the city's 19th-century street gangs were mostly young men, but some notorious women were admitted into their ranks as well. One was Sadie the Goat, part of the Charlton Street Gang, a group of vicious river pirates who plundered ships docked along the Hudson in the 1870s. Before joining the gang, Sadie had been a fierce mugger who robbed her targets by startling them with a head butt to the stomach. Battle Annie was the leader of the Lady Gophers, the all-female subsidiary of Hell's Kitchen's brutal band of robbers, the Gophers.

Rather than fight alongside men, female criminals often headed elaborate pickpocket, shoplifting, and fencing rings. Prussian immigrant Marm "Mother" Mandelbuam pilfered millions in stolen goods from the 1860s to the 1880s, operating out of a Clinton Street

dry goods store that was a cover for the web of con men and pickpockets she controlled. Sophie Levy Lyons was known as "Queen of the Underworld" for her talent for shoplifting and blackmail. Old Mother Hubbard came to New York from Ireland and embarked on a fifty-year career as a pickpocket and shoplifter. Both Lyons and Mother Hubbard made it into police chief Thomas Byrnes' book, *Professional Criminals of America*.

"Women do not often succeed in effecting large robberies, but the total of their stealings makes up a large sum each year," wrote James McCabe in 1872's *Lights and Shadows of New York City*. "They are not as liable to suspicion as men, and most persons hesitate before accusing a woman of theft. Yet, if successful, the woman's chances of escaping arrest and punishment are better than those of a man."

115	116	117	118	119	120
ELLEN CLEGG, ALIAS ELLEN LEE, SHOP LIFTER AND PICKPOCKET.	MARY HOLLBROOK, ALIAS MOLLY HOEY, PICKPOCKET.	MARGRET BROWN, ALIAS OLD MOTHER HUBBARD, PICKPOCKET AND SATCHEL WORKER.	CHRISTENE MAYER, ALIAS KID GLOVE ROSEY, SHOP LIFTER	LENA KLEINSCHMIDT, ALIAS RICE—BLACK LENA, SHOP LIFTER.	MARY CONNELLY, ALIAS IRVING, PICKPOCKET AND SHOP LIFTER.

Margaret Brown (117), also known as Old Mother Hubbard, was added to the Rogue's Gallery in 1883 when she was fifty-five years old. Byrnes wrote she "makes a specialty of opening hand-bags, removing the pocket-book, and closing them again." Brown was caught shoplifting from Macy's on 14th Street and did a stint in the penitentiary on Blackwell's Island

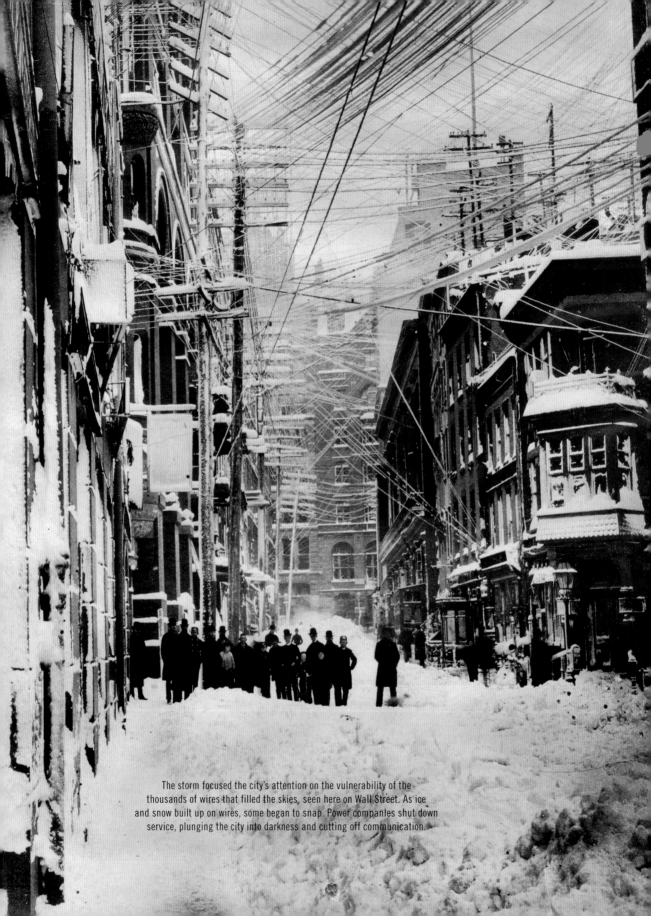

The storm focused the city's attention on the vulnerability of the thousands of wires that filled the skies, seen here on Wall Street. As ice and snow built up on wires, some began to snap. Power companies shut down service, plunging the city into darkness and cutting off communication.

BRINGING THE MODERN CITY TOGETHER

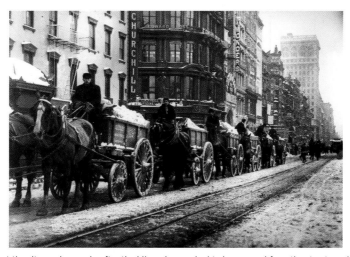

To get the city moving again after the blizzard, snow had to be removed from the streets and carted by horse to be dumped into the rivers. "Through the white hummocks move leagues of men. The snow already runs in dirty rivers in the busiest streets under the onslaught of it assailants. With spades, with shovels, with their own chests and those of the horses, they push back the snow, which retreats to the rivers." —José Martí in *La Nacion*, 1888

THE "WHITE HURRICANE" WALLOPS NEW YORK

Sleet began icing the streets late in the afternoon. It was March 11, 1888, a Sunday, and the noontime temperature had clocked in at forty degrees. The winter had been relatively warm, and the official forecast—made from the roof of the five-story Equitable Building at 120 Broadway—called for a day of clouds and light rain. Instead, New York watched as a wintry mix of snow and rain came down, whipped by an increasingly frigid wind.

By early Monday the sleet had turned to snow, and the temperature fell to twenty-one degrees. Wind gusts of up to seventy-

five miles per hour carried snowdrifts so high they were hard to distinguish from the heavy gray clouds. "When dusk came there was no abatement of the fury of the blizzard," wrote the *New York Sun* on March 13. "It howled more and more loudly, accentuated by the darkness and absence of all distracting sounds . . . The city went into its gas-lighted rooms and its heated houses, and its parlors and beds tired, wet, helpless, and full of amazement."

By 7:00 A.M., trains running in and out of the city were stuck: thousands of trapped passengers waited in unheated cars on snowy elevated tracks for help. Enterprising men and boys reportedly hoisted ladders to the platforms and charged money to help riders escape. The storm continued all day. Salesgirls stranded at Macy's napped in the furniture department. Cafes, hotels, and saloons kept their doors open—some throwing champagne parties, others offering cheap booze to marooned customers. Two-thirds of Manhattan's light poles came crashing down, plunging the city into darkness. The only connection to the outside world was the transatlantic cable buried underground.

Late Monday night the gas jets in tenement houses went off, and coal to heat stoves was in short supply. "Coal delivery stopped with the blizzard and the grocer's coal bin was soon depleted," reminisced one New Yorker who had experienced the storm as a boy living in a tenement near West Broadway. "There was much suffering for want of coal."

The ferocity of the storm caught Gotham very much off guard. "The angry wind nipped at the hands of pedestrians, knifed through their clothing, froze their noses and ears, blinded them, hurled them backward into the slippery snow, its fury making it impossible for them to get to their feet, flung them hatless and groping for support against the walls, or left them to sleep, to sleep forever, under the snow," wrote Jose Martí, the exiled Cuban poet, in a dispatch to the Spanish-language newspaper *La Nacion*, based in Buenos Aires.

Early Tuesday morning, with the thermometer registering 1 degree, the blizzard had ceased. New Yorkers began digging out. The Brooklyn Bridge, closed because of high winds, reopened—but the walkways were so jammed, that hundreds of people decided to walk across ice floes in the river instead. It took a week for regular train, telegraph, and telephone service to resume. Two hundred residents were killed initially, while many more died later from injuries sustained during the storm. One was Roscoe Conkling, a former Republican senator who could not find a cab and was forced to walk from his Wall Street office to the New York Club at Madison Square. After a harrowing journey through darkness and snowdrifts, he made it to the club—but died a month later of pneumonia.

The twenty inches of snow that fell didn't break records. This blizzard left its mark in a different way—by revealing the inadequacies of New York's infrastructure. "People vexed at the collapse of all the principal means of intercommunication and transportation became reflective, and the result was a general expression of opinion that an immediate and radical improvement was imperative . . ." wrote the *New York*

Times on March 13, 1888. "Now, two things are tolerably certain—that a system of a real rapid transit which cannot be made inoperative by storms must be straightway devised and as speedily as possible constructed, and that all electric wires—telegraph, telephone, fire alarms, and illuminating—must be put underground without delay."

Prior to the blizzard officials had mandated that the unsightly, potentially dangerous network of wires roping the city be buried underground. Western Union, the Brush Electric Light Company, and other big communications companies, however, fought the city, unwilling to pay the extra cost. The wires would become a focal point of the 1888 mayoral election, as politicians were hitting back. After Mayor Hugh Grant won in November, his administration put all wires under the street. "At a quarter past ten the last pole fell on Broadway, leaving that thoroughfare clear of poles and wires from Fourteenth Street to Forty-Fifth Street," wrote the *Evening Telegram—New-York* on April 23, 1889.

A month and a half before the blizzard, Mayor Abram Hewitt had proposed that the city borrow $50 million to build an underground network of electricity-powered trains. His idea floundered. But with fresh memories of halted trains and a paralyzed city,

New Yorkers were ready for a transit system designed to withstand storms, similar to the one in London. A public referendum in 1894 came down in favor of approving the funds to develop the new subterranean system.

The Blizzard of 1888 tested the city. Its infrastructure failed—yet residents persevered. "For two days, the snow has had New York in its power, encircled, terrified, like a prize fighter driven to the canvas by a sneak punch," Martí, *La Nacion* correspondant, wrote after the storm finally let up. "But the moment the attack of the enemy slackened, as soon as the blizzard has spent its first fury, New York, like the victim of an outrage, goes about freeing itself of its shroud . . . Man's defeat was great, but so was his triumph."

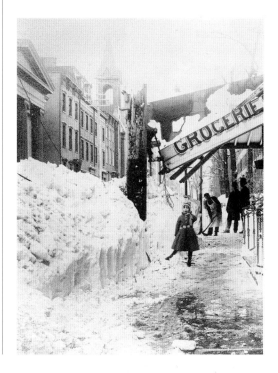

On West 11th Street seen from Waverly Place, inhabitants dig out after the blizzard of '88, which blanketed twenty inches of snow on the city, creating snowdrifts in excess of thirty feet.

"BEAUTIFUL, FAIRY-LIKE ELECTRIC LIGHT"

A *Harper's Weekly* illustration from 1882 shows electrical workers wiring a house in New York City with electric lights.

In the mid-1880s, New York's new electrical illumination—emanating from streetlights, hotel lobbies, theater facades, and billboards—dazzled the senses. Residents and visitors alike were absolutely enchanted. "The effect of the light in the squares of the Empire City can scarcely be described, so weird and so beautiful is it," wrote one British traveler in 1882. Light was "thrown down upon the trees in such a way as to give a fairy-like aspect."

The first electric street lamps were installed along Broadway from 14th Street to 26th Street in 1880. Built by the Brush Electric Light Company and powered by a small generating station on 25th Street, they offered a cleaner, whiter illumination than the gaslights that had lit the city since the 1830s. The tangle of black wires festooned to wooden poles that carried the electricity may have been an eyesore, but the light itself was captivating.

A reporter from the *Truth* standing at Broadway and 19th Street watched the first lights as they were switched on December 20, 1880. He described it in vivid detail: "the newborn light burst forth, shedding its white splendor over the thronged thoroughfare and bringing out on the stone pavement innumerable sharply cut silhouettes that sped along in a fantastic manner, dancing, swaggering, gliding, and many passersby turned their heads and rolled their eyes to see their shadowy outline."

Electric light was not only alluring, but also made the city feel safer. Powerful arc lamps perched on a 160-foot tower illuminated the streets surrounding Madison Square Park, packed with shoppers and theatergoers. Blinding arc light created a sense of safety, but it was so harsh that women complained it gave their skin a ghostly pallor. Security trumped vanity, however, and seventy arc lamps were installed along the

new Brooklyn Bridge when it opened in 1883. By 1886, 1,500 arc lamps illuminated the city. After the Statue of Liberty was dedicated that October, arc lights in the pedestal and torch shined so bright that the statue served as an official lighthouse, visible twenty-four miles out to sea.

Though outside attractions and large indoor spaces continued to rely on arc lights, Thomas Edison's new incandescent bulbs were favored indoors. The warmer, softer glow made rooms, faces, and objects appear more magical. By the 1890s, many newspaper offices, the New York Stock Exchange, and department stores were lit by these "little globes of sunshine," as one publication called them. Edison's company began selling electricity to private customers, with J.P. Morgan among his earliest subscribers. The days of the lamplighters, men who turned on and off the gas streetlights manually, were numbered.

New York's light became a metaphor for the city's energy—a metropolis that never slept, blasted colorful advertisements on multistory billboards, and as of January 1, 1908, celebrated New Year's Day by dropping a brilliant ball decorated with one hundred lightbulbs in Times Square. A gas- and oil-lit city that once mostly shut down at dusk now pulsed until dawn. Light allowed factories and offices to function at night and thus lengthened the workday; an entire culture of night shifts and nightlife blossomed. "New York is lavish of light, it is lavish of everything . . ." wrote British writer H.G. Wells in 1906 after a trip to the city. Theaters, restaurants, and clubs glowed around the clock from the Bowery to Columbus Circle.

"The Sleeplessland of New York leads a double life," wrote the *New York Times* on January 8, 1905. "Its laughter, gaiety, and music; its ceaseless rush of pleasure and business never stop. Day and night, for every second of the twenty-four hours, the tide of human life ebbs and flows, with the dinner hour as the dividing line. . . Shop windows that are dressed to attract the passing throngs at midnight even more alluringly than they are at midday; restaurants that are busiest between the time the theatres close and the milkman starts on his morning rounds; hotels that employ a larger staff of clerks at night than they do when the sun shines; blazing cafes and barrooms where everybody seems to be spending money—a literal paradise for revelers of all descriptions and nationalities who seem to have forgotten that there is such a thing as sleep or a municipal 'lid.'"

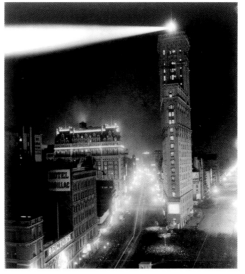

Broadway south of 42nd Street in 1908. The *New York Times* chronicled the new tradition of dropping an electric ball in Times Square to ring in the new year: "Tens of thousands stood watching the electric ball. And then—it fell. The great shout that went up drowned out the whistles for a minute. The vocal power of the welcomers rose above even the horns and the cow bells and the rattles. Above all else came the wild human hullabaloo of noise, out of which could be formed dimly the words: 'Hurrah for 1908.'"

THE CITY STRETCHES
UPWARD AND OUTWARD

In 1906, H.G. Wells chronicled his recent first trip to New York. Coming into New York Harbor, he wrote, he was awed by the gravity-defying buildings of Lower Manhattan. "Against the broad and level gray contours of Liverpool one found the ocean liner portentously tall, but here one steams into the middle of a town that dwarfs the ocean liner," recalled Wells. "The sky-scrapers that are the New-Yorker's perpetual boast and pride rise up to greet one as one comes through the Narrows into the Upper bay, stand out, in a clustering group of tall irregular crenellations, the strangest crown that ever a city wore."

Wells likely caught a glimpse of the twenty-story Broad Exchange Building, completed in 1901, and the domed, twenty-story *New York World* Building, opened in 1890 on Park Row, one of many newspaper headquarters that reached to the clouds. He may have

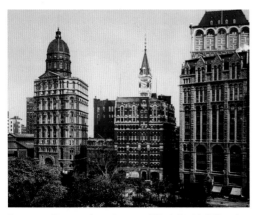

Newspaper Row was home to some of the tallest buildings in New York. Left to right: New York World Building (1890), New-York Tribune Building (1875); the white building behind the New York Times Building (1889) is the twenty-story American Tract Society Building (1895).

seen the 1895 American Tract Society Building at Nassau and Spruce streets, with its winged caryatids on the upper corners, and across from Trinity Church, the U-shaped, eighteen-story Manhattan Life Insurance Building: After it opened in 1894, it was the tallest in the world for seven months. In fourteen years, the Singer Tower would stand tall at a dizzying, incomprehensible forty-one stories.

The skyscraper era had arrived, and these towering edifices owed their existence to an engineering breakthrough. Walls of brick and masonry had to be extremely thick to support several stories, leaving little room for office space. A steel skeleton, however, was just as strong but much thinner. With steel prices falling in the 1880s and the demand for office space soaring, developers turned to steel, which had other advantages: It was fireproof and could withstand wind. New Yorkers witnessed this firsthand in 1889 as the slender Tower Building was going up at 50 Broadway. Workers had almost completed the thirteen-story building when an eighty-mile per hour wind suddenly roared through Lower Manhattan. Startled crowds watched, expecting this early example of a steel-frame building to topple. It didn't budge.

The cityscape was heading skyward as well as northward. The West End, west of Central Park, was one of the last areas of Manhattan to be urbanized in this period. Elegant townhouses and fashionable flats went up on wide new avenues throughout the 1890s. While Columbus and Amsterdam Avenues carried elevated trains, stately River-

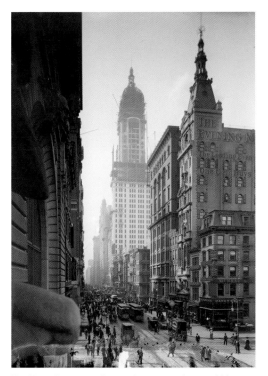

The Singer Tower, seen here under construction, would loom 41 floors above Liberty Street and Broadway and be the tallest building in the world for just one year after it opened in 1908.

opulent Gilded Age mansions. A generation earlier the West End had been dotted with small villages along its meandering, colonial-era thoroughfare, Bloomingdale Road. In the 1890s, Bloomingdale Road was graded, paved, and renamed the Boulevard, and was then absorbed into Broadway. The small villages—Harsenville around West 70th Street, Stryker's Bay in the West 80s, and Bloomingdale in the West 90s—quietly vanished as magnificent luxury residences such as the Ansonia, the Apthorp, and the Belnord took their place.

New York in 1890 had 1.5 million residents, and they needed affordable places to live. Developers flocked to the open stretches of Harlem. With elevated trains established on several avenues, brownstones and tenements intended for a middle class began going up. No longer a village outpost, Harlem had its own shops and entertainments, including an opera house, built by Oscar Hammerstein on 125th Street in 1889, that drew performers such as Lillian Russell and Edwin Booth. Morningside Heights earned the nickname of "New York's Acropolis" after Columbia University relocated there in the 1890s. In 1895, the city annexed the eastern part of the Bronx; it had acquired the western and southern parts decades earlier. Brooklyn's wide swatches of farmland south of Prospect Park were becoming spacious suburban neighborhoods of single-family homes.

Of course, not everyone agreed that rapid development improved the city. Upon his return from Europe just after the turn of the century, author Henry James—bewildered by the changes to the smaller-scale city he was accustomed to, having spent part of his childhood a block from Washington Square—wrote that the "tall buildings" appeared to look like "extravagant pins in a cushion already overplanted, and stuck in as in the dark, anywhere and anyhow."

The city's village outposts were mourned as well. "Nowhere on the whole northern

A shantytown on 5th Avenue and 116th Street in 1893, with contemporary tenement buildings constructed along its outer edges.

This 1907 view shows Prospect Park South in Brooklyn, a housing community built on former farmland in 1899 by the Brooklyn real estate developer Dean Alvord, who claimed it would "illustrate how much of rural beauty can be incorporated within the rectangular limits of the conventional city block."

front of the advancing city is the imminently impending ploughing under of the old by the new accented with such dramatic intensity as in the vicinity of 97th Street and Park Avenue; where a score or more of little houses, surviving from a primitive rural time, stand close under the shadow of the stately armory of the Eighth Regiment and are pressed upon closely by solidly built blocks of handsome dwellings of almost literally the present day," wrote the historian Thomas Allibone Janvier in *In Old New York*, published in 1894.

These houses, which Janvier noted now sat in a hollow created when the streets around them were brought to grade by the city, were "no more than shanties" and seemed to have no place in the gleaming, mechanical Gotham. "In the meantime these shanties of low degree give a touch of the pic-

turesque to a neighborhood that otherwise— save for the redeeming glory of the armory— would be an ill-made compromise between the unkempt refuse of the country and the dull newness of the advancing town."

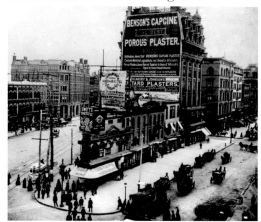

The cowcatcher-shaped wedge at 23rd Street between Broadway and Fifth Avenue in 1884, the site of the future Flatiron building. The building with the painted side is the Cumberland Hotel, the site of New York's first electronic billboard in 1891.

FLATIRON

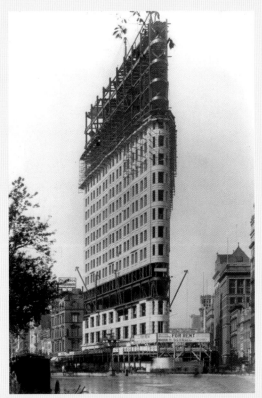

The Flatiron Building resembled "a ship sailing up the avenue," noted *Architectural Record* in 1902. A steel frame made construction of the skyscraper possible.

" **I** found myself agape, admiring a skyscraper—the prow of the Flatiron Building, to be particular, ploughing up through the traffic of Broadway and Fifth Avenue in the afternoon light . . ." wrote H.G. Wells in 1906 after a trip to New York. He wouldn't be the only visitor stunned by this 1902 structure, which was never the city's tallest nor its most architecturally significant. Yet, its graceful loveliness made it an icon of the Gilded Age city.

The name came from the shape of the land it sits on—a triangle-like wedge similar to a flat iron at the junction of Fifth Avenue, Broadway, and 23rd Street. During Madison Square Park's heyday in the 1870s and 1880s, the location hosted an early co-op apartment house called the Cumberland— with one side of the building functioning as an early electric billboard.

By the time the architect Daniel Burnham designed the Flatiron building, the area was more commercial and less residential. An early example of the steel-skeleton skyscraper, the Flatiron featured a beaux-arts limestone façade with terra cotta ornamentation and a slender design reminiscent of a Greek column. What was dubbed "Burnham's Folly" when construction started in 1901 was greeted enthusiastically by the city once it was completed a year later.

Pedestrians openly gazed at it. "Sometimes a hundred or more, with heads bent backward until a general breakage of necks seems imminent, collect along the walk on the Fifth-Ave side of Madison Square and stay there until 'one of the finest' orders them to move on," wrote the *New York Tribune* in 1902. It was especially popular with artists such as Paul Cornoyer, Childe Hassam, Edward Steichen, and Alfred Stieglitz, who celebrated it in paintings and photographs. The Flatiron Building "appeared to be moving toward me like the bow of a monster steamer—a picture of a new America still in the making," said Stieglitz.

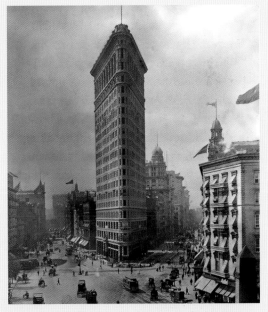

The *Architectural Record* wrote in 1902 that the Flatiron was "quite the most notorious thing in New York and attracts more attention than all the other buildings now going up together."

GETTING AROUND THE
MODERN CITY

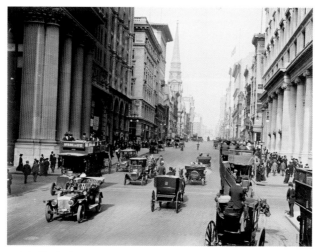

Automobiles and double-decker buses shared the road with horse-drawn carriages on Fifth Avenue and 34th Street, c. 1910. Note the absence of traffic lights; they wouldn't arrive until the 1920s.

"Horseless carriages," as cars were called, made a mass debut in the city on Decoration Day 1896, at a race that began at City Hall and ended in Westchester. They came out again in 1899 as part of an automobile parade that wound its way from Fifth Avenue at 34th Street to Claremont, near Grant's Tomb. "Get a horse!" cheeky kids would shout at drivers, mocking what some dubbed "devil wagons" and what seemed like a passing fad for millionaires such as Diamond Jim Brady, who tooled around town in the city's first electric car.

It wasn't a fad. So many automobiles began appearing in New York in the first decade of the new century that the state began licensing drivers. Automobile taxis powered by gas hit the streets by 1900. Easy to spot with their red and green paneling, these taxis charged fifty cents a mile—a rate only afford-able to the rich. "But a few short years ago the passer on the Avenue could pride himself on a count of twenty automobiles in his walk from Murray Hill to the Plaza; now he can easily number hundreds," wrote the author and critic William Dean Howells in 1910.

The first major automobile show in the United States opened at Madison Square Garden on November 3, 1900. More than forty thousand people attended the week-long event, which featured cars with electric, steam, and gasoline engines.

Once a novelty, automobiles were quickly replacing horse-drawn carriages as the city's primary vehicle on city streets—which were increasingly paved with hard, smooth, easier-to-clean asphalt rather than granite block or cobblestones. "The smoke and smell of the asphalt kettle, the clank and rumble of the huge rollers, and the bustle and the jargon of gangs of pavers are familiar to the residents of nearly every quarter of New-York," wrote the *New York Times* in 1899. "The tenement districts and the fashionable residence streets have been treated with undeviating impartiality, and the beneficial effects of the new pavements have been demonstrated by a marked decrease in the mortality statistics from the tenement localities."

Cars were considered a vast improvement over horses, whose clip-clopping created a constant din. William Dean Howells complained that hearing "the sharp clatter of the horses' iron shoes" against the pavement tormented him. Automobiles were more hygienic than horses; the typical street previously contained piles of manure. No wonder electric-powered streetcars were so popular when they appeared in the 1890s, despite the fact that they were powered by unsightly overhead cables. The new motorized buses that replaced horse-drawn omnibus lines in 1905 were also heralded as cleaner, healthier, and more modern.

Yet no mode of transportation revolutionized New York like the subway. Underground mass transit had been tried before in Manhattan in 1870, when Alfred Ely Beach dug a 312-foot tunnel under Broadway from Warren to Murray streets for his pneumatic subway, powered by an enormous fan.

Building the first subway at Union Square, New York City, June 8, 1901. Subway workers used the "cut and cover" method, which involved cutting a deep trench and then buildng a temporary roadway over the excavation site.

Money dried up, and his subway was abandoned. But with the Blizzard of 1888 paralyzing the city for days, officials realized that a subway was a necessity. A public referendum in 1894 opened the way toward funding, and soon planning began.

The financier Augustus Belmont headed the newly formed Interborough Rapid Transit Company, which took charge of the first leg of the system. Ground was broken in March 1900 at City Hall, where the first station would be a grand starting point for a line stretching up the East and West Sides into the Bronx and extending downtown into the new borough of Brooklyn. For four years workers excavated tunnels, blasted rock with dynamite, and laid down track. After finishing the City Hall station, the "sandhogs" progressed north, building stations every five or so blocks. This was perilous work, and 16 men died doing it.

"Morning and night the hordes of clerks and stenographers and business men who fill the offices of down-town New York

have poured across Newspaper Row and City Hall Park with scarcely a glance at the labor progressing underfoot that is going to bring them so many minutes nearer their work in the morning, and at night so many minutes nearer their play," stated a 1902 article in *The Century*. "A still more interesting question, perhaps—that of the effect of this sudden increase in the ease and rapidity of transportation on the country at the city's edge, and of the other paths of rapid travel which are destined to honeycomb our narrow Babylon—the morrow, our all too precipitate to-morrow, will answer."

The answer would begin to emerge on October 27, 1904, the day the first nine miles of track out of a planned 700 opened. This was a joyous day for the metropolis: At 2:00 P.M., factory whistles blew in celebration. "From the Battery to Harlem, at the same time, the tugs, ferry boats, and steamships on the two riverfronts were blowing their greeting, vying with the steam whistle of hundreds of power plants, the chiming of church bells, and the cheering of the citizens," wrote the

New York Times the next day. "The city was in an uproar from end to end as general manager Hedley opened the kiosk door and descended the steps to the station platform where the first train of eight cars stood waiting."

After a ceremony, Mayor George McClellan took the controls and drove the subway from City Hall's beautifully tiled and chandeliered Beaux-Arts station to 42nd Street at Grand Central Terminal. There, the tracks crossed west to Broadway and continued up the west side to 145th Street in Harlem. Trains ran on the local track back and forth all day. An estimated 150,000 New Yorkers squeezed onto the crowded, newly opened platforms and caught their first rides.

"New-York played with its new toy, the subway, last night, with characteristic energy and spirit, and found it as much fun as going to the show, seeing the Bowery or 'doing' Chinatown," wrote the *New York Tribune* on October 28, 1904. "Most of the superlative adjectives in the dictionary were applied to the subway by women passengers, but the most popular verdict was 'simply perfectly grand!'"

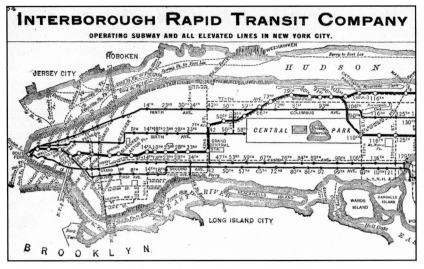

This Interborough Rapid Transit Company Map from 1906 shows elevated train and subway routes criss-crossing under and over Manhattan.

BROOKLYN BRIDGE OPENING DAY

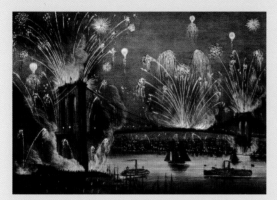

Fourteen tons of fireworks were set off on May 24, 1883, to celebrate the opening of the bridge; the *New York Times* wrote that the fireworks "broke into millions of stars and a shower of golden rain which descended upon the bridge and the river."

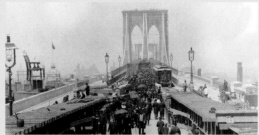

On opening day of the Brooklyn Bridge, the *New York Times* reported, "The pleasant weather brought visitors by the thousands from all around . . . It is estimated that over 50,000 people came in by the railroads alone, and swarms by the sound boats and by the ferry-boats helped to swell the crowds in both cities . . . The opening of the bridge was decidedly Brooklyn's celebration. New York's participation in it was meager, save as to the crowd which thronged her streets."

After 16 years, up to thirty workmen deaths (including that of its chief engineer, John Roebling) and the decompression sickness that paralyzed Roebling's engineer son Washington in 1872, the East River Bridge was complete. Opening day of the longest suspension span in the world was set for May 24, 1883.

Schools closed, workers took the day off, and thousands of New Yorkers attended ceremonies. Sailing vessels glided under the bridge as bands played, cannons fired, and fireworks blazed in the sky. President Chester Arthur and New York Mayor Franklin Edson walked together to the Brooklyn side, where Brooklyn's Mayor Seth Low greeted them warmly. Emily Roebling, who helped direct the building of the bridge after her husband was gravely injured, was the first of about 150,000 citizens to cross the bridge by foot that day.

"A clamorous and swelling multitude pressed against the barriers which encircled the Sands Street entrance when the strains of a patriotic air rang through the building which will serve as a depot," wrote the *Brooklyn Daily Eagle* on opening day. "It was all [police] could do with the best efforts of two or three hundred officers, to hold the dense and swaying throng in check."

Six days after the opening festivities, tragedy struck. As thousands of residents strolled across the bridge, a rumor spread that it was close to collapse. The resulting stampede killed twelve people. "Men and Women Crushed and Trampled to Death in

the Blockade at the New York Anchorage," read the *Brooklyn Daily Eagle* headline.

The opening of the Brooklyn Bridge isn't remembered for the stampede, but for ushering in a massive wave of public enthusiasm for bridge construction. The elegant Washington Bridge connecting Manhattan and the Bronx would be the next to open, in 1889, followed by other Harlem River bridges. The Williamsburg Bridge went up north of the Brooklyn Bridge in 1903, and the Manhattan and Queensboro bridges debuted by the decade's close.

They are all stately, graceful, and knit the greater city together. But none are as iconic as the Brooklyn Bridge, perhaps New York's greatest symbol of progress, might, and triumph.

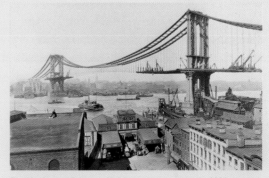

The Manhattan Bridge, which began construction in 1901, opened in 1909; it was the third bridge to connect Lower Manhattan to Brooklyn. That same year, farther up the East River, the Queensboro Bridge would link midtown to Queens.

GOTHAM COMES TOGETHER

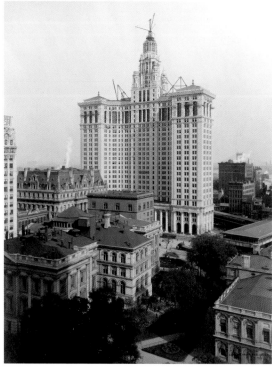

The forty-story Manhattan Municipal Building, designed by McKim, Mead and White, was completed in 1914 to house the city's new government after the 1898 consolidation.

"To all intents and purposes, New York and Brooklyn form one metropolis, and the day is not far distant when the two cities will be united under a single corporate government," wrote James McCabe in 1882's *New York by Gaslight*. Perhaps McCabe could see that consolidation was inevitable because he had watched the Brooklyn Bridge—still one year away from its opening—slowly join the two great metropolises by rope and steel.

He also may have known that as far back as 1868 the city planner and visionary Andrew Haswell Green had proposed combining Manhattan and its neighboring cities and towns along the sprawling New York waterfront into one vast "Imperial City." Green was an esteemed leader who had a hand in the creation of Central Park, the Bronx Zoo, the Public Library, and the Washington Bridge over the Harlem River (in 1888). "Green's Hobby," as his consolidation idea was known, had a mixed reception. It was an effort to thwart mismanagement and corruption of the waterfront by so many different municipalities, but support grew slowly, mostly from merchants and anti-graft progressives.

Finally, in 1890, a committee was formed to examine the idea. "Public improve-

ments, such as streets, drains, sewers, parks, facilities for rapid transit, bridges, and other measures for the convenience of densely populated communities, will all be better devised, constructed, and administered under the agencies of a single government," a document published by the committee stated. "There will be fewer office-holders for the taxpayers to support, administration will be less costly, and fresh impetus given to advantageous development." On the other hand, Manhattanites weren't so keen on picking up Brooklyn's debt. Brooklyn worried that Manhattan's poorest immigrants would move in.

"Our narrow island, bounded on each side by the rivers that serve our commercial businesses so well, is hemmed in by natural moats more effective than any which military skill could construct," Green told the committee. "As if these natural moats do not suffice to mark our separation, we emphasize them artificially by statute declaring them to be the boundary of our political jurisdiction. We may bridge the river or tunnel under it, but we cannot bridge or tunnel through the artificial barrier of separate jurisdiction."

While the small towns of Queens and Staten Island supported the idea of "Greater New York," one locale held out: Brooklyn. In 1897, it was already the fourth-largest city in the country, a manufacturing powerhouse that refined sugar, built ships, and made clothes, cigars, and other items in its many factories. Brooklyn had an educated elite, and wealthy residential neighborhoods as well as working-class tenements. It had parks, museums, hospitals, and sport teams. When debated in newspapers and at political events, consolidation remained wildly unpopular with Brooklynites.

After an 1894 referendum passed, Green pushed consolidation through legislative channels in 1896 and helped write the charter a year later, to take effect on January 1, 1898.

William Randolph Hearst helped raise money for a party on New Year's Eve 1897 at the Broadway Central Hotel at West 3rd Street. Yet the big celebration with fireworks was held at City Hall. Not everyone felt so festive, especially across the East River. Manhattan Mayor William Strong, who had rejected the charter, suggested holding a funeral instead. The front page of the *Brooklyn Daily Eagle* on December 31, 1897, featured an image of Brooklyn City

Progressive reformer Seth Low served two terms as mayor of the city of Brooklyn and then one term as mayor of the consolidated city of New York. He wrote, "the great city can teach something that no university by itself can altogether impart: a vivid sense of the largeness of human brotherhood, a vivid sense of man's increasing obligation to man; a vivid sense of our absolute dependence on one another."

Hall with the headline "The Passing of the City of Brooklyn." A short article blamed the state of New York for allowing consolidation to pass. "In 1896, the State Legislature deprived the one million institutions of Brooklyn of their municipal independence in disregard of the votes of their own representatives," the piece contended.

No matter—with or without the support of every resident of the 56 municipalities joining forces, New York would double its population and become a 320-square-mile metropolis. At midnight, a giant new city flag was lit up by blue and white lights at City Hall. A 100-gun salute and fireworks display in City Hall Park topped off the festivities. The state's new charter uniting the boroughs of New York City commenced.

Already connected by bridges, elevated trains, and telephones, and six years away from being linked by the subway, Andrew Green's "Imperial City" was born.

City Hall festooned with electric lights on New Year's Eve 1899 to celebrate the turning of the century.

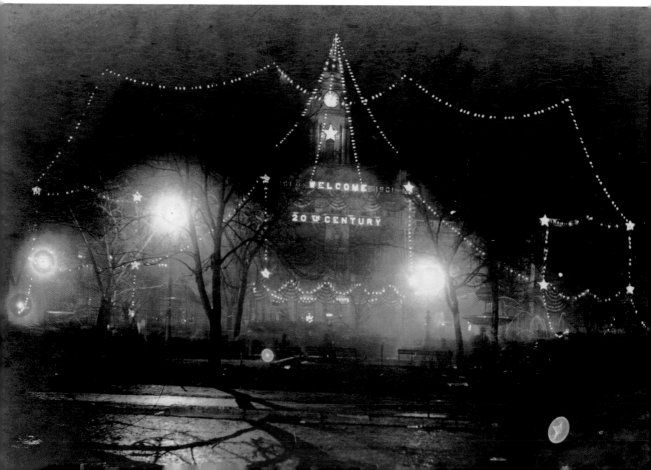

INDEX